THE WORLD'S GREAT
CIVILIZATIONS

TABLE OF CONTENTS

LIFE BOOKS

Managing Editor Robert Sullivan
Director of Photography Barbara Baker Burrows
Creative Director Mimi Park
Deputy Picture Editor Christina Lieberman
Copy Chief Barbara Gogan
Copy Editors Don Armstrong, Parlan McGaw
Writer-Reporters Michelle DuPré (writer),
Danny Freedman (writer), Marilyn Fu
Photo Associate Sarah Cates
Editorial Associate Courtney Mifsud
Consulting Picture Editors
Mimi Murphy (Rome), Tala Skari (Paris)

Editorial Director Stephen Koepp
Editorial Operations Director
Michael Q. Bullerdick

EDITORIAL OPERATIONS

Richard K. Prue (Director), Brian Fellows
(Manager), Richard Shaffer (Production),
Keith Aurelio, Charlotte Coco, Kevin Hart,
Mert Kerimoglu, Rosalie Khan, Patricia Koh,
Marco Lau, Brian Mai, Po Fung Ng, Rudi Papiri,
Robert Pizaro, Barry Pribula, Clara Renauro,
Katy Saunders, Hia Tan, Vaune Trachtman

TIME HOME ENTERTAINMENT

President Richard Fraiman
Vice President, Business Development & Strategy
Steven Sandonato
Executive Director, Marketing Services Carol Pittard
Executive Director, Retail & Special Sales Tom Mifsud
Executive Publishing Director Joy Butts
Director, Bookazine Development & Marketing Laura Adam
Finance Director Glenn Buonocore
Associate Publishing Director Megan Pearlman
Assistant General Counsel Helen Wan
Assistant Director, Special Sales Ilene Schreider
Book Production Manager Suzanne Janso
Design & Prepress Manager Anne-Michelle Gallero
Brand Manager Roshni Patel
Associate Prepress Manager Alex Voznesenskiy

Special thanks: Christine Austin, Katherine Barnet, Jeremy
Biloon, Jim Childs, Susan Chodakiewicz, Rose Cirrincione,
Lauren Hall Clark, Jacqueline Fitzgerald, Christine Font,
Jenna Goldberg, Hillary Hirsch, David Kahn, Amy Mangus,
Robert Marasco, Kimberly Marshall, Amy Migliaccio,
Nina Mistry, Dave Rozzelle, Adriana Tierno, Vanessa Wu

Copyright © 2012
Time Home Entertainment Inc.

Published by LIFE BOOKS, an imprint of
Time Home Entertainment Inc.,
135 West 50th Street, New York, New York 10020

ISBN 13: 978-1-60320-228-2
ISBN 10: 1-60320-228-5
Library of Congress Control Number: 2012940776

"LIFE" is a registered trademark of Time Inc.

We welcome your comments and suggestions
about LIFE Books. Please write to us at:
LIFE Books, Attention: Book Editors
PO Box 11016, Des Moines, IA 50336-1016

If you would like to order any of our hardcover
Collector's Edition books, please call us at
1-800-327-6388. (Monday through Friday,
7:00 a.m.–8:00 p.m. or Saturday,
7:00 a.m.–6:00 p.m. Central Time).

ENDPAPERS: THE ACHAEMENID EMPIRE (CUNEIFORM WRITING ON A STAIRWAY WALL IN PERSEPOLIS, IRAN), PHOTOGRAPH BY DIEGO LEZAMA OREZZOLI/CORBIS.
PAGE 1: THE INCA EMPIRE (AN ALPACA AT MACHU PICCHU), PHOTOGRAPH BY BRIAN A. VIKANDER/CORBIS. **PAGES 2–3:** THE MING DYNASTY (BEIJING'S FORBIDDEN CITY), PHOTOGRAPH BY STUART FRANKLIN/MAGNUM.
THESE PAGES: THE MUGHAL DYNASTY (THE TAJ MAHAL IN AGRA, INDIA), PHOTOGRAPH BY GERARD DEGEORGE/CORBIS.

The story of any one of history's great civilizations could fill a book or several of them. Edward Gibbon's *The Decline and Fall of the Roman Empire* was six fat volumes, and that only dealt with the decline and fall. And yet here we present to you a picture history of two dozen countries and cultures that left their mark through the centuries. Is this not a presumptuous book?

Yes, in a way. It is of course impossible to detail the multitude of twists and turns that led to any of these republics or monarchies having their moment in the sun. However, there is something to be gained by approaching this volume front to back, and watching how Civilization itself—not 24 civilizations, but the march of mankind's civilized history—built on what had come before. Legacies were left for the next fellow or were appropriated from the last. Lessons were learned or not. Some countries did things better.

We can see, as we progress from the ancients to the entirely new rules of the 20th and 21st centuries, the accretion of knowledge. We witness the evolution of everything from architecture and scholarship to military strategy and even ethical thought. We can see mistakes being made, and the mistakes of previous societies being ignored at a cost.

So while this is a book about the great civilizations it is, even more so, a book about, again, Civilization, capital C: Humanity's overarching progress as time has marched on. So many aspects of human nature are constant parts of this story: ambition, avarice, courage, intelligence, fear (fear of the enemy, fear of the deities). It is fascinating to see which traits led to success and which to failure.

It is, as we hope is true of all LIFE books, not only fascinating but fun to look at the rich photographic and pictorial record, and to imagine the day-to-day at the Parthenon or High Mass at the Hagia Sophia. *These* are the plains across which Genghis Khan and his Mongols thundered, and *this* is the mountaintop where the Inca built stunning, inscrutable Machu Picchu. *This* was the Atlantic port from which Portuguese ships sailed forth to launch the Age of Discovery in the 1400s, and *this* was the part of the moon that Neil Armstrong and Buzz Aldrin called Tranquility Base, and where they planted an American flag in 1969.

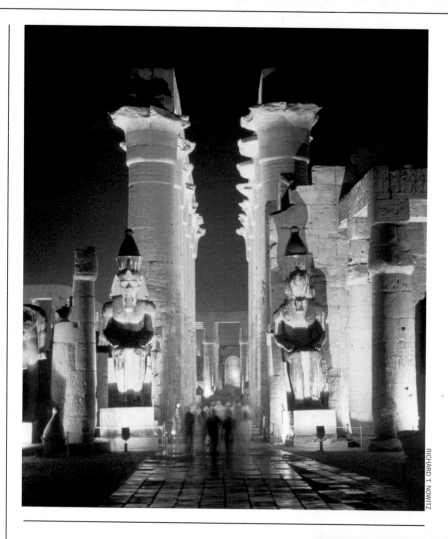

RICHARD T. NOWITZ

There are many lessons to be learned from a look at Civilization's progress, two clear ones being: Many things are, as said, handed down through history, and nothing is immutable. Even before man started writing histories that made these truths evident, there were cultures laying the building blocks of our present-day historical record. They were already experiencing days of glory and days of strife, or so the modern archaeologists tell us. Some long-ago cultures were doing better than others; some may have been dominating. We will visit them first, and then head to the land of the pharaohs, which we know much about. We will finish our journey back home, looking toward tomorrow, wondering at the future fate of the world's latest great civilization—a civilization that is trying a new way of doing things.

Above: Thebes and its Luxor Temple represented the capital of Egypt during the New Kingdom reign of the great Pharaoh Ramses II. Opposite, top: One of the glories of Islamic architecture was and is the Dome of the Rock in Jerusalem, built by the Umayyad Caliphate between 688 and 691. Bottom: Today, the White House in Washington, D.C., is where the leader of the United States conducts business.

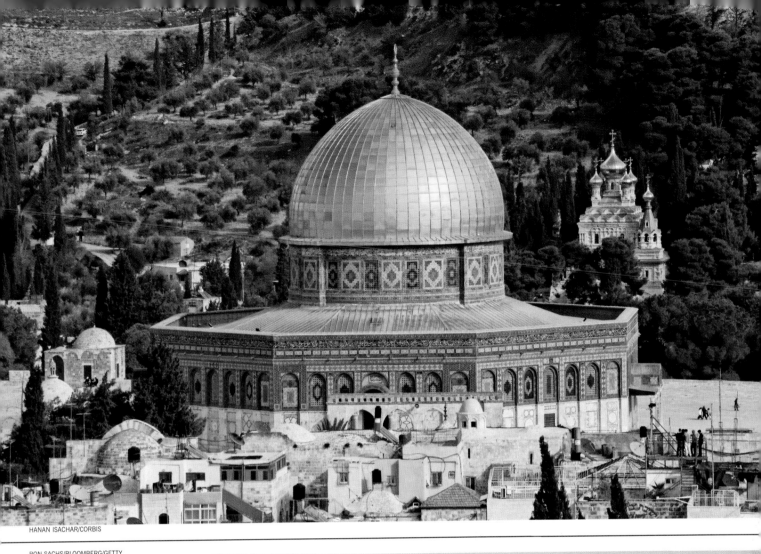
HANAN ISACHAR/CORBIS

RON SACHS/BLOOMBERG/GETTY
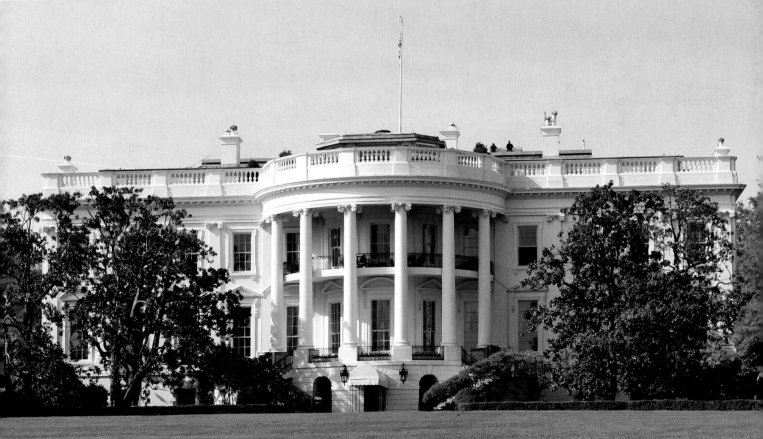

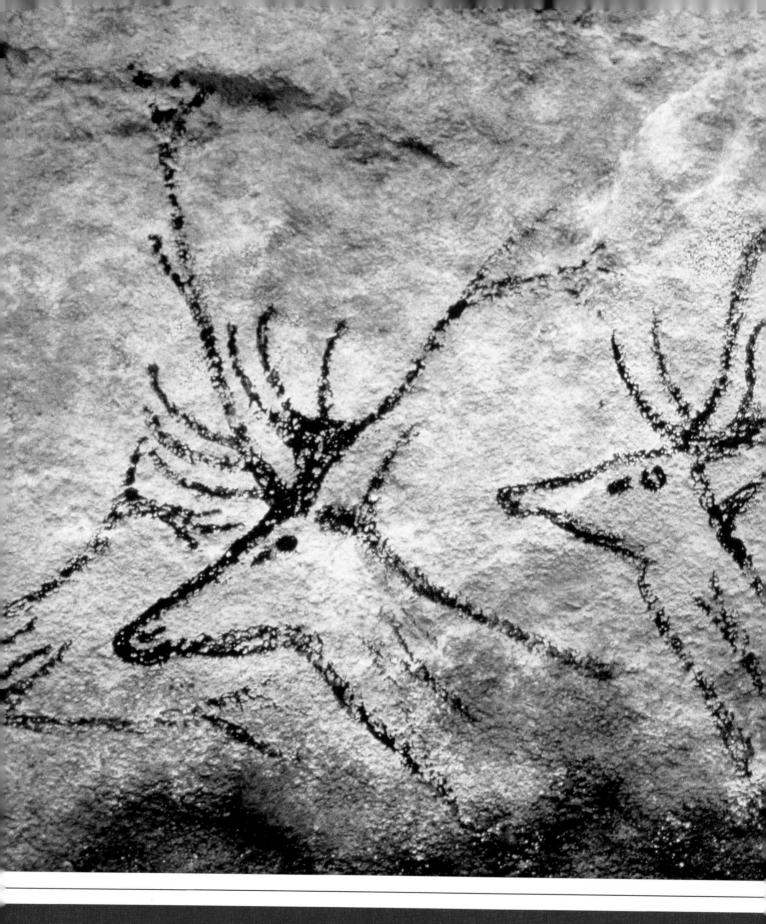

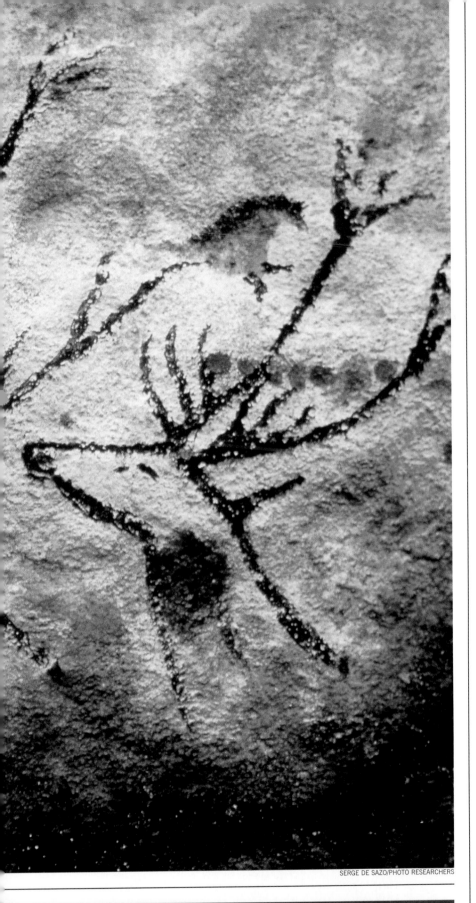

Before there arose what we officially credit as *Civilization*, there were civilizations all over the place. Some of them were focused almost exclusively on exercising their power and might, trying to get to tomorrow via the cudgel or spear. Others of them were culturally sophisticated. Some of these were, to use another popular term when looking at historic cultures, *advanced*. Some were all of the above—smart, influential and powerful—and, it can very reasonably be argued, they were great civilizations.

Traditionally, many of these have been thoroughly overshadowed down the centuries by the hallowed, somewhat romantic and lately leaky notion of the Fertile Crescent. When the University of Chicago archaeologist James Henry Breasted first posited it in his 1906 book, *Ancient Records of Egypt*, it seemed an elegant historical construct: Various bygone kingdoms (*great* civilizations; the earliest known Western civilizations) evolved in a crescent-shaped region of lush lands in western Asia and northeast Africa where they could use the soil and water to nourish their growing populations. And, since this fertility had long been the case in the area historically known as Mesopotamia and the land between and surrounding the Tigris and Euphrates rivers, the people already had a head start (writing, glass, the wheel—and beer!—were thought to have been invented in the Fertile Crescent). Certainly, many of the early Western civilizations to which we have always paid attention did prosper in this region, which today comprises all or part of Iraq, Iran, Kuwait, Syria, Lebanon, Jordan, Israel, the Palestinian Territories, Turkey and Egypt. And certainly Mesopotamia (the Assyrians and Babylonians), Macedonia, Greece and, eventually, Rome stood on the shoulders of earlier, dominant nations in the Fertile Crescent. We will learn about all of that in the pages to follow.

But the history of civilization is complicated and often nonlinear—this we have learned for a certainty in the century and more since Breasted theorized. The Fertile Crescent wants to be regarded as a Garden of Eden for today's civilizations. It wants to be, as it has often been

CIVILIZATION

France's now-famous Lascaux caves, filled with paintings dating from the Upper Paleolithic period, were not discovered until 1940, at which point the question was asked anew: What constitutes civilized?

called, the Cradle of Civilization.

Modern historians and archaeologists have been chipping away at its claim.

The Indian subcontinent had its own mighty, life-supporting river in the Indus, and there is no question but that an early, advanced and now lost civilization prospered there. Another arose along the banks of the Yellow River in China. Deeper into Egypt than Cairo there was a civilization that hardly influenced—or was influenced by—those of the Fertile Crescent. Similarly, there were civilizations in South America and Mesoamerica that would inform the Inca and Maya and Aztecs, who wouldn't catch a whiff of Eurasian or North African culture for centuries.

Scholars have felt compelled to decide on what exactly constitutes a civilization, and often writing is used as the benchmark. Fair enough, and under this definition Sumer, in the heart of the Fertile Crescent in southern Mesopotamia, is cited as perhaps the earliest great civilization. A notable culture appeared there at least as early as the 3rd century B.C., with pottery and metalworks made into fine arts, and cuneiform writing becoming a mode of communication. Sumerian city-states including Ur, Erech, Kish and Lagash, each supported by a solid agricultural base, grew strong and rivaled the Semitic cities. As we will see with many of our civilizations, rivalry is always dicey, and war often begets the fall. The Semites conquered the Sumerians. There was a revival at Ur in 2050 B.C., but the rise of Babylonia ended the story of—if not the memory of—Sumer.

So that was Sumer.

But should writing be the measure?

Much, much earlier than Sumer, Stone Age cultures were using tools and also telling stories in pictures; the Upper Paleolithic–period artwork found in the Lascaux caves in France has been estimated at 17,300 years old; in 2012 artwork dozens of centuries older was found in Spain. The first thrust of organized building at the famous circle called Stonehenge in England dates to the Neolithic: people using deer antlers to excavate ground circa 3100 B.C. In our own country—or on land that is today

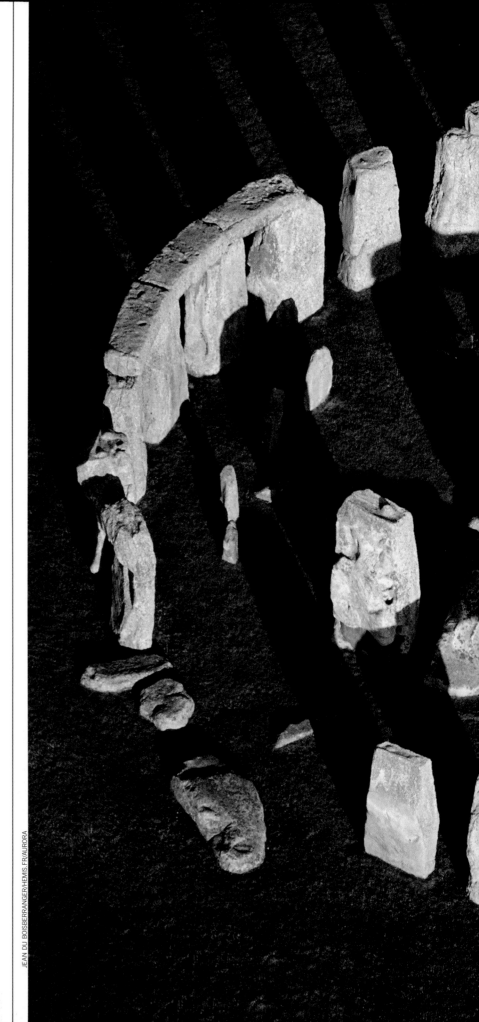

England's Stonehenge as it exists was erected by different communities over many, many years. We are impressed but mystified by their achievement because they left no histories.

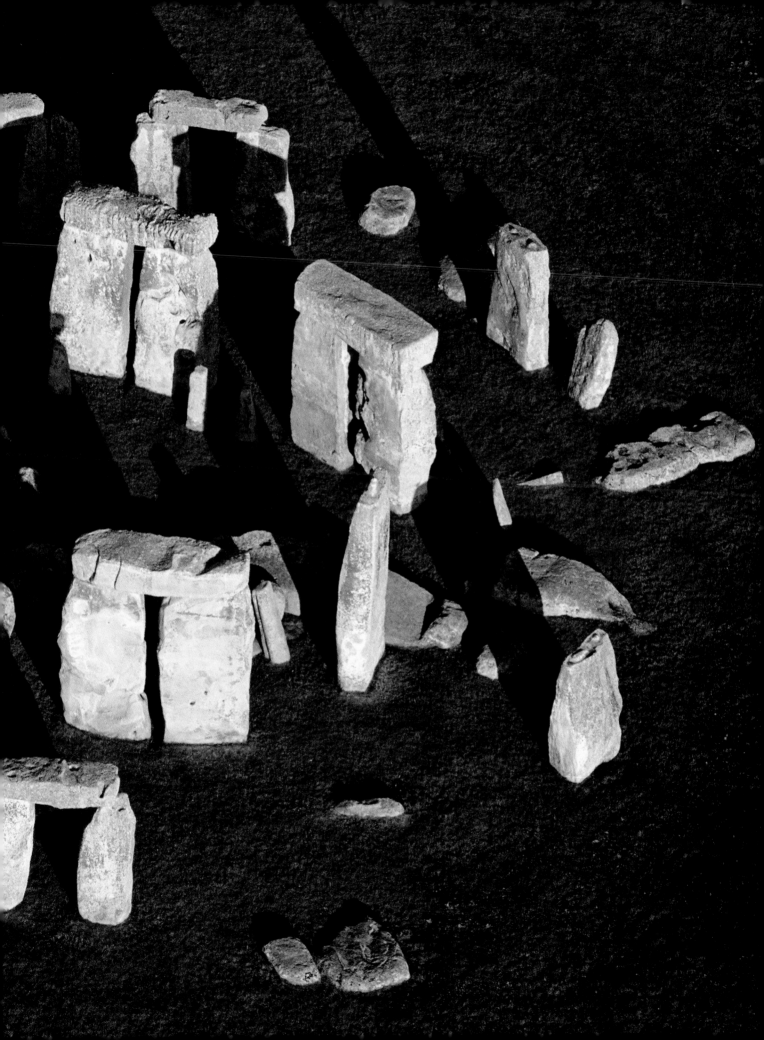

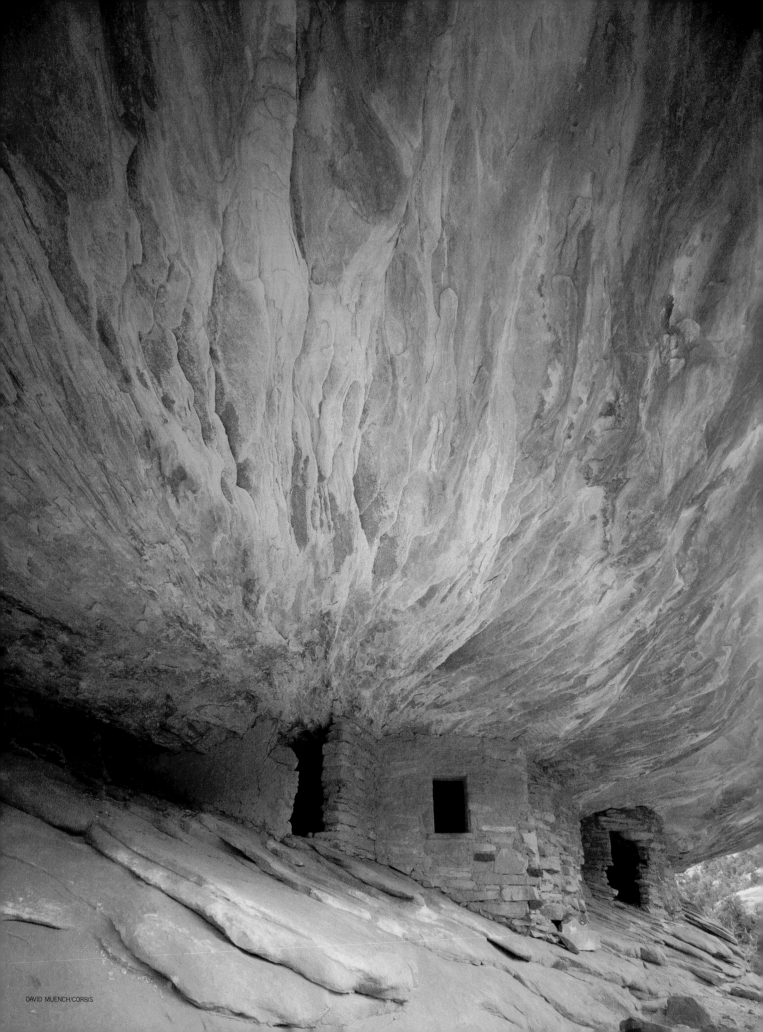

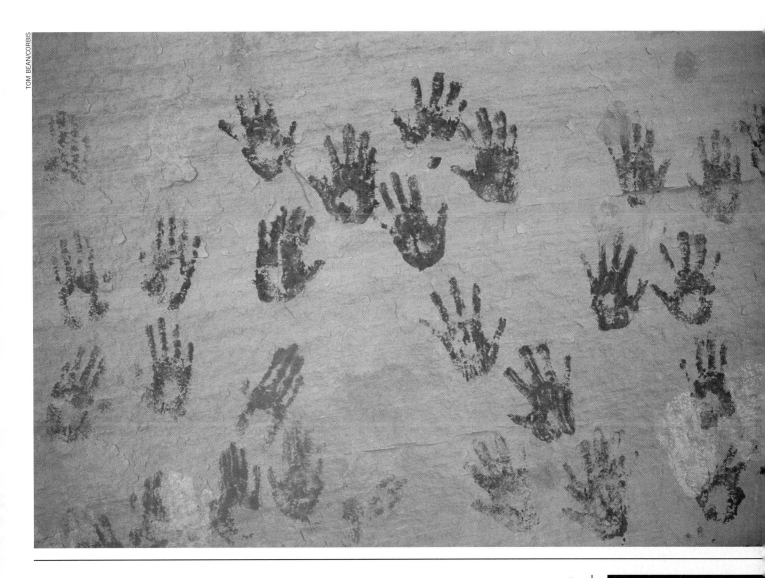

part of our own country—we didn't have any truly ancient civilizations, but we had a very mysterious, advanced culture that bloomed in the Southwest in the 12ᵗʰ century A.D. The Anasazi were ancestral Puebloans who lived in cliffside abodes up to 2,000 feet high and, according to the petroglyphs on so-called Newspaper Rock in Utah, were cultured, productive and spiritual—all without any hand-me-down influence from Athens or Rome, not so much as an Aristotelian spore blown in on the breeze. The Anasazi were "advanced" seemingly on their own. And by 1300, they had abandoned their cave dwellings, drifted off south and east, blended elsewhere, and were no more—a vanished civilization.

As are most of those that we will now read about: vanished, gone from the planet or thoroughly assimilated into what we are presented with today, our current world community. Everything from the dominance of the Egyptian pharaohs to the global spread of the British Empire is significant only as history and cultural tradition. These superpowers have come and gone, and Civilization, under any definition and no matter the benchmark for membership, has walked on.

It is perhaps futile to search for *the* cradle—there were cradles everywhere—but the search is not without profit. In looking back, we can see what nurtured the great civilizations, and often what led to their fall. Excess ambition, hubris, corruption, injustice, cruelty: These, it seems, do exact a final penalty. Learning, invention, investment, a moral code, a spreading of the wealth: These can underlie the rise of a successful civilization.

It's funny—funny, in a way—when we look far back. To play off writer and philosopher George Santayana: You would think we might have learned this long, long ago.

Opposite: The Anasazi in what is now Utah's Mule Canyon lived high in the cliffs in dwellings of seemingly unique architectural provenance. Their people's pictographs (above) in the Grand Gulch Primitive Area, also in Utah, and others on Newspaper Rock tell the story of a well-ordered, forward-thinking society.

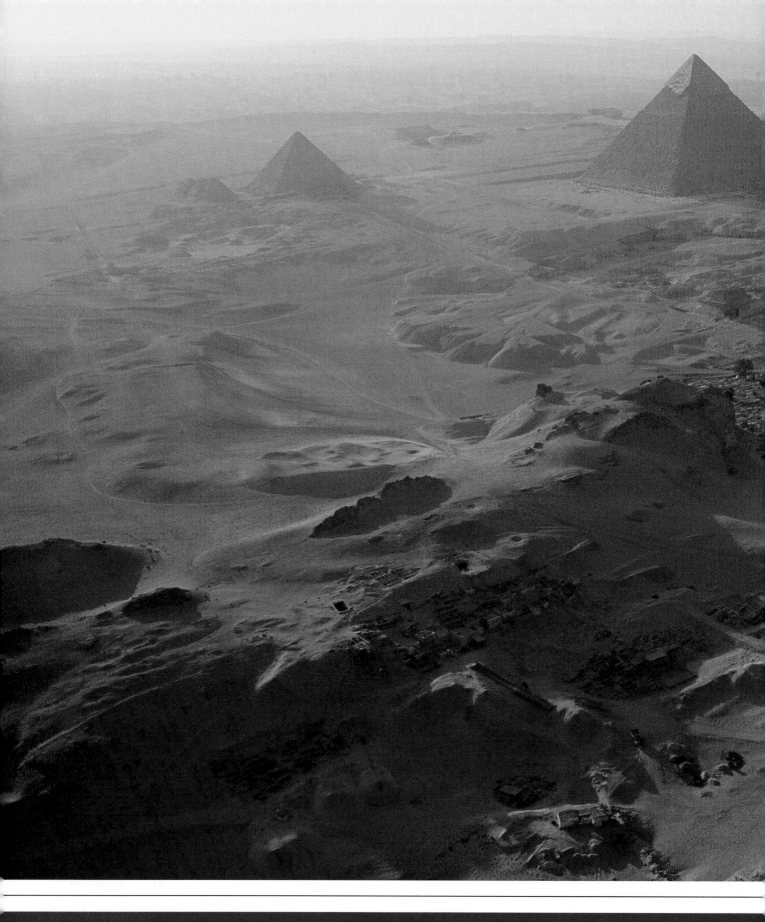

ANCIENT EGYPT

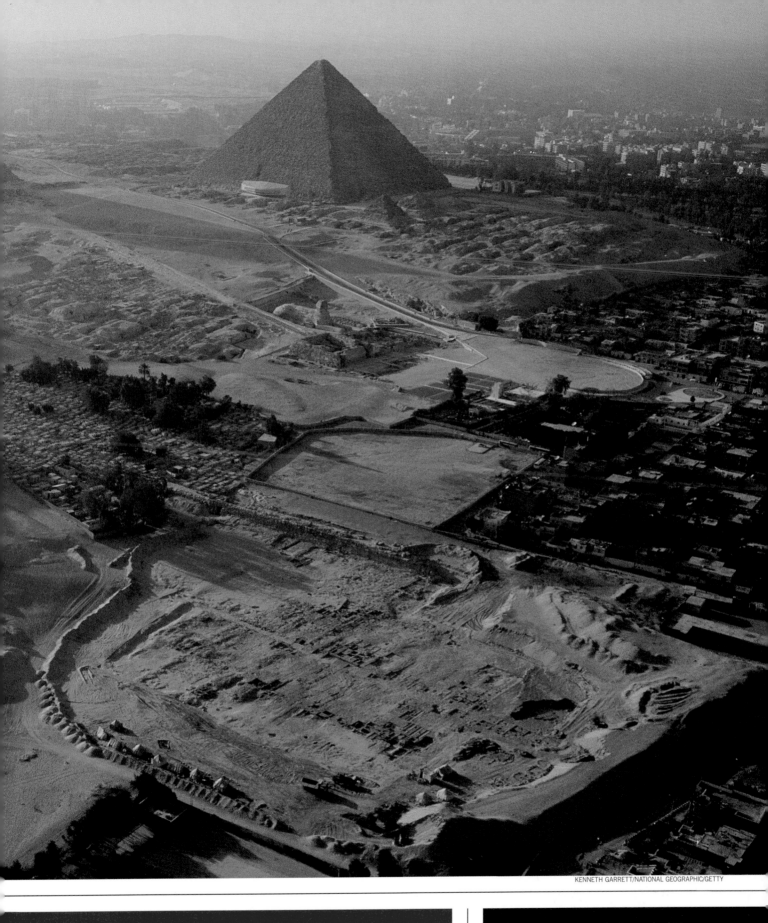

This is an aerial view of the Pyramids of Giza outside Cairo, including Khufu's Great Pyramid. The inscrutable Sphinx is also in the area.

The Egyptian calendar was adopted in 4242 B.C. and, according to Egypt's historical chronology, a succession of 30 dynasties began its run in about 3090 B.C.—a fantastic three millennia of rule, with occasional periods of instability, yes, but unbroken. Circa 3150 B.C., Upper and Lower Egypt were unified and the first pharaoh came to rule this nation in northeastern Africa. In the many centuries that followed, Egypt passed through distinct periods known, now, as the Old Kingdom, the Middle Kingdom and the New Kingdom. If Egypt reached its apex of power during the New Kingdom reign of Ramses II, three other personalities—one who lived earlier in the history, one a good deal later and one at the very end—are eternally interesting, and useful as markers as we briefly delineate ancient Egypt.

King Khufu (also known as Cheops) was the second pharaoh of the Fourth Dynasty (circa 2575–2465 B.C.). Ruling for nearly two dozen years, he was rumored to have been quite a tyrant. Beyond that, and the fact that he was the son of a pyramid-building king named Snefru, facts about him are scarce. He clearly approved of Egypt's Old Kingdom tradition of erecting pyramid-shaped superstructures to encase royal tombs and chose the plateau of Giza, on the west bank of the Nile and southwest of modern day Cairo, as the site of his own. What went into the building of what is today known as the Great Pyramid is testimony to the

KAZUYOSHI NOMACHI/CORBIS

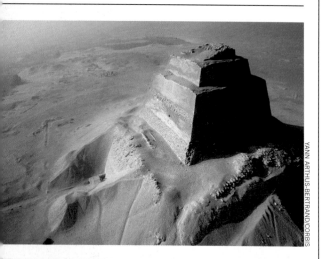

YANN ARTHUS-BERTRAND/CORBIS

FRÉDÉRIC SOLTAN/SYGMA/CORBIS

Three pictures from in and around the Ancient Egyptian capital of Memphis, near today's Cairo: At left, top, is a pyramid dating to circa 2613 B.C. at Maydum near Memphis; bottom is a relief inside the Necropolis of Saqqara; and above is the burial chamber of the Pyramid of Unas at Saqqara. In the Memphis excavation sites

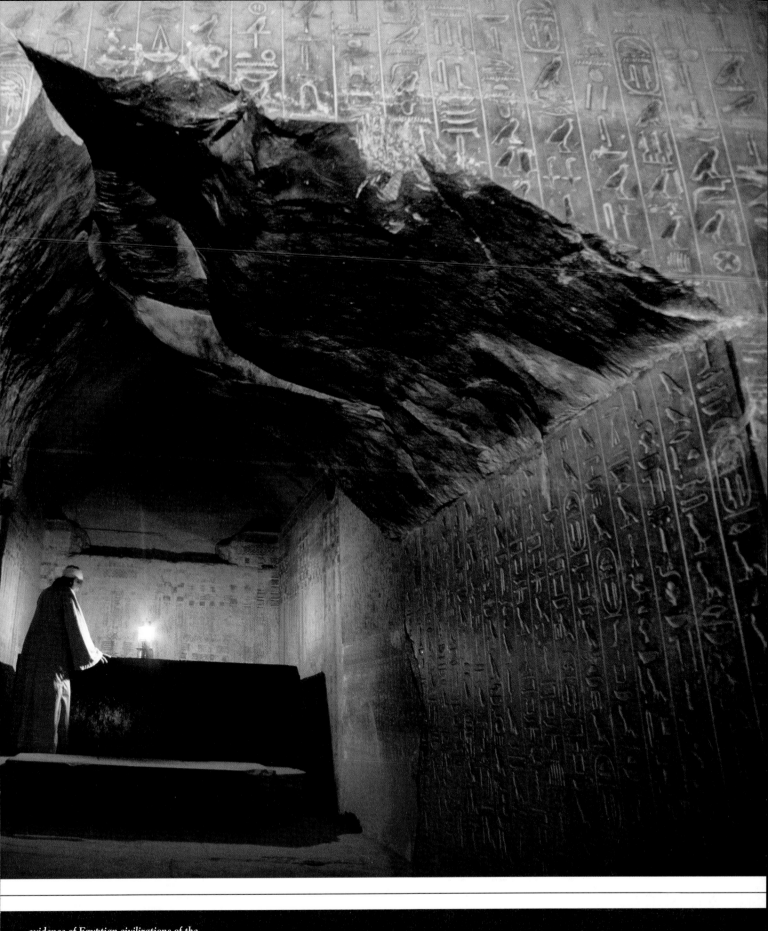

evidence of Egyptian civilizations of the
earliest Dynastic period through all the
kingdoms—Old, Middle, New—has
been found.

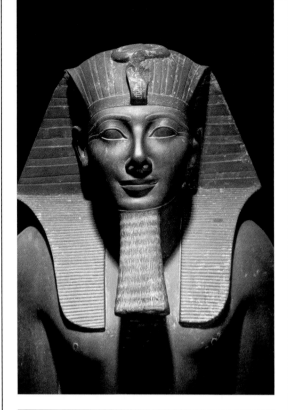

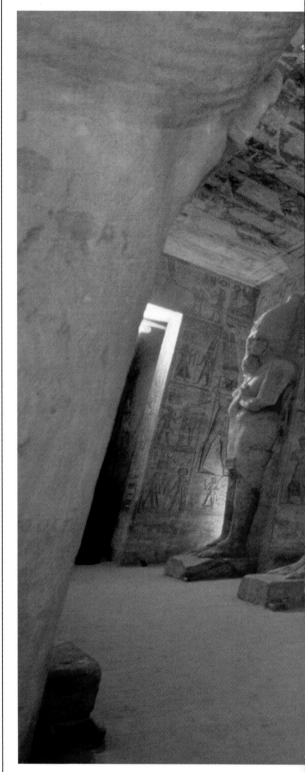

absolute, awesome, awful power of the pharaohs. It is believed that as many as 25,000 men worked on the pyramid for up to four months each year for at least 20 years. The word *toil* doesn't begin to tell the tale. Consider that the pyramid's 2.3 million blocks of stone average 2.5 tons apiece (the heaviest are 15 tons); consider that the blocks had to be dragged by teams of men up ramps made of mud and brick, and that the ramps then needed to be raised to begin work on the edifice's next level; consider that only the interior stones were quarried nearby because Khufu's architect wanted to use a better-quality white limestone for the casing layer, and this high-grade rock had to be brought from quarries on the other side of the Nile at Tura, then up from a harbor at the plateau's edge; consider that dense granite blocks were required for the burial chamber in the pyramid's center and to serve as plugs for the corridors, and that the heavy granite could be supplied only by a quarry in Aswan, nearly 600 miles south; consider that the pyramid was designed to grow to a height of 481 feet and that its base would spread over 13 acres . . . and then consider that ancient man, through blood, sweat and no doubt a considerable flow of tears, was asked to pull it off. Those considerations amount to a measure of the pharaoh's might.

Tutankhamun was a pharaoh of the 18th dynasty who ruled for barely a decade during his childhood, adolescent and teenage years before dying young in 1323 B.C. He would be less well remembered today had Howard Carter and George Herbert, 5th Earl of Carnarvon, not discovered his perfectly kept tomb and its treasures in 1922. Every so often, a sampling of King Tut's jewels and other riches (but not his signature burial mask, which stays home) tours the world yet again, reminding those who gaze upon them what it meant to be the absolute king when Egypt was a dominant power.

However, as mentioned, the long rule of the pharaohs was not without trials and troughs, and after Ramses II's reign, Egypt slumped, then entered its final decline. Other civilizations pressed

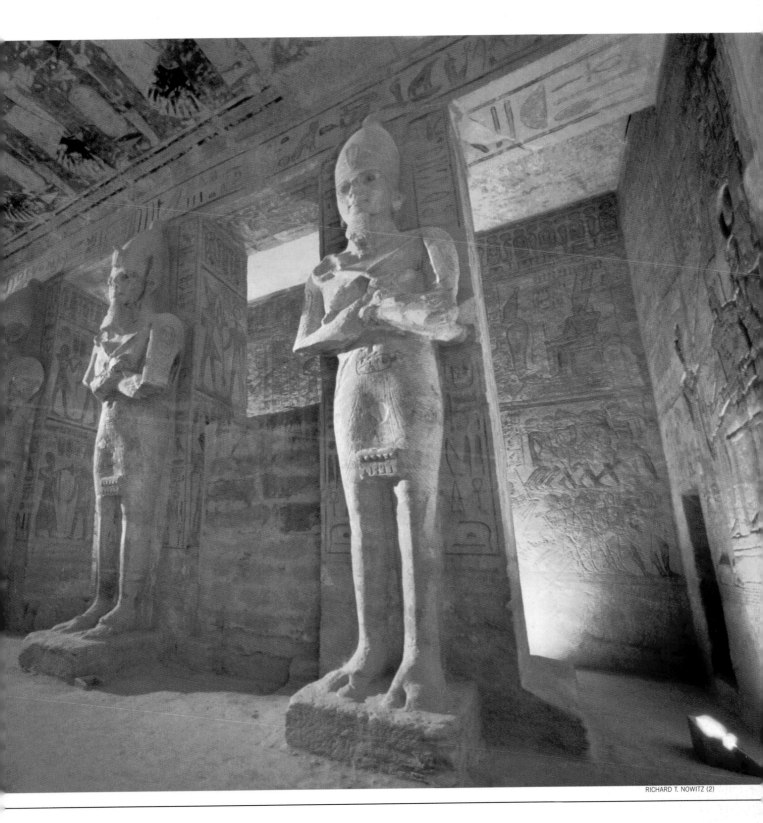

in, and Egypt was conquered serially. When Alexander the Great died, one of his generals, Ptolemy I Soter, took over as Egypt's ruler. The Ptolemaic Dynasty would persevere until 30 B.C., and its final pharaoh was Cleopatra VII—*the* Cleopatra—whose double-dealing, games-playing, fall and coerced suicide were emblematic of the death of Ancient Egypt itself. The Roman Empire was now in charge, and the pharaohs, after so long

a time, were relegated to the history books.

The Egyptian civilization's successes in agricultural development, cultural and social advancement, education, architecture, foreign policy and military execution are not to be denied, and they greatly influenced all nations that followed in the region. But after many centuries, the counting of dynasties and naming of kingdoms had finally come to a close.

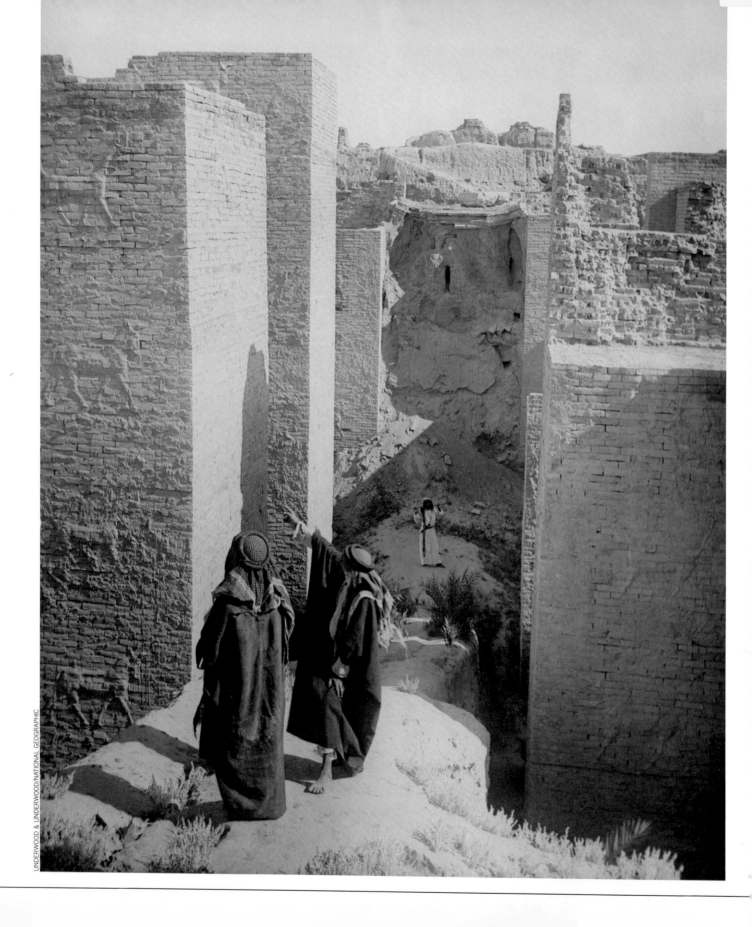

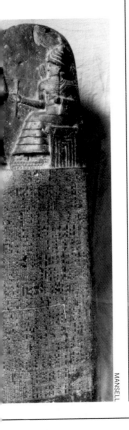

As we have mentioned, many of these civilizations and empires persevered for generations or even centuries past their apex years, and certainly the history books pay attention to the subsequent dynasties, their rulers and other dominant personalities. In the instance just delineated, that of Egypt, Cleopatra was in charge (sort of) of a state that was nothing as it was when Ramses II was in charge; it was, relatively, a shambles, hardly even Egyptian in heritage. When one thinks of Babylon, perhaps the famous Hanging Gardens come to mind (one of the original Seven Wonders of the World, along with Khufu's pyramid near Cairo) as well as the ruler who, as legend has it, built the gardens for his wife in the 6th century B.C., the famous Nebuchadrezzar II. No doubt Nebuchadrezzar was a more forceful and charismatic king than others in the 11th Babylonian Dynasty, defeating the Egyptians and Assyrians at Carchemish as he did, and also perhaps interacting with the Bible's David. But by Nebuchadrezzar's time, Babylon had been kicked around for more than a millennium and had traveled far from its roots, which lay in that "first civilization" centered in Sumer. In fact, the age of Nebuchadrezzar is seen as a "Neo-Babylonian" dynasty.

Let's go back closer to the start and look at the reign of Hammurabi, circa 1792 B.C. to 1750 B.C., when Babylon was establishing itself as the capital of Babylonia: along with Assyria, one of the truly great powers of the Middle East. Hammurabi was the sixth king of Babylon, that reign beginning when he was young. After his father was out of the picture and Hammurabi was subsequently successful in wars with neighboring kingdoms, including the formerly Sumerian city of Larsa, he became the first king of the Babylonian Empire. By the time of his death, Hammurabi was able to gaze over Mesopotamia and say that all of it was his. That his successors failed to hold the empire together is not of consequence here. What is important is that Hammurabi not only built the whole of it, but invented a glue to unify his holdings. This glue has led to his historical reputation as "the lawgiver."

The Code of Hammurabi is one of the first written sets of laws in the world—282 societal rules in all, written in cuneiform on a diorite stela. The code can be supposed to have gone down agreeably with the intellectual and cultural elite of Babylon, who represented society's upper strata of the region. Even today, though the code clearly establishes things we would deem unjust (a formalized three-tiered class system; the institution of slavery; brutal punishments under its *lex talionis,* or "law of retaliation" of "an eye for an eye, a tooth for a tooth" nature), the brilliance of its organization and original thinking (it forwards the ideas of a presumption of innocence and the value of evidence) are, from our modern vantage, breathtaking.

Hammurabi's historical importance is clear, but his code couldn't protect Babylon when he was succeeded by kings of lesser quality. The city was eventually sacked by the Hittites, then conquered by the Kassites. Babylon had always had a reputation for being multiethnic and multicultural—a historic New York City—but now the kings of Babylon were foreigners. The empire was greatly changed—you can even say it was no more—and by the time of Nebuchadrezzar II and others, it certainly was what we now term a neo-empire.

In its last throes in the 6th through 4th centuries B.C., Babylon would be dominated first by the Persians and then by Alexander the Great's Macedonians. Today, the ruins of Babylon, Larsa, and other Sumerian and Mesopotamian cities lie in a baked landscape within the borders of Iraq—whispering of a time when here was the center of the civilized world.

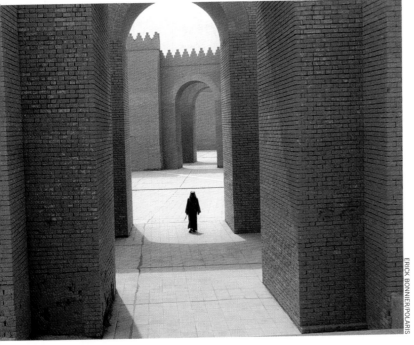

BABYLONIAN EMPIRE

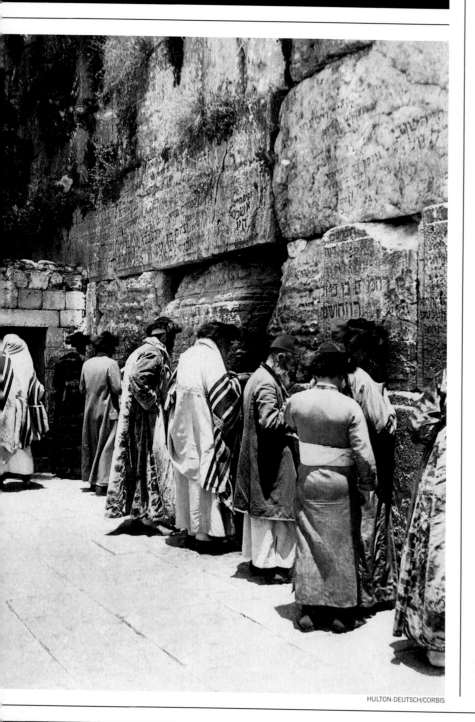

HULTON-DEUTSCH/CORBIS

W hile we are trying to present in these pages nations, kingdoms or, to use the term again, great civilizations that came to prominence in rough sequence, we freely admit—and here's a good place to do so—that there will be overlap and backtracking and, well, problems. As was pointed out in our chapter entitled "The Many Cradles of Civilization," communities of considerable sophistication were building their own worlds in Asia and Mesoamerica quite independent of what was happening in the Fertile Crescent. And now we come to Israel, which we slot here between Babylon and Persia. As we have indicated, we're trying to pick a point—especially with these eternal civilizations that have lasted in fact or in the cultural mind-set forever—when they truly contributed to the global conversation, some would say: at their apex of power and glory. Certainly Israel in the post–World War II years provides a dramatic and significant story, and so does the Israel of the 9th century B.C., as it is described in the Torah or the Christian Old Testament. We need to place Israel somewhere, and we think this is the sensible place.

Why? Because it helps us forward the historical narrative of the world's great civilizations; at various times during the two Iron Ages, from the 12th century B.C. to the 6th, Israel was of consequence, and at intervals was formidable and influential. Moreover, in this period Israel fortified in the Hebrew memory what Israel once had been and could be again— someday soon, or someday eventually.

In the Bible, Israel is the name given to Jacob as ancestor of the Hebrews, God's chosen people. The 12 tribes of Israel were named for 10 sons and two grandsons. It was seen that Israel's holy land was the tract hard by the Mediterranean (known often as the Great Sea), the land that had been called, in various contexts, Canaan or Palestine as well. We fast-forward here to the reign of Rehoboam, son of Solomon and grandson of David, 41 years old when he took the Israeli throne circa 922 B.C., promising in a politically maladroit declaration: "My father made your yoke heavy; I will make it even heavier. My father scourged you with whips; I will scourge you with scorpions." This went over as you might expect in some corners, and a rebellion split the monarchy into the Kingdom of Israel in the north, led by Jeroboam I, and the Kingdom of Judah to the south, which continued *(continued on page 26)*

(continued on page 26)

ANCIENT ISRAEL

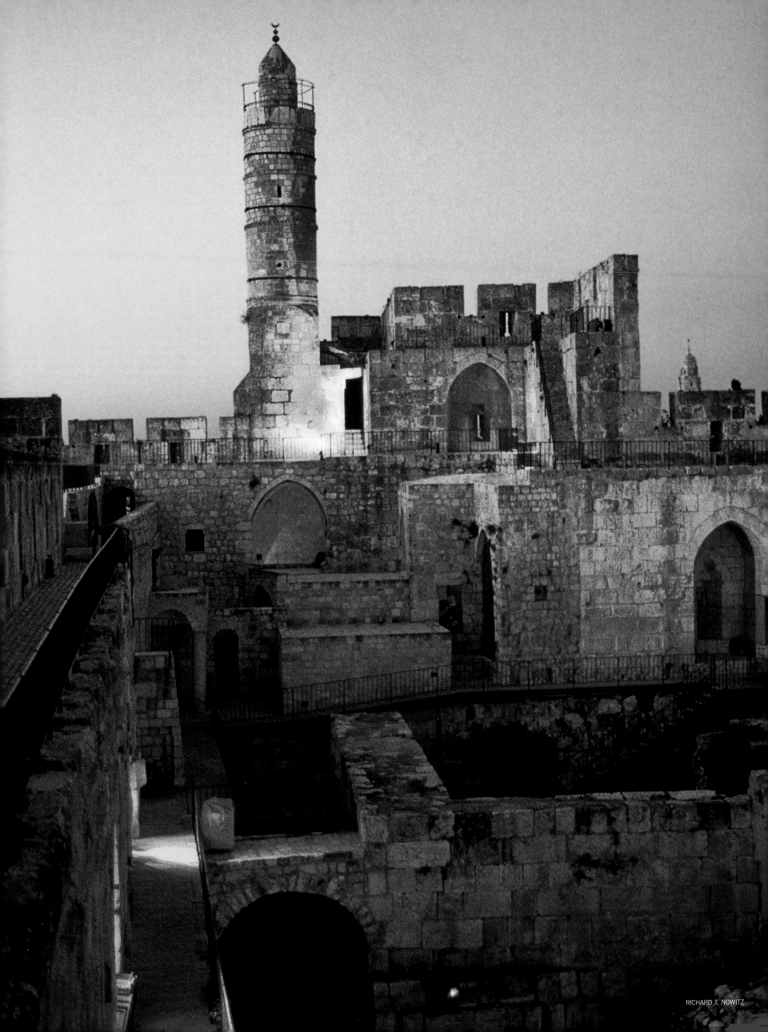

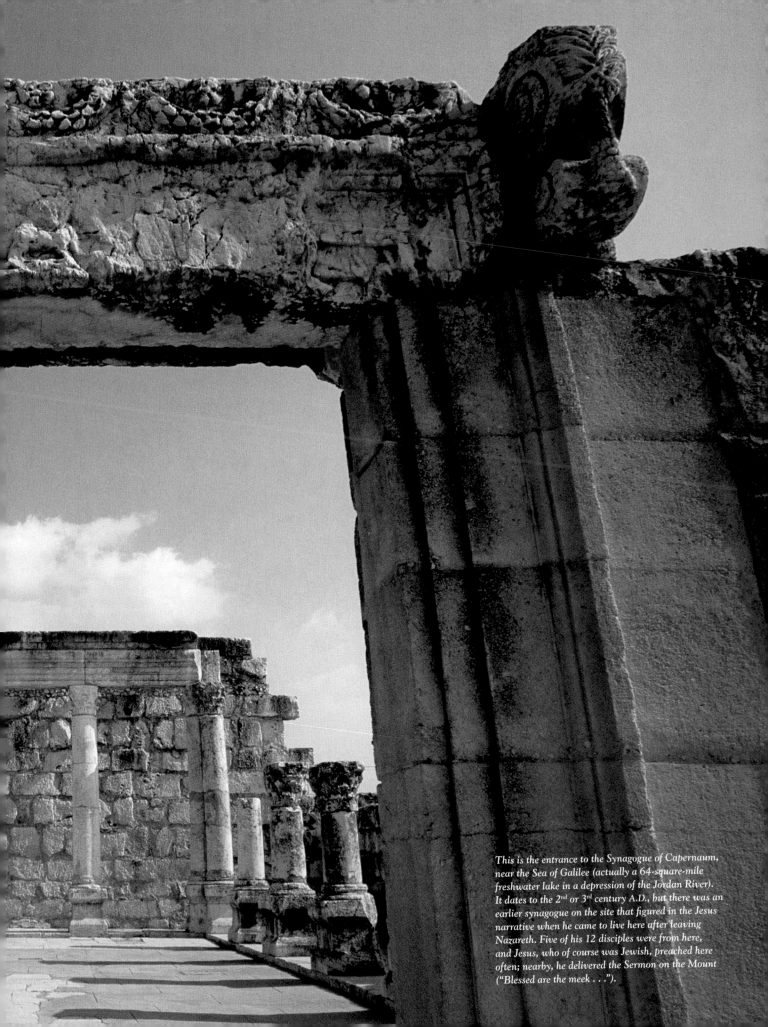

This is the entrance to the Synagogue of Capernaum, near the Sea of Galilee (actually a 64-square-mile freshwater lake in a depression of the Jordan River). It dates to the 2nd or 3rd century A.D., but there was an earlier synagogue on the site that figured in the Jesus narrative when he came to live here after leaving Nazareth. Five of his 12 disciples were from here, and Jesus, who of course was Jewish, preached here often; nearby, he delivered the Sermon on the Mount ("Blessed are the meek . . .").

with Rehoboam. At one point during Rehoboam's reign, Egypt attacked Judah and won; Judah became a vassal state of Egypt.

The Kingdom of Israel, meanwhile, became an important cultural and military force in the 9th century B.C. But now Mesopotamia's two great empires, the ages-old Assyrian to the north and the Babylonian to the south, became a large part of the story. When Judah emerged as a progressive entity in the 8th century B.C., it did so as a vassal of Assyria. Israel, too, fell to the Neo-Assyrian Empire in 722 B.C. Then came Babylon, seizing Judah and destroying Jerusalem and its temple, and damaging

the notion that God had chosen for Israel's people to dwell and reign there forever. Eventually, the whole was controlled by the Persians. Interestingly, in this period in the 6th and 5th centuries B.C., Jerusalem again became the capital of Judah, and many old traditions returned. The lessons and rules of the Torah, or Hebrew Bible, again were taught and enforced.

Israel—Israel and Judah—have been often fought over and often fractured. Sometimes, Israel has existed as an idea, a code and a faith as much as a nation. It surely exists, and tangibly, in the current day, and is still at the center of storms.

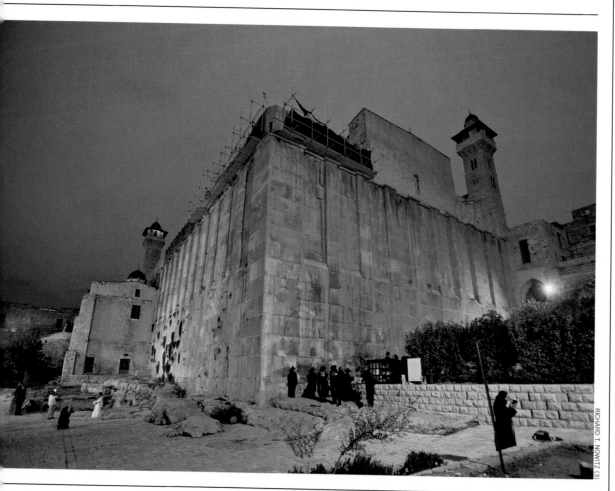

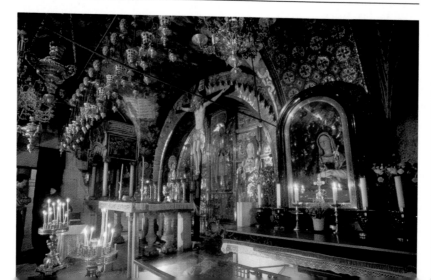

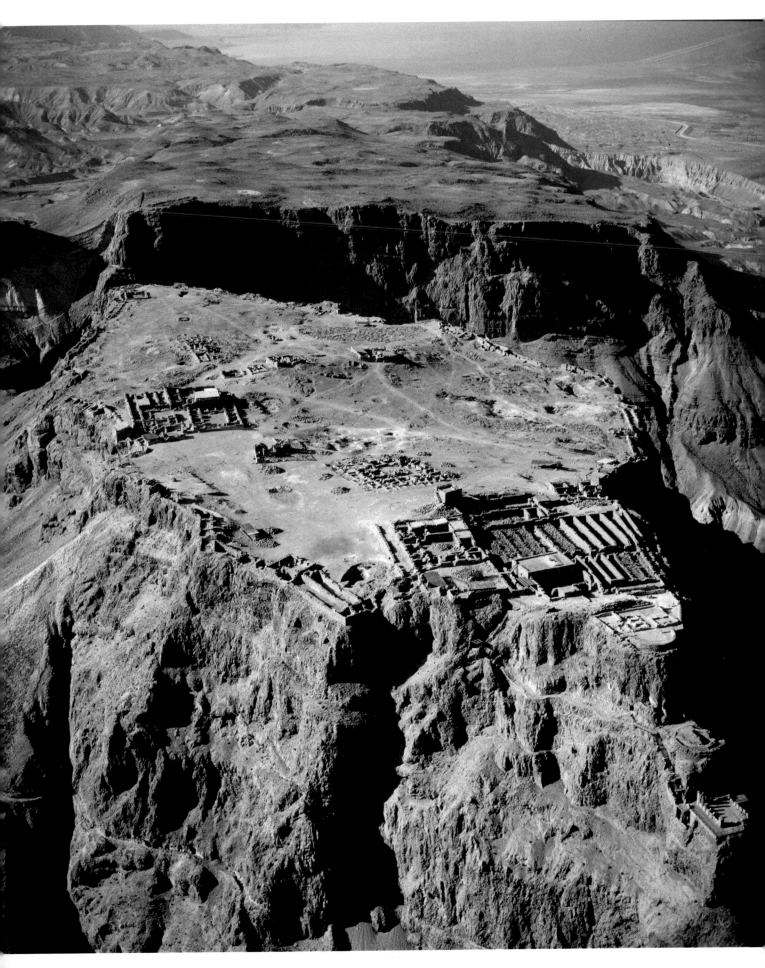

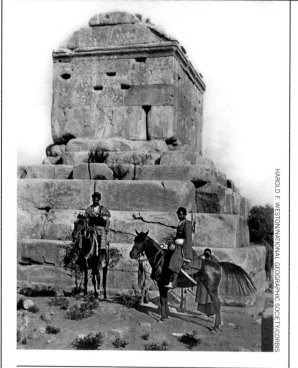

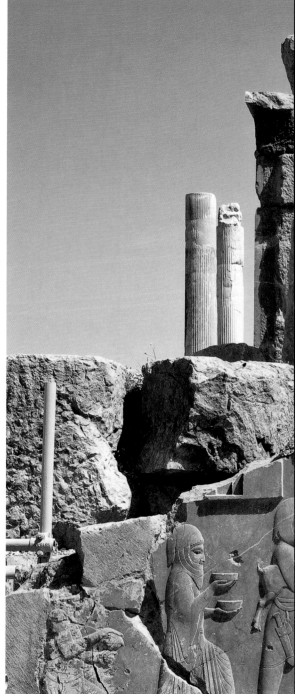

Above, right: Men on horseback in Pasargadae, Iran, in 1921, pass the tomb of Cyrus the Great. Far right: In Persepolis, Iran, the palace of Darius I, who was also known as Darius the Great. The third ruler of the Achaemenid Empire, he gathered power and sought retribution. After he retook the throne from a usurper with the help of other important Persians, he built the dynasty to its strongest and largest: much of west Asia, central Asia, the Balkans, Egypt, Libya, most of Pakistan, the Aegean Islands and northern Greece. And when he invaded Scythia, seeking to punish the people who had killed Cyrus the Great, he too was beaten—like Cyrus— but not killed.

Interestingly, though it probably signifies nothing, we turn now in our book to a short string of chapters featuring rulers who fashioned themselves (or were fashioned by history) "the Great." First up is Cyrus II of Persia, better known as Cyrus the Great. Then we will pause for a look at the attractively modest Ancient Greece, which had leaders who certainly were great but didn't make a big deal out of it, and that will be followed by the rise of Macedonia and its leader, Alexander the Great. After addressing the Roman Empire, which as we will see underwent a fundamental transition under the influence of the emperor Constantine the Great, we will visit China's Han Dynasty. Then we will meet the Mayan Pakal the Great. Again: This probably means nothing, all this Greatness, beyond the fact that these men thought very highly of themselves (or were highly regarded by their people), and that they obviously, for a time, wielded power that was absolute.

Now, to ask an often asked question: Why is history's awesome Persian kingdom, which emerged under Cyrus II as a sudden titan of the Middle East, called by the strange title, the Achaemenid Empire? A dominion more vast than the world had theretofore known—of a scale that would remain unparalleled until the Roman colossus took its full form centuries later—and yet its name has no readily apprehended meaning.

Ah, but it does, if we listen to Cyrus. He traced his lineage back to a Persian leader named Achaemenes, who may have lived at the turn of the 7th century B.C. or who may have been strictly legendary. Achaemenes may have been king of one of the dozen or so Persian tribes, or he may have been the first king of all of Persia between 705 B.C. and 675 B.C. That's all conjecture, but this much is known for sure: Over time, his people's land in

THE ACHAEMENID

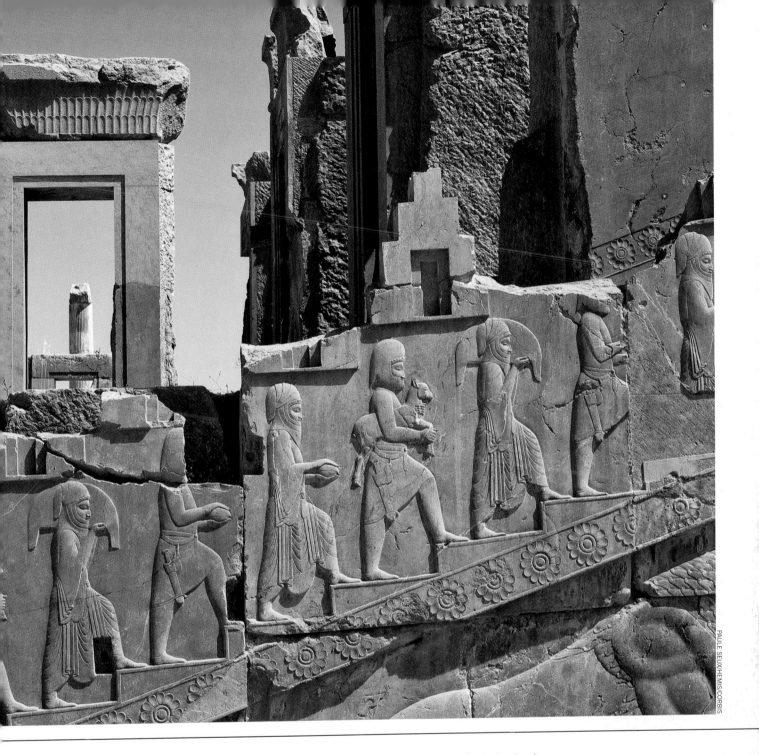

what is now southwestern Iran fell under the control of a regional power, the Medes; and in 559 B.C., they came to employ Cyrus, who in his career had proved himself skilled not only on the battlefield but also in diplomatic maneuvering (the Ancient Greek historian Herodotus said that at one point Cyrus threw over his own grandfather Astyages to get ahead). Cyrus was named administrator of the vassal state. He would hardly settle for that bureaucratic job, and indeed would carry Achaemenes' banner all the way to world history.

Two decades under Cyrus's rule was all it took for the Persians to absorb Media and two of the three remaining dominant forces in the region—Lydia and Babylonia. Only Egypt was left, and that nation's leader, Amasis II, bowed to Cyrus.

EMPIRE (THINK: PERSIA)

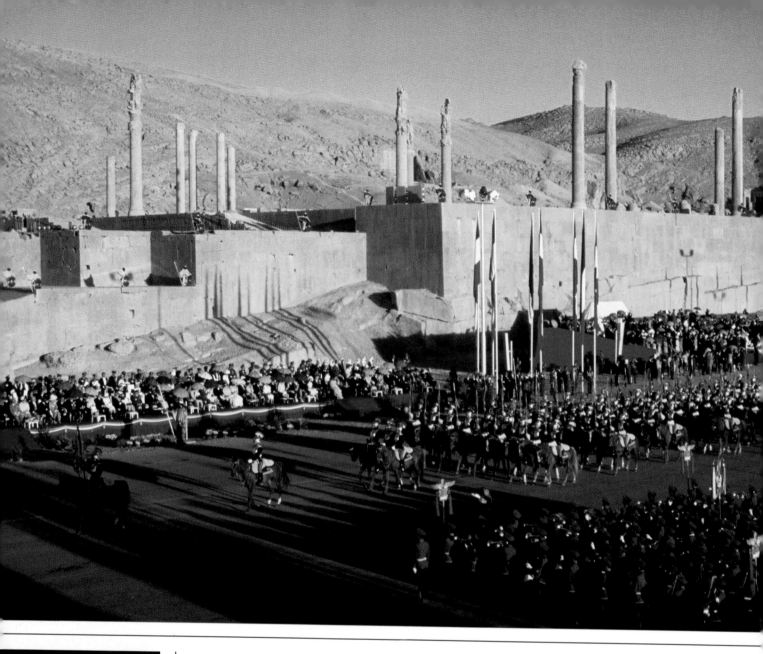

Above: In Pasargadae in 1971, Iranian troops in ancient dress take part in ceremonies commemorating the 2,500th anniversary of monarchy in their country. Opposite, top: In Yazd, Iran, a "tower of silence" constructed by Zoroastrians, who believe the impure dead must not be mixed with earth, fire or water and so put them in these towers to be consumed by vultures.

It needs be noted: Cyrus did not formally conquer Egypt; that would be left to his son and successor, Cambyses II, who also added Nubia and Cyrenaica to the kingdom during his brief reign. At its fullest, the first Persian Empire stretched westward from modern-day Pakistan, clear across the Mideast to the Mediterranean Sea, down through Egypt and into parts of Greece.

If this remarkably vast (and fast) spread of dominion suggests a ruthless tyrant or frothing-at-the-mouth warlord, the suggestion is errant. As remarkable as what Cyrus (and his successors) did, was what he didn't do. He didn't force conquered peoples to abandon their religions or customs of their daily life. He is celebrated in the Old Testament for releasing Jews from exile in Babylonia and allowing them to return intellectually to their faith and physically to Jerusalem. His was a most uncommon brand of imperialism, and Cyrus's trendsetting tolerance, which vaulted him

far beyond father figure in the eyes of his fellow Persians, allowed him to become a role model even to some of the peoples he conquered. One of the reasons Persia was so successful is that it generally wasn't onerous being under Persian rule.

Culturally, art and architecture in Cyrus's world reflected the patchwork nature of his empire, and also the progressivism that relative freedom encouraged. Crafts and materials from far-flung locales were combined to create something distinctly new; these pieces still impress today in artifacts, including intricate metalworks, that have survived down the centuries. It is easy to see by viewing the ruins of Persepolis why forward-thinking Greeks were impressed and influenced by what the Persians had accomplished, and how—in governing with encouragement rather than the iron fist—they had done it. The Persians also laid a network of roads, including a 1,600-mile stretch of expressway used by couriers to get messages from here to there as

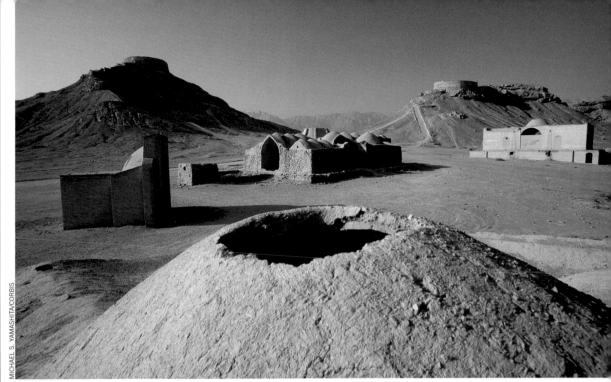

MICHAEL S. YAMASHITA/CORBIS

BETTMANN/CORBIS

Right: Zoroastrian pilgrims pray around a fireplace in 2001 in their temple in the village of Chak Chak, also in Iran. Theirs was once one of the world's very largest religions, dominant during the Achaemenid Empire. But Zoroastrianism began a swift decline after the Macedonians of Alexander invaded. Much later, it and so many other religions in the region were overwhelmed by the spread of Islam.

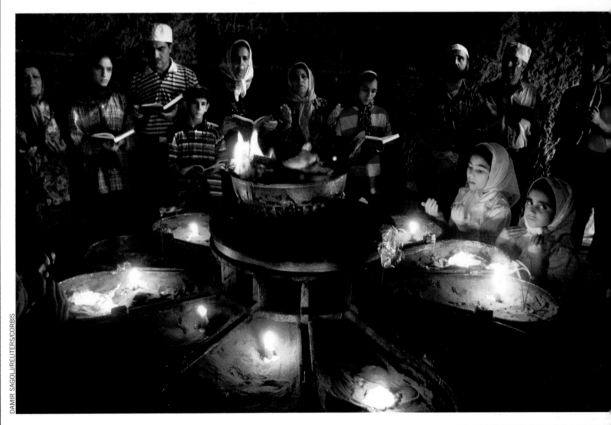

DAMIR SAGOLJ/REUTERS/CORBIS

rapidly as humanly possible. Herodotus marveled that neither snow, nor rain, nor heat, nor darkness of night could hamper the Persians' speedy deliveries: "There is nothing in the world which travels faster."

If the Persians had admirers in Greece, they also had quarry, and they spent nearly half a century trying to overrun various Greek city-states. They were

unsuccessful, and there followed discord: a harried period of assassinations at the top and uprisings in the provinces. Even so, the Achaemenid Empire was durable enough to last, more or less intact, until 330 B.C., falling finally, as did so many, to Alexander of Macedonia, who swept like thunder across western Asia, establishing his own brand of Greatness.

When the term *great civilizations* is floated, a common reactive thought is: Greece and Rome. There are reasons for this, many of them reflecting mankind's better angels. Greece and Rome, when they were on the ascent and even for a time when they were on top, were progressive and innovative in many ways both physical and philosophical. They held Civilization's hand, and helped it up the next step. They were powerful, certainly, but they were optimistic and, at their best, hopeful of building a just society. Greece in particular, during its short, 50-year Golden Age in the 5th century B.C., established a record of political and cultural achievement that is arguably unrivaled in the history of mankind: for too short a time, a shining light—the fountainhead of Western civilization. They out-Persianed the Persians.

When we speak of Ancient Greece we are actually talking about Ancient Athens, the capital city from which the nation's laws, attitudes and aspirations emanated. That Athens was in fact a shining city on a hill is convenient, and metaphorically apt.

At the dawn of the 5th century B.C., Athens had recently endured a century marked by tyrannical rulers, but now was in the hands of Cleisthenes, who founded a democracy that was to be the base on which the Golden Age was built. All male citizens were asked to play a part in the running of the city and state. Every man had a place in the Assembly—the decision-making tribunal—and a right to ask questions or initiate debate. (Of course, if you happened to be a woman, a slave or of non-Athenian parentage, you were disqualified. But even here, consider: Slaves in Athens were thought of as valued members of the family and were paid wages so that they might buy their freedom and thereby become citizens.)

Athenian courts had no judges or lawyers. Plaintiffs and defendants worked their way through their own cases in front of a jury of their peers (jury size ranging from 200 to 1,000 citizens, depending upon the significance of the allegations). If the verdict was guilty, both the plaintiff and defendant suggested a penalty and then the jury chose; no appeal was permitted. There was taxation in Athens, but it too was underpinned by original thinking. The money that was needed to maintain and improve the city, pay public servants and keep up the Athenian military was collected on an ability-to-pay basis. A man of excessive

YANNIS KONTOS/POLARIS

The Parthenon, dedicated to the goddess Athena, was built more than 2,500 years ago atop the holy rock of Athens's Acropolis. More than simply a building, it was a symbol of man's ability to achieve.

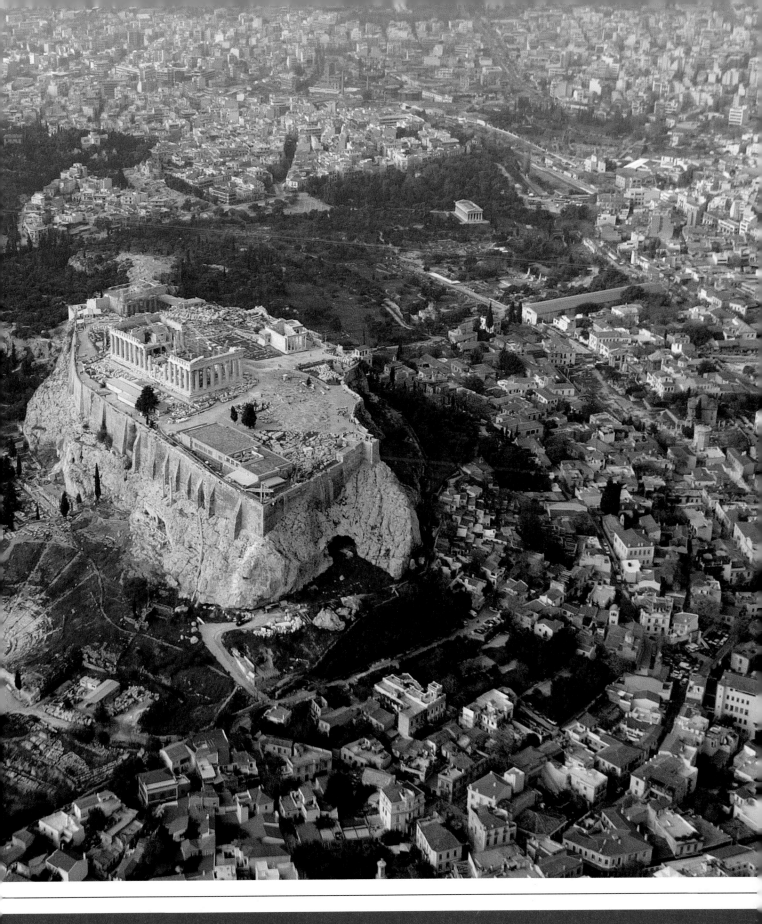

GREECE'S GOLDEN AGE

wealth needed to perform a "liturgy": He could underwrite a warship for a year, for instance, or the production of a play, or a religious pageant. It all worked, for a time. In an important example, during the Persian wars (492–449 B.C.) to which we recently alluded from the other vantage (page 31), relatively small Athens, with such storied naval leaders as Miltiades, Themistocles and Cimon, prevailed against the Persian armies, setting Greece up as something of a regional empire.

Clearly all of these revolutionary ideas, not to mention the extraordinary aesthetic and architectural achievement that came to mark Athens in this period, did not fall out of the sky (or even come from Persia): They emerged from the minds of fiercely intelligent men, men who were listened to, beginning with Cleisthenes and continuing with Pericles. Moral lessons were promulgated by the playwrights—Aeschylus, Sophocles, Euripides—whose works continue to be staged today as their messages have proved eternal. Still taught today, of course, are the Athenian philosophers: the men who rocked the Cradle of Democracy. Socrates, and then—at the close of the Golden Era, and after its end—Plato, Aristotle, Aristophanes and the orator Demosthenes. They lectured in the Academy, and were quoted in the town square.

A brief aside, in this book on civilizations, concerning two of Civilization's greatest-ever teachers: Plato and Aristotle. This is the original case of the brilliant pupil outshining the brilliant professor. Aristotle studied under Plato (who in turn had been mentored by Socrates) for two decades, beginning at what we would consider his "college age" of 17 in 366 B.C. and continuing until the master's death in 347 B.C. If Plato is rightly seen as the father of Western political and ethical thought,

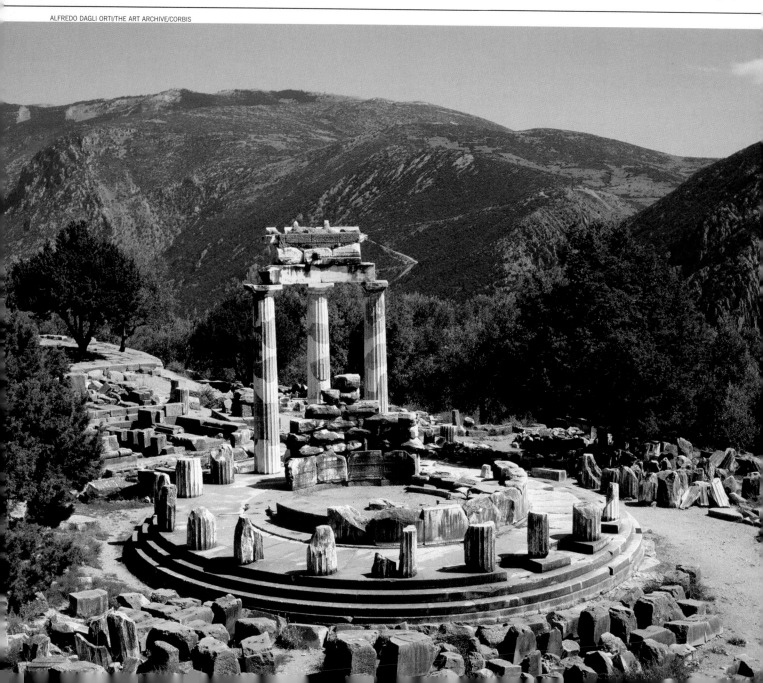

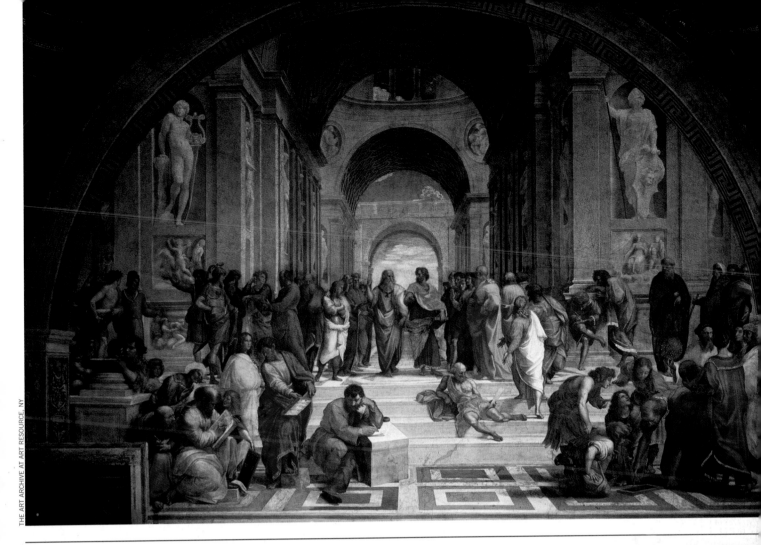

Above: One of Raphael's most famous frescoes, painted between 1508 and 1511, is "School of Athens," which was made for Pope Julius II and remains in the Vatican today. In the center are Plato and Aristotle. **Left:** Pottery at the archaeological site at Akrotiri on the island of Santorini. In bygone days, this place off the Grecian coast, where apparently an advanced culture thrived, was destroyed by a volcano and subsequent tsunamis. A prevalent theory holds that Santorini was the model for Plato's mythical utopian land, Atlantis.

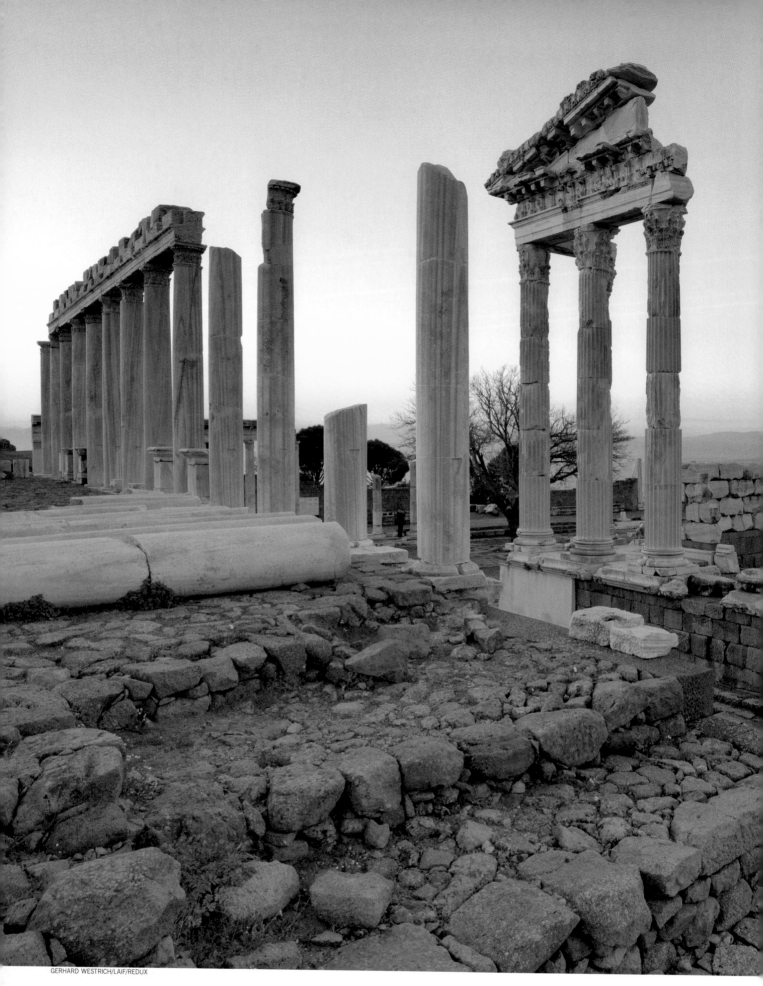

Aristotle, who disagreed with his teacher on crucial points, was the philosopher who, in perhaps as many as 170 books on all manner of subjects, consolidated the new way of looking at the natural order. He agreed with Plato that the universe was an ideal world, but felt that form and matter were inseparable; this crucial departure was at the root of his theories on motion and change that, while not universally correct, would inform Western science for centuries. He divided nature into four elements—earth, air, fire and water—which wasn't exactly fact but pointed a way forward. In arguing ethical points, he said the goodness of a thing lay in its realization of its specific nature. To seize upon a profound transition point in the history of civilization: He handed down these notions, beginning in 343 B.C., to the Macedonian king's son, a young teen who would go on to become Alexander the Great. Aristotle would eventually find himself in opposition to Alexander's imperial ways, and some historians maintain that this nearly cost him his life. Regardless, he influenced evolving political thought just as he influenced everything else, from astronomy to zoology. Aristotle encouraged his followers to think for themselves and taught them how, and much of his philosophy became deeply embedded in subsequent Jewish and Christian tradition.

He was, as indicated, a descendant of the Athenian Golden Age, but not of it. To return there, briefly: The transcendental statesman Pericles made a famous speech in 431 B.C. reflecting his citizenry's pride in its accomplishments and praising Athens for being "an education to Greece"—the ultimate achievement of civilization and democratic principles. He knew that the stunning Parthenon, only a decade in the making, was recently completed: an ultimate symbol of Athenian brilliance, built with public funds and the work of civic-minded individual citizens. What Pericles could not know was that plague would visit the city the very next year, killing thousands, and that the Spartans would invade before century's end, taking control. They would cede to Macedonia's Philip II, Alexander's father, in the next century, and while such as Aristotle would continue to think, and thereby contribute to society, whatever influence the Greeks still had was in their legacy, and the Golden Age of Athens was over.

Greece used to be bigger. Back in antiquity, the city of Pergamum was a part. Today it is within the borders of Turkey, 16 miles from the Aegean Sea, and its heritage lives on in the renovated Sanctuary of Trajan. The modern traveler can go many places in the general region, round a corner, and confront—suddenly—Ancient Greece.

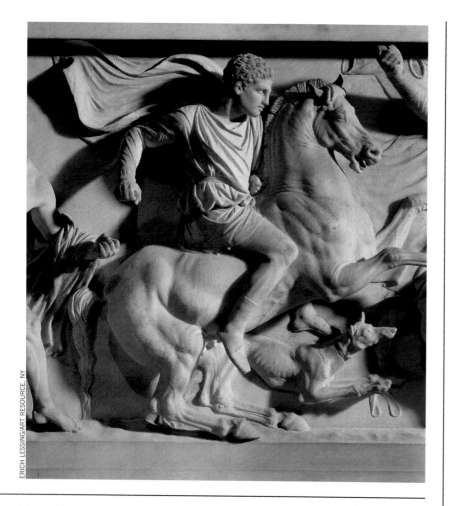

In his own time, as well as ever since, Alexander was the very stuff of legend: a brash young general cut from the cloth of heroes and, he contended, gods. He was the man who brought to its knees the largest empire the world had ever known. Alexander the Great ruled for 13 years and died young, and this occurred more than two millennia ago. Yet today he is still regarded as one of the greatest military leaders—ever—in world history. This is perhaps not the reputation his tutor Aristotle might have chosen for the lad, but it is the one that endures.

Alexander was born in 356 B.C., the son of Macedonian King Philip II, whose power-minded state was situated north of Platonic Greece. Succeeding where the Persians couldn't, Philip took Athens, and, as just mentioned, the adolescent Alexander was schooled by the very best (perhaps, the very best of all time). If he was any kind of a smart student—and he must have been—he was a West Pointer, combining keen intelligence and a strategist's mind-set with a fierce will to win. Always win. At 16, while standing in as Macedonia's head of state, he was victorious in his first battle. At 18 he helped lead the army in the victory that gave his father influence over much of Greece. And at 20, upon Philip II's assassination, Alexander took the throne.

By then, plans were already in place to challenge the Achaemenid Empire. Alexander and his men would go up against the Persian powerhouse to the east that stretched from the Mediterranean Sea into modern-day Pakistan. It was to be a campaign of epic proportions: Tens of thousands of men would be marched perhaps 20,000 miles. They would face not only formidable, entrenched Persian defenses, but many other mobile soldiers, including ones atop battle-trained elephants. They would be subject to the whims of weather, and at times they would certainly be victims of uncharted terrain.

Alexander didn't shrink from the challenge. Not for a second. He dove in, and drove on.

All the while, Alexander made certain that his trail was seeded with allusions to heroism, even the divine. He made a pilgrimage to Troy, site of the legendary Greek Trojan horse ruse. In Egypt he consulted with the oracle of Amon, king of Egyptian gods. And from Asia Minor came tales of his quick work with the puzzling Gordian knot, which, according to legend, could be untied only by the person who would rule Asia. Alexander's publicity people were either early masters of

THE MACEDONIAN EMPIRE

Opposite, top: A detail from the Alexander Sarcophagus found in the Phoenician royal necropolis at Sidon. In this late 4th century B.C. marble carving, Alexander the Great is depicted on the outside of the sarcophagus on his horse, a dog at his feet. Are his remains inside? No. It is not certain for whom the sarcophagus, which is today the greatest treasure of the Istanbul Archaeology Museum, was intended. Bottom: An archaeologist works at a site in Siwa oasis that some believe is Alexander's burial place. Right: The ruins of the Ancient Greek city Aegae, where was formed the Kingdom of Macedonia. This capital city was so-called—Aegae means "goat"— because, as legend held, Perdiccas I, a Macedonian king, had a dream in which he was told to settle his people where the goats led him. From Aegae, the kingdom spread to most of Macedonia and eventually, thanks to Alexander, on and on and on.

(THINK: ALEXANDER THE GREAT)

mythmaking or stunned chroniclers of a world-beating phenomenon that simply defied all reason.

As Alexander routed the Persians and pushed into India, he left behind a landscape dotted with new cities: a rash of Alexandrias, perhaps several dozen. Among them was Egypt's one-time capital, which still today is a major urban center. Many of the others persevere as mere outposts, or have been blown away altogether by the breezes of time.

Alexander's continuing conquest—his shark-like instinct to press forward—was stopped only by his own men, who in 326 B.C. refused to go any deeper into India. The Macedonian forces turned back. As if purposeless without battle, Alexander died three years later in Babylon after a brief illness, at age 32.

With a leader gone so suddenly and so young, there quickly formed a power vacuum. Alexander's warring generals rent the Macedonian empire into a handful of kingdoms, none of which would exert the influence of Assyria or Babylon or Persia or Alexander's Macedonia. The civilizations of the Fertile Crescent entered into the Hellenistic age, an era that—certainly building on Alexander's wide-reaching crusade, as well as the lingering influence of Greek culture and thought—brought a certain worldliness, if not a homogeneity, to all Mediterranean nations and those of western Asia. Seeds were being sown for a future empire. Some of the smart money was on Rome.

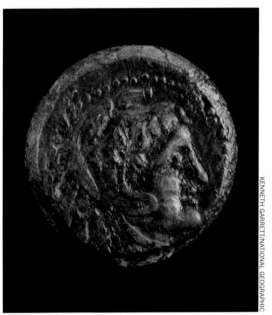

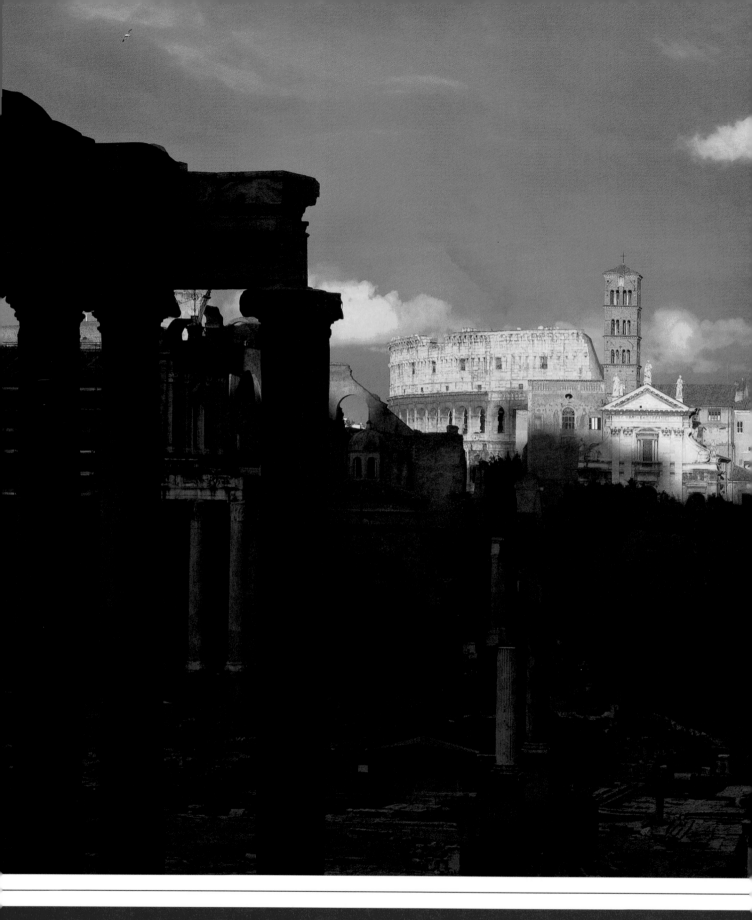

THE ROMAN EMPIRES

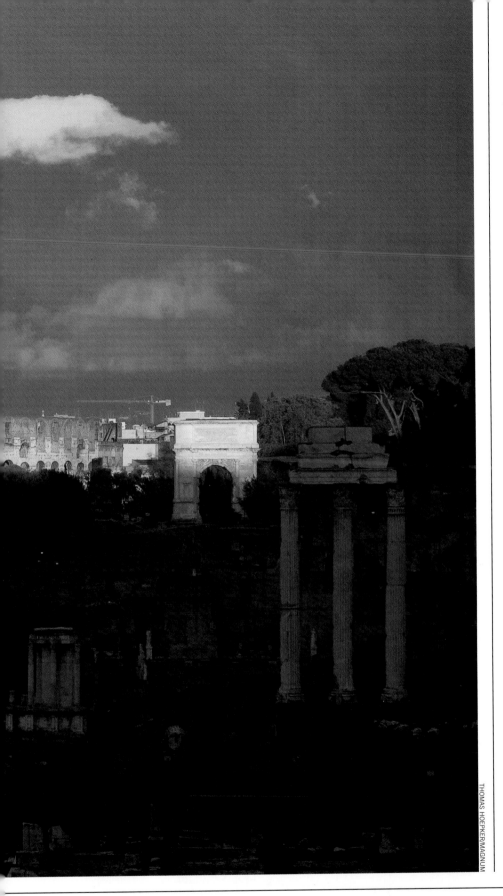

Twin brothers, divinely sired by the god of war, are set adrift by an interloper king in the Tiber River, the storied stream that makes its way from the Italian highlands down to the Tyrrhenian Sea. The boys are nourished by a she-wolf and a woodpecker, raised as shepherds and then, as adults who now have learned of their heritage, they overthrow and kill the man who had not only usurped their throne but tried to be rid of them. The twins, named Romulus and Remus, determine to cofound a city on a hill. They can't agree on which hill and, with their fraternity soured, Romulus kills Remus. Romulus goes on to build his desired city, through which the widening Tiber flows, and that city is called . . .

That, in very short form, is the mythological story of the dawn of Rome, which would become the vast, militaristic and hero-hungry empire whose emblematic phrase, *Veni, vidi, vici*, tells it all: "I came, I saw, I conquered." The Romulus/Remus beginnings of Roman history are traditionally said to be set in 753 B.C., when the region that would become the city-state was essentially an agricultural community near the sea. A relatively inconsequential monarchy there gave way in the 6th century B.C. to a republic, which oversaw a voracious expansion of the small city of Rome. By the end of the 3rd century B.C., Romans controlled Italy and continued to press their frontiers outward.

As a rough figure for the life of the Roman Republic, 500 years is suitable. Rome was growing more powerful by the month, and drinking in influences from those cultures it subsumed, particularly the Greek. There is little question but that the earlier work—and lessons—of the Persians, Greeks and Macedonians in the Mediterranean region informed the republic and, subsequently, the empire. That transition, which was never formalized by any declaration, occurred

In the Italian capital, the Forum Romanum and Coliseum are illuminated after a thunderstorm.

after expansion and then internal fissions stressed the republic, leaving it open to dominance by one man or faction. By the 1st century B.C., conquering generals, in particular Julius Caesar, grew emboldened to use their loyal armies as tools of political intimidation, sparking civil wars that weakened the republic. Caesar made his move in this time of turmoil, and in 46 B.C. was appointed perpetual dictator. "Perpetual" turned out to be a very short time as he was assassinated that same year. A power-sharing triumvirate of his adopted son, Gaius Julius Caesar (born Gaius Octavius Thurinus and known as Octavian), Mark Antony and Marcus Aemilius Lepidus replaced him, but partnerships within military dictatorships rarely come to a good end, and this one came asunder in due course. Lepidus was forced into exile, Antony (supported by his lover Cleopatra VII, Egypt's final pharaoh) was defeated in the 31 B.C. Battle of Actium by Octavian's fleet, and Octavian took a firm grip on Rome. He still called it a republic but ruled it as an autocrat—which trumps any notion of republicanism—and many historians see his rise as the beginning of the first Roman Empire, though Octavian

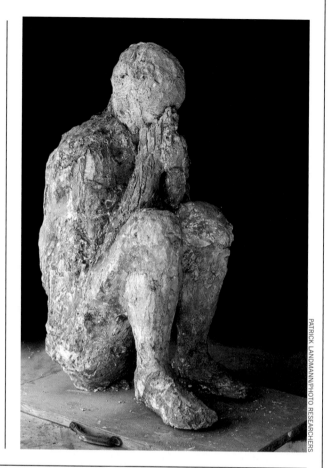

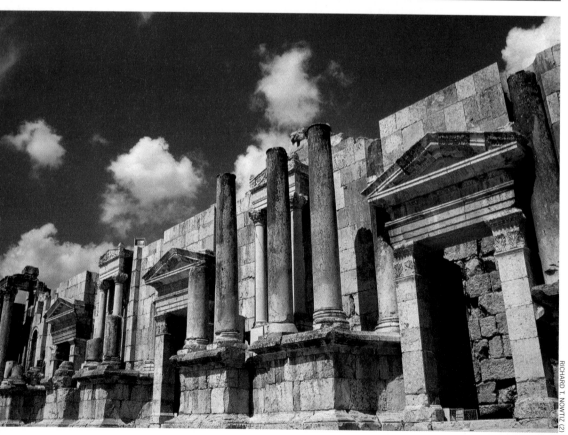

When Rome was great, all great events assumed elevated degrees of profundity. In A.D. 79, the volcano Vesuvias erupted, and the Roman city of Pompeii was destroyed, then buried in thick layers of ash (left, top, the cast of a victim in a crouched position holding his hands over his nose and mouth against the noxious fumes that would claim him. Right: A chariot rut in the streets of excavated Pompeii). What did the gods mean by this eruption and violent death? Who could say? Left: In the same period that Pompeii was being obliterated, the city of Jarash was thriving—a model of what Rome could do, and a sure sign of the gods' manifold blessings. That Jarash itself would be wrecked by an earthquake seven centuries on, long after Rome had forsaken its pantheistic beliefs, is one of natural history's cruel ironies.

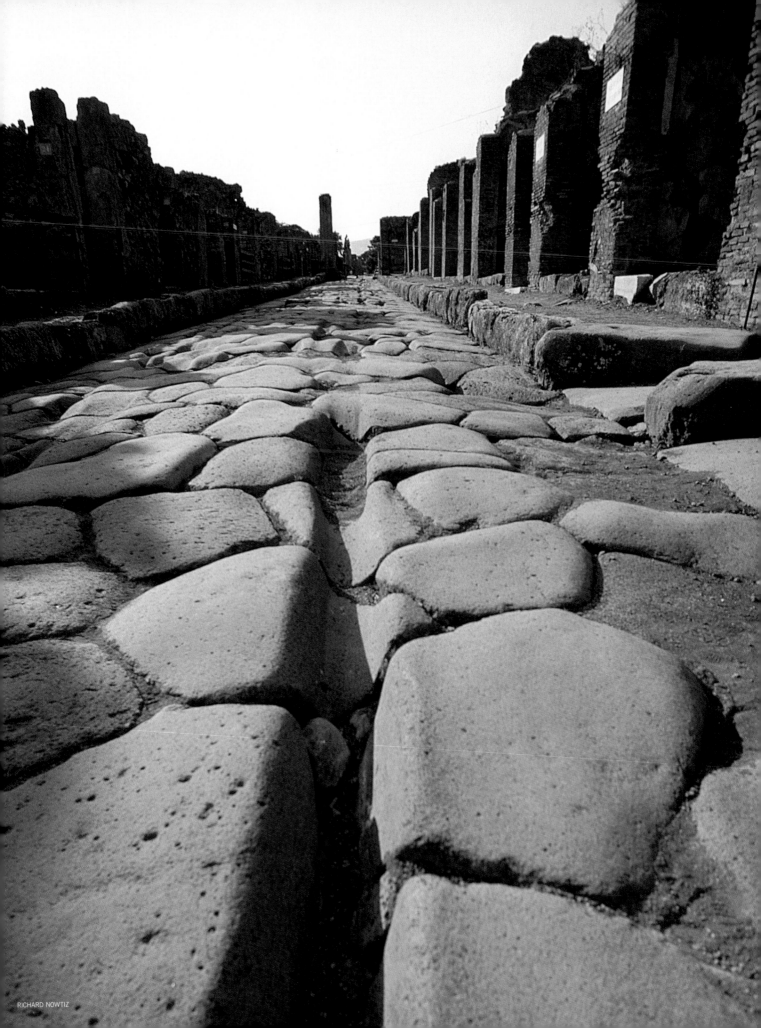

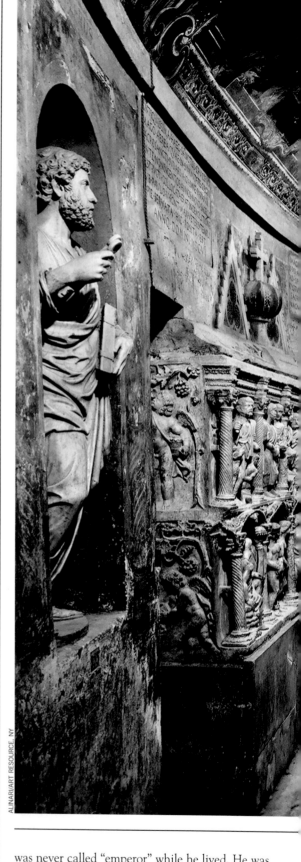

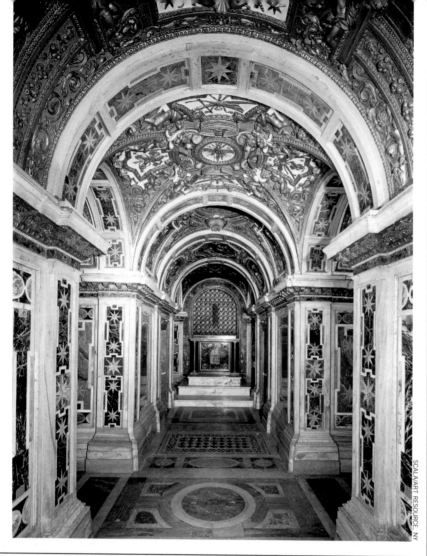

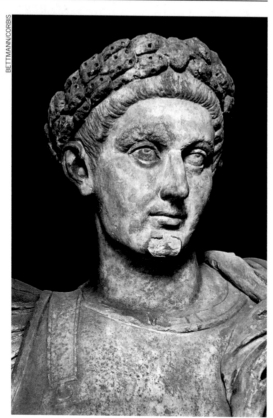

Clockwise from above: The altar of Saint Peter above his tomb at the Vatican; the interior of the Vatican Grotto; and a bust of Constantine the Great. Even before the emperor dictated religious tolerance throughout the land, Christianity had become a force not to be denied. Evolving from clandestine "churches" (really, just gatherings) sprinkled throughout the holy land and creeping northward, following in the steps of Paul and Peter (who would both be martyred in Rome), Christianity spread a message that many found irresistible. Eventually, the empire found it so, too.

was never called "emperor" while he lived. He was awarded something even better in 27 B.C. when the senate, which he firmly controlled, bestowed on him the title Augustus, indicating he was to be revered. After his death, he immediately would be

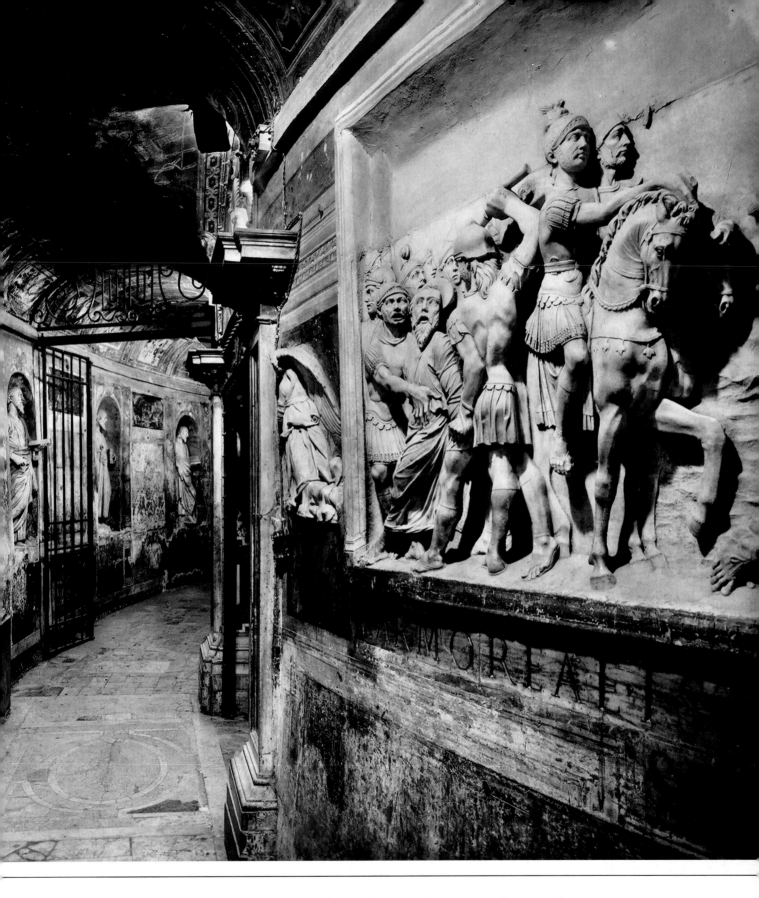

made a god by the Roman legislature.

Octavian/Augustus was superb at empire building. A military man, he kept his soldiers happy and close, and they rewarded him with foreign conquests—Egypt, other African outposts, Hispania, Dalmatia, Pannonia, Raetia—as well as a stable domestic situation. Augustus reformed Rome's tax system, built roads, started police forces and fire departments and rebuilt much of the capital. His son and successor, Tiberius, continued Augustus's

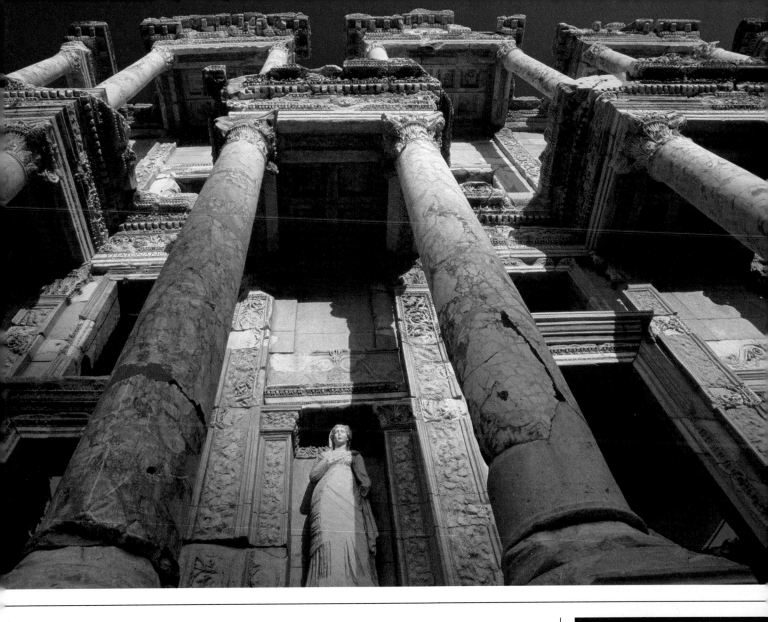

course, and then Tiberius's successors were more vigorously expansionist. By the end of the day, it was a daily matter that Roman influence was everywhere in the so-called Western world. At the empire's zenith, in the 2nd century A.D., it covered perhaps 60 million people and reached up to northern Britain, across Western Europe along the Rhine and Danube rivers, and down through Syria, Egypt and North Africa.

A complex array of languages, cultures and religious beliefs intermingled, each of them absorbing elements of the empire's official Latin tongue and elements of a Roman philosophy that owed much to the Greeks; the Roman Empire made even Persia's assimilative record look meager by comparison. Again through what would come to be called Greco-Roman behavior, the empire celebrated its virtues with elaborate monuments, sculptures and mosaics, and through feats of engineering: the design of cities; a network of painstakingly built, all-weather roads; Rome's 50,000-seat Coliseum, a

shrine to violent "entertainment" inaugurated with 100 days of brutal games; religious temples like the 2nd century Pantheon, with its 142-foot-diameter dome—a cathedral that would be unrivaled in its magnificence until the 1800s.

Roman ingenuity helped form the calendar system that is used today by much of the world (August is named for Augustus). The empire's laws would, down the centuries, influence the legal foundations of many new-forming Western countries, including those of the United States. The spread of Latin had spin-offs in the sublime modern Romance languages.

Of course, no nation or even empire is an island in the world, and various things that were set in motion in the first centuries anno Domini brought pressure on Rome. One was the very thing that today gives us a distinction between B.C. and A.D.—the birth and life of Jesus, and the subsequent rise of Christianity, most all of which played out in the first three centuries anno Domini in places ruled by Rome, and in

The most famous of the Roman Empires existed between the devil and the deep blue sea. On these pages we have two photographs from Ephesus, in today's Turkey, where Saint Paul once delivered his eloquent, moving, inspiring, challenging Letters to the Ephesians. Paul, who had been a fierce and worldly man before becoming a Christian evangelist, knew what he was faced with when he spoke. Opposite is a stone advertisement for an Ephesian brothel, and above is the façade of the Library of Celsus in Ephesus. What course would the Romans choose?

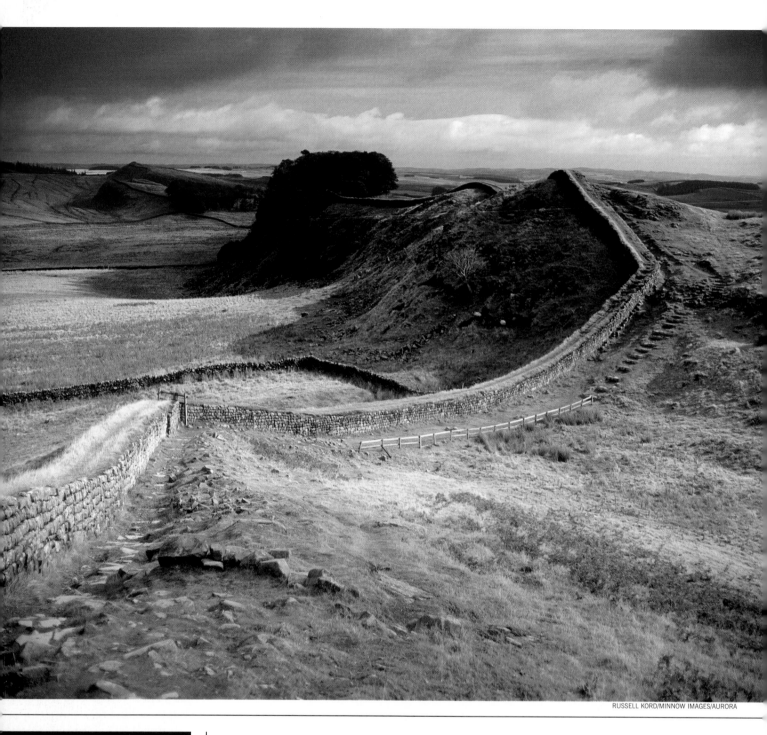

"Far and wide" doesn't begin to describe Rome's reach at the empire's zenith. Above is Hadrian's Wall in Northumberland, England. When the 73-mile barricade against "barbarians" was built during the reign of the emperor Hadrian in the 2nd century, it was—and remained—the empire's most heavily fortified border ever. Hadrian said that "divine instruction" had prompted him to do what he could to keep "intact the empire."

Rome itself. In the time of Christ, Romans prayed to pagan gods, and many of these new "Christians" were martyred in the decades after Jesus' own execution. But inexorably, Jesus-worship and Jesus' attractive message grew in the minds of many, and finally Emperor Constantine—Constantine the Great—issued, in 313, the Edict of Milan, ordering religious tolerance throughout the land. He himself would convert to Christianity on his deathbed, and before long his empire was Christian as well.

Constantine, who ruled from A.D. 306 to 337, was a talented general, and oversaw the defeat of Roman secessionists in civil wars. The strains within the enormous empire grew increasingly great, and in 324 he moved his capital eastward to Byzantium, on the Bosphorus Strait. He wanted to create here, in what is now Turkey, a city he would call New Rome. His people insisted on naming the metropolis in his honor, Constantinople, and today it is Istanbul.

Constantine the Great is seen as the founder of what was, by century's end, the Eastern Roman Empire; this dynasty would last another thousand years, and we will visit

it again four chapters on in its evolved state: the Byzantine Empire. The left-behind Western Roman Empire had a rougher go than the Eastern: Steady incursions by Germanic tribes—like the Visigoths (who stormed Rome in 410), Vandals and Suebi—and others chipped away, and in 476, the last Western emperor was unseated.

A final footnote to this tale of Roman Empires: From 962 to 1806 there existed in central Europe a forceful, Germany-based Holy Roman Empire. It can be seen as a tribute state, hoping to connote grandeur by borrowing a trademark. As the 18th century French writer Voltaire observed dryly, "This agglomeration which was called and which still calls itself the Holy Roman Empire was neither holy, nor Roman, nor an empire."

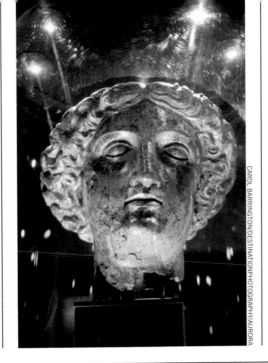

On this page, a detail and a wider view of the Roman Baths in Bath, England, which were begun in the 1st century A.D. Bath is in the southwest of the country, and would have then been remote. There, the conquering Romans built an extensive bathing establishment like those back home. Centered on a natural hot spring that still today, in what amounts to a living museum, bubbles daily at 115 degrees, the baths included a temple to Sulis Minerva, goddess of the thermal spring. The Romans called their resort Aquae Sulis, and it flourished for five centuries.

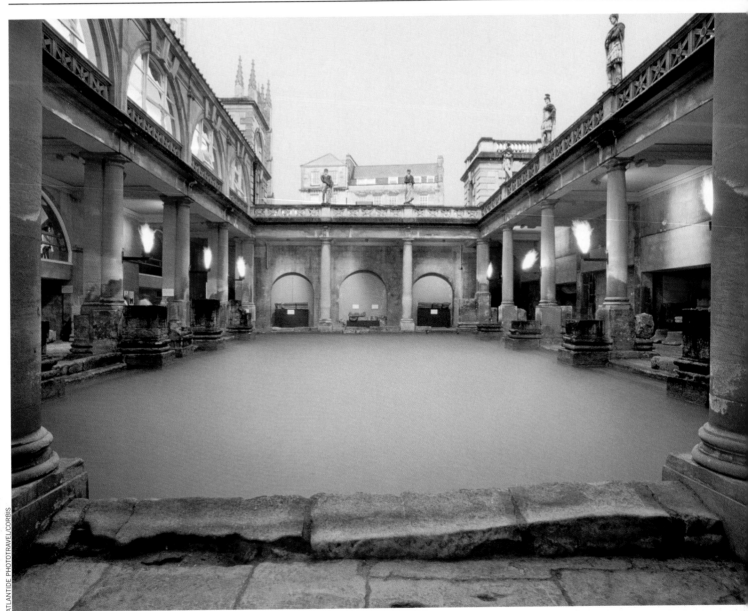

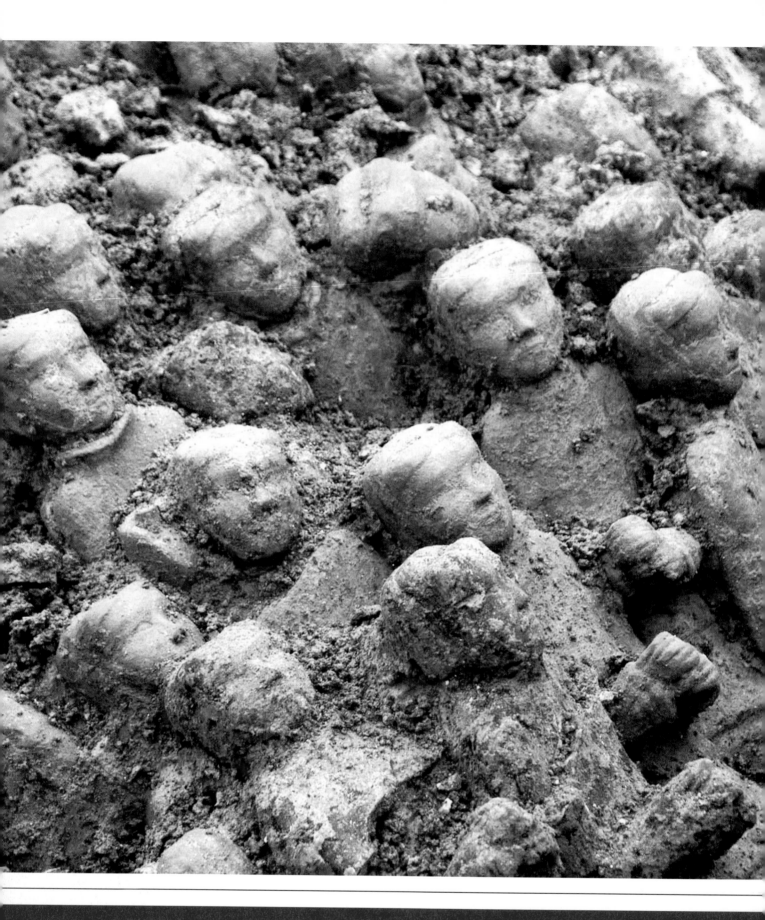

THE HAN DYNASTY

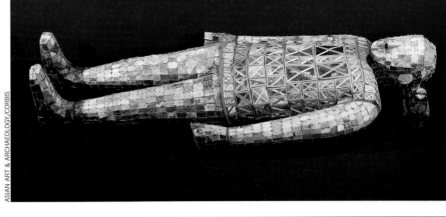

As the Romans were expanding their territories, advancing science and laying the very foundations of future life in the Western world, much the same was happening thousands of miles to the east. In China, the Han Dynasty was fashioning a culture based on principles so elemental and durable that today many Chinese still consider themselves "the people of Han."

Led by commoner-turned-emperor Liu Bang, the Han Dynasty emerged in 206 B.C. in a land that had been singed by centuries of war. Liu, in fact, had helped lead the ultimate uprising that ousted the influential but authoritarian Qin Dynasty (pronounced "chin," from which the name China is derived) after just 14 years of rule. The Qin's unquestionable—and monumental—legacy would be the unification of China's kingdoms for the first time under a centralized bureaucracy. This was the dawn of Chinese imperialism, which would inform China's course for hundreds of years until the early decades of the 20th century.

The Han were the first heirs to the Qin reformation, and achieved what the Qin could not. The Han struck a balance between governmental efficiency and a commonsense policy that there must be, for long-term success, tangible societal benefits provided for the ordinary man by those in power. This philosophy would keep the Han in power for more than 400 years, during which period lasting ideas about the great value of Chinese unity took root.

Even as the Han moved vigorously away from their predecessors, they borrowed much of the architecture of government that had been built by the Qin. They were, however, sophisticated in ways the Qin were not. While keeping old frameworks, they stressed new initiatives, many of them intellectual or philosophical. There was a fresh reverence for scholarship and the arts, and a renewed interest in the long-discarded teachings of the 6th to 5th century B.C. philosopher Confucius. Was Confucianism, perhaps, at the heart of what it was to be Chinese? Such questions were being pondered for the first time in a long time.

Left: Small warrior figures from China's Eastern Han Dynasty are seen being unearthed in the city of Xuzhou on November 6, 2002. Archaeologists said the figures were discovered in the tomb of an imperial family. Above: The burial suit of Princess Tou Wan, the wife of Liu Sheng, a prince of the Han Dynasty. Her tomb was discovered in 1968, and her and her husband's jade burial suits were the first of their kind to be unearthed. The Han Dynasty was marked by great wealth and a high aesthetic.

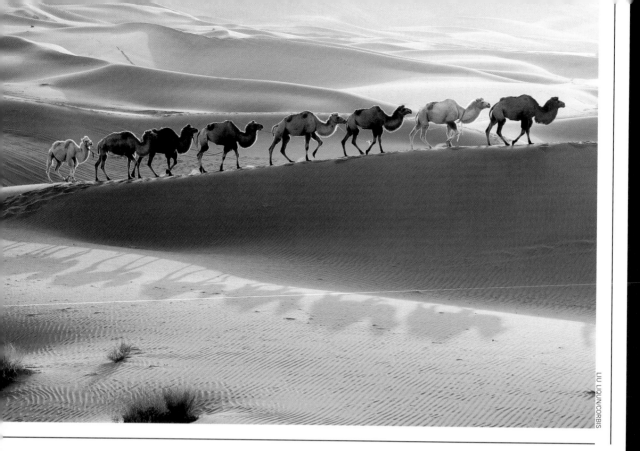

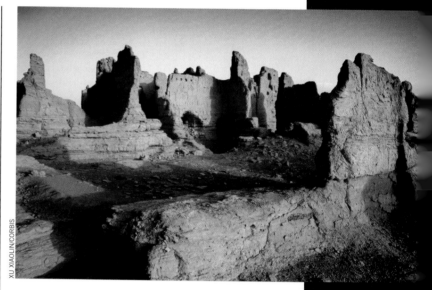

The Han practiced what they preached. Their dynasty was marked by an attempt to infuse the government's approach with a Confucian zeal for loyalty, morality and virtuous conduct. Jobs and advancement in the Han civil service were, in large part, merit-based rather than hereditary, and the study of texts associated with Confucius became a requirement for bureaucrats. The rulers had found their manifesto in writings hundreds of years old.

Language and literature blossomed, including an expansion of the written Chinese vocabulary. The first written version of an epic history of China was completed around 85 B.C. The compilation of the first Chinese dictionary followed circa A.D. 100. And the invention of paper by A.D. 105 changed everything, first in China and later abroad. Under the Han, knowledge was spread in dynamic new ways. On other fronts: Scientists, charting celestial bodies, devised a modern-looking calendar. Researchers, engineers and military men developed the hand crank and the wheelbarrow, created one of the earliest seismographs and built thousands of miles of roadway. Iron was used to reshape agricultural and military industries. Exquisite silks were crafted, many of them exported by way of the Han-controlled Silk Road, which connected most of Asia with the Mediterranean, European and Middle Eastern worlds—thus offering the West not only product, but a glimpse of Eastern luxury and sophistication that was positively startling.

Of course, those who have grown great—in terms of power or wealth or just about anything—are eventually envied or rivaled (or both). In the Han's final century, after a good long run of progress, the administration had to deal with imperial power grabs, corruption and finally battle that resulted in China being torn into three, a division that would endure for more than 350 years after the demise of the unified Han Dynasty in A.D. 220.

If the Han were gone, they lingered. The physical legacies and institutional memory of their achievements have influenced millions of Chinese since, leaders and followers both. This is why, in the early 21st century, there still exist, proudly, "the people of Han."

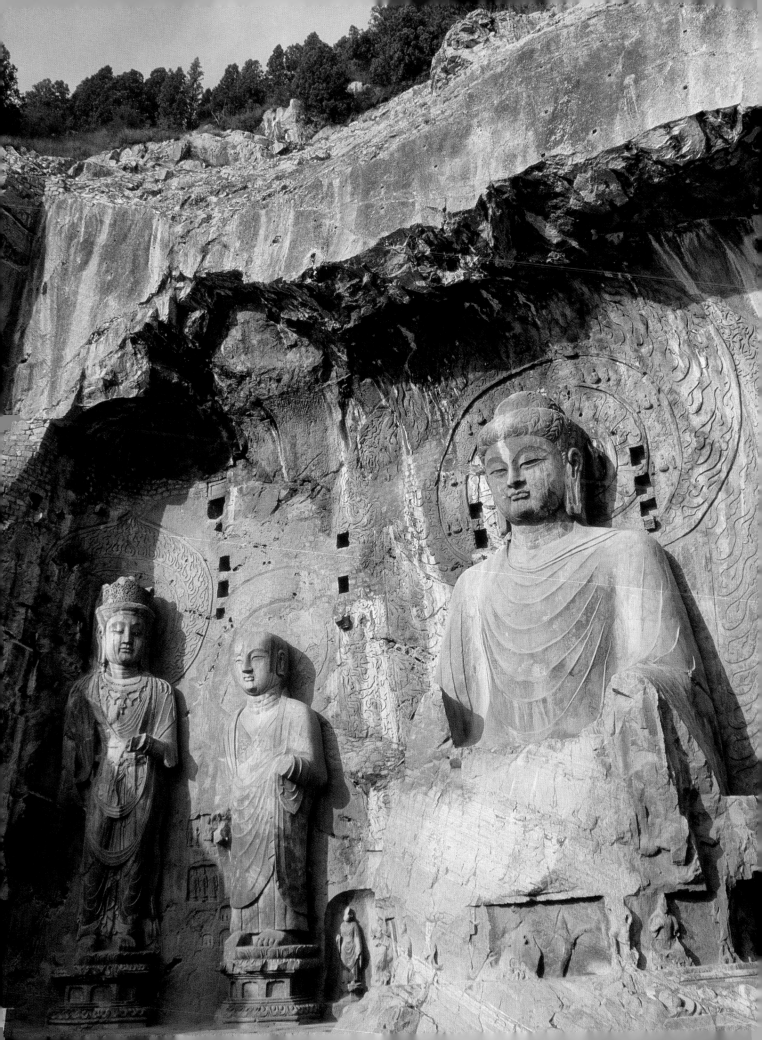

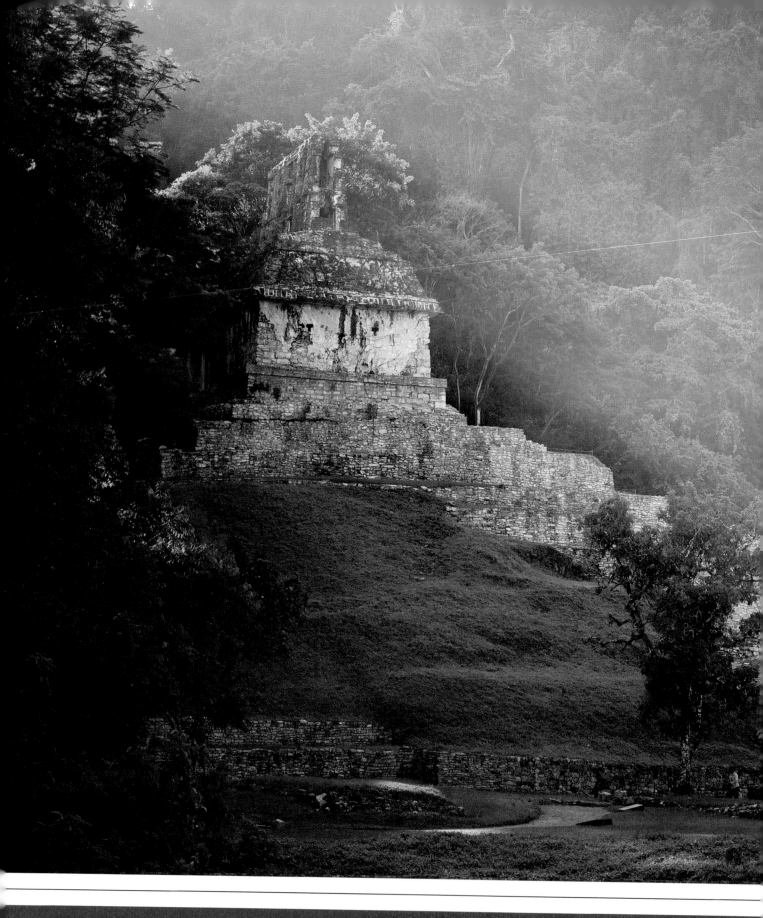

THE MAYA EMPIRE

Thus far we have explored, for the most part, the early civilizations of the Fertile Crescent, some of which pushed just beyond those indistinct boundaries. We venture now far afield to Mesoamerica, a term used to define the people and land of Mexico and Central America before the Spaniards arrived in the 1500s. As said in our chapter "The Many Cradles of Civilization," it is now acknowledged that there was sophisticated activity here way back when—activity unknown to Western man for the longest time. Today we fully realize that a great civilization formed itself deep in the jungle over many centuries, becoming an empire to rival the rest: the empire of the Maya. At the pinnacle of the dynasty's Classic Period, which extended from approximately A.D. 250 to 900, there were more than 40 Mayan cities on the Yucatán Peninsula and down into central and southern Mexico, each of them with a citizenry of between 5,000 and 50,000 people engaged not just in agriculture but architecture, building, hieroglyphic writing and sciences, including mathematics and astronomy.

As the term *Classic Period* implies, the Maya went much further back; there were earlier "periods." They built gradually to their glory years, developing in their own way, as their isolation from so-called Western civilization allowed. Early Maya were agrarians living in small villages as long ago as 1800 B.C. In their culture's formative years, farmers began expanding into high- and lowland regions. As they traveled, they interacted with other Mesoamerican civilizations such as the Aztec and especially the Olmec. From the latter, the Maya adapted religious and cultural beliefs as well as the Olmec number system and calendar, which they developed into their famous (or infamous) Long Count calendar. Today this calendar has the Maya back in the news because doomsday enthusiasts interpret the Long Count as prophesizing the end of the world on December 21, 2012.

Over time, the Maya made great advancements in pyramid building and town and city construction. The most famous of their early cities is perhaps El Mirador, located in northern Petén, Guatemala, which once had a population estimated at 200,000. Discovered in the 20th century, El Mirador, which means "the lookout" in Spanish, prospered from circa 700 B.C. to A.D. 150. Connected to other

KRYSTIAN BIELATOWICZ/VISAVIS.PL/AURORA

These ruins of the Mayan city Palenque in southern Mexico date from circa 100 B.C. to the city-state's decline and fall near the end of the first millenium A.D. Hieroglyphs found there detail its heyday from the 5th through 7th centuries. The tomb of Pakal the Great in the Temple of the Inscriptions is a highlight of what remains.

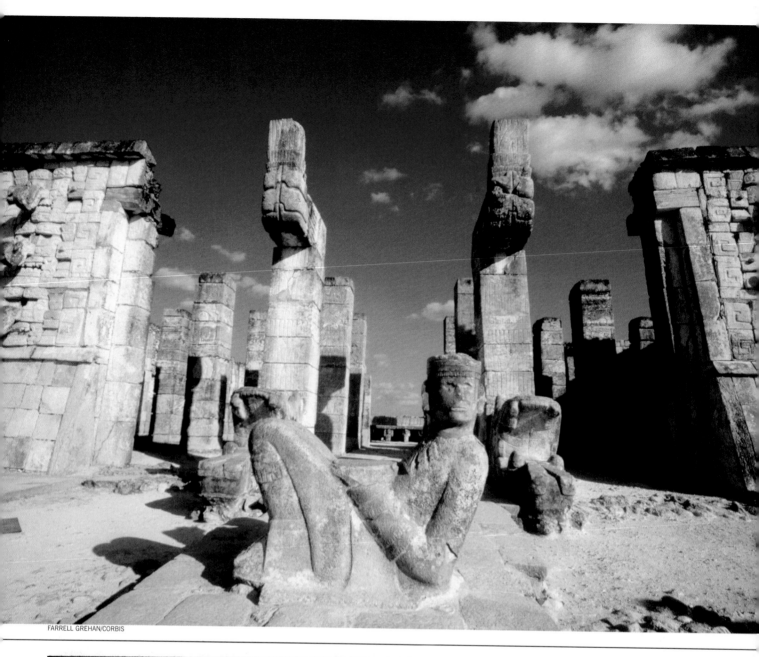

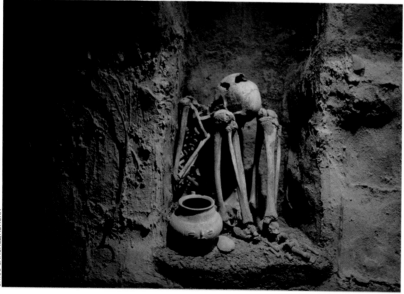

early Maya outposts by paved roadways, El Mirador was a hub. It was (and is) home to La Danta, one of the world's largest pyramids, and surely many Maya made pilgrimages to the site. Standing 230 feet high and containing 99 million cubic feet of rock and fill, La Danta illustrates that the Maya civilization was well along even before arriving at its Classic Period.

But what a long and astonishing period that was! Beginning in the 1830s, decade after decade of excavations at Classic Period Mayan cities such as Copán, Palenque and Tikal have turned up one surprise after another, and have forced archaeologists and historians to completely rethink their views of bygone Mesoamerica. Unearthed plazas, palaces, temples and pyramids, many marked with the Maya's intricate hieroglyphic language in elaborate inscriptions and reliefs, implied a Mexican Athens or Alexandria.

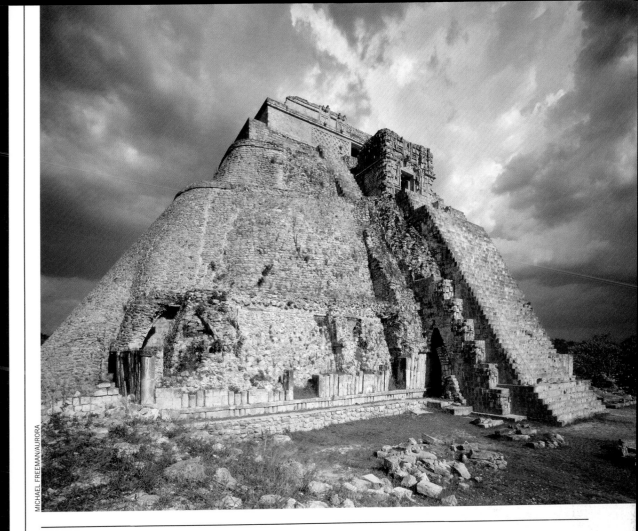

MICHAEL FREEMAN/AURORA

When translated, the hieroglyphics told the story of a deeply religious people who worshipped a pantheon of nature gods. Responsible for mediating between these gods and the citizenry were the *k'uhul ajaw* or "holy lords." These were kings who followed a hereditary succession to the throne. K'inich Janaab' Pakal I, or Pakal the Great, is one of the most famous of these kings. Acceding to the throne at age 12, Pakal ruled Palenque for 68 years before dying in A.D. 683. In 1952 his undisturbed tomb was discovered. Within, Pakal's adorned body was found. It was outfitted with jade and shell earplugs, pendants, necklaces, bracelets, rings and a jade mask: a burial costume and accoutrements fit for a pharaoh.

The deciphered hieroglyphics also delineated those earlier-mentioned developments in mathematics and astronomy, including the use of zero and the advancement of a complex calendar system based on 365 days. And they told more disquieting tales. Although early researchers thought the Maya to be peaceful scholars and scribes, a better understanding of the hieroglyphics revealed a people dominated by powerful rulers, with nearly perpetual war between the city-states. Human sacrifice and torture were culturally accepted, and there were, in sum, many more tensions in the Maya world than was previously thought.

This internal struggle—or perhaps drought, or perhaps an exhausted surrounding environment—may have been the principal factor in the Maya's downfall, or maybe it was just a contributor. Whichever, the Maya had deserted their great cities in the southern lowlands by the year 900. Until 1500, the Maya continued on in such cities as Chichén Itzá and Uxmal on the Yucatán highlands, but by the time the Spanish invaders arrived, the Maya were again living in agricultural villages, their once-gleaming cities having been consumed by the rainforest jungle. Today, a half-millennium further on, contemporary Maya still hew to their agricultural roots, growing crops of corn, beans and squash. In the melting pot that has always been part of their history, they speak some 70 Maya languages.

In around the year 600, the Maya population totaled 2 million people, and the world as they knew it was theirs to shape as they would. With their infighting, they were already in trouble, and then arrived the "Western world," with armaments at the ready and conquest in mind, and also bearing diseases the Maya could not resist. Such a long history to that point, and then a so much shorter one.

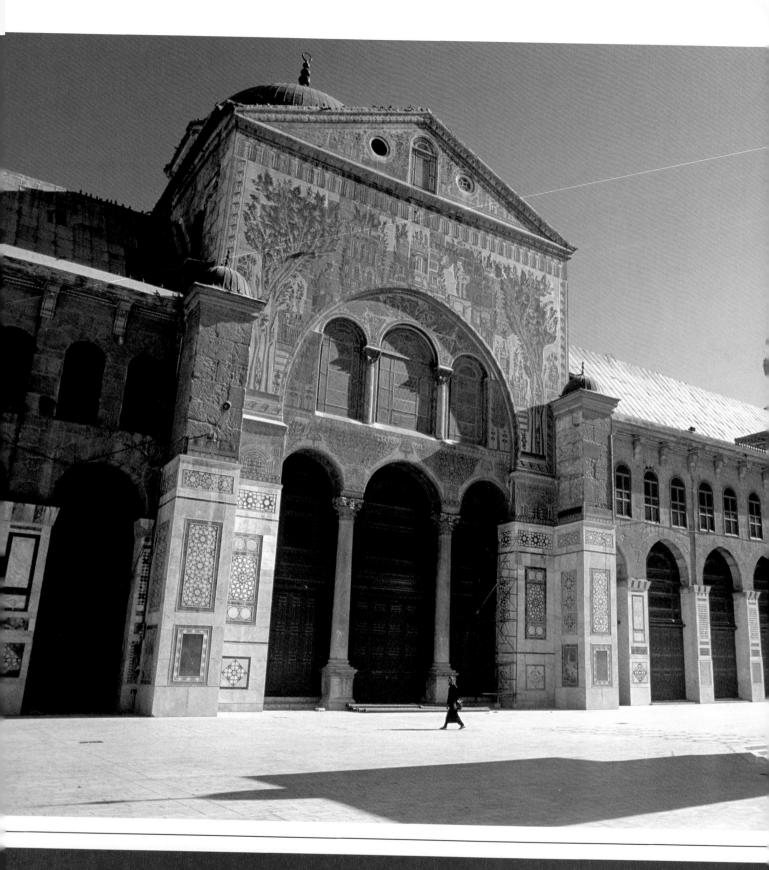

THE

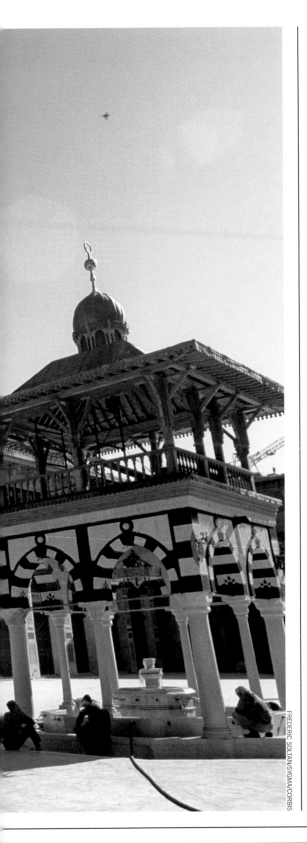

FREDERIC SOLTAN/SYGMA/CORBIS

This is in a way the heightened Islamic version of the Roman Empire after Constantine's Edict of Milan and his subsequent influential conversion to Christianity. If Rome became more than somewhat focused on the growth and spread of a religion, the Umayyad Caliphate was almost exclusively about this.

What is (or was) a caliphate? It was the land, nations and/or people under the jurisdiction of the caliph, and the caliph was the principal Muslim civic and religious ruler, recognized by the faithful as a successor of Muhammad—it could be said, an Islamic pope or archbishop as well as, in political terms, a head of state. Of the caliphates established not long after Muhammad, that of the Umayyad family, which hailed from Mecca but headquartered its empire in Damascus, Syria, did the most to bring imperial uniformity to the territorial gains of a nascent Arab-Muslim world, helping to propel Islam along the path to becoming, today, the second-largest religion on the planet.

First, Muhammad: In a volatile age in the 7th century there emerged a serene, strong leader who bequeathed to his people a treatise so moving and wise that it became their bedrock of belief. Muhammad, born circa A.D. 570 and descended from Abraham through Ishmael in a line that included many prophets (but none after him, for he was considered the Seal of the Prophets), always

Two views of the Umayyad Mosque in Damascus, Syria: Left, from outside; below, inside the shrine of John the Baptist. It is interesting how many historical figures are revered by Christians and Muslims alike; Mary, mother of Jesus, is mentioned more times in the Koran than she is in the Bible, and both Christianity and Islam honor John the Baptist as a prophet. The Umayyad Mosque is one of the largest, oldest and holiest mosques in the world. The first monumental work of architecture in Islamic history, it served as a central gathering point (after Mecca) for Muslims not only to renew their faith, but to organize the conquest and consolidation of surrounding territories under the Umayyad Caliphate.

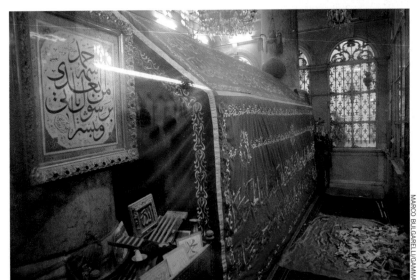

MARCO BULGARELLI/GAMMA

UMAYYAD CALIPHATE
(THINK: THE ISLAMIC EMPIRE)

said that he was merely an agent. The Koran was the word of Allah, offered to Muhammad by an angel in a cave outside Mecca where he went regularly to contemplate, to question the beliefs of his wanton age and to pray. The angel delivered its message and charged Muhammad to "Recite!" This, beginning in about the year 610 when he was 40 years old, Muhammad would do, in the words of Allah that were dictated to him during the remaining 22 years of his life. In Medina, which like Mecca is situated in today's Saudi Arabia, he built a following and eventually challenged Mecca for the soul of Arabia. He won. In 632, Muhammad died in Medina. During the next century Muslim armies washed over Armenia, Iraq, Lebanon, Palestine, Persia, Spain, Syria and most of North Africa, including Egypt.

Relatively early on, just a few decades after Muhammad's death, one of those armies, a formidable one, was under the control of the Umayyads.

The great prophet's first three successors, all called caliphs, had little trouble with the once-mighty Byzantine and Sassanid empires, which were exhausted from warring with each other. The Muslims took resource-rich lands across the Middle East, including the cities Alexandria, Damascus and Jerusalem. The ascension of the next caliph ignited a civil war, which ended in

that caliph's assassination and the rise of his chief rival, Mu'awiya ibn Abi Sufyan, a member of the Umayyad family and governor of Syria. From the start, there were questions over the pedigree required, if any, to be considered a legitimate successor to Muhammad—divisions that laid the foundations for the Khariji, Shi'ite and Sunni Muslim sects. Unlike the earlier caliphs, Mu'awiya bore no direct blood or marital ties to the prophet, and many Umayyads were seen—and have been considered by some historians—as late adopters of Islam. Popular discontent mounted from this inauspicious starting point. When Mu'awiya moved the Arab Muslim capital to Damascus and later appointed his son to succeed him, establishing a hereditary model that bypassed the traditional deliberative process, not all were pleased. Over their reign—the dynasty came to power in A.D. 661, though it would last less than a century—the Umayyads continued to rile Islamic religious scholars, and non-Arab Muslims grew increasingly resentful of second-class treatment.

And yet, secular as well as religious policies promulgated by the Umayyads began fusing what had been a loose collection of conquered lands. As their state continued to expand into Spain, India and central Asia, the Umayyads' well-organized bureaucracy, with Arabic as its official language,

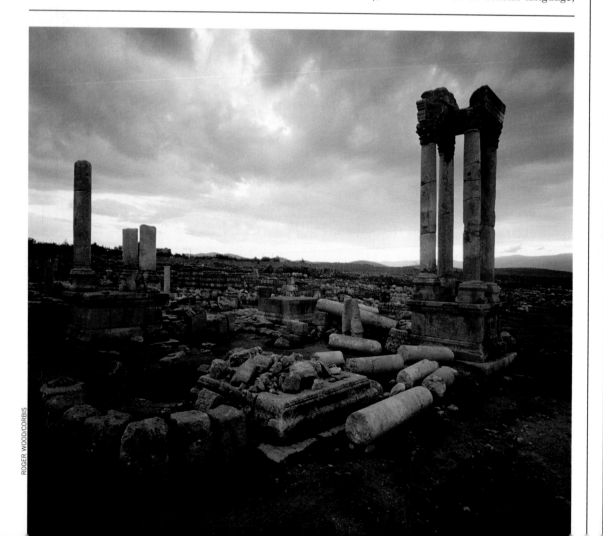

ROGER WOOD/CORBIS

Left: Constructed well before the rise of the caliphate, this is a Roman tetrakionion in what became the Umayyad stronghold of Gerrha in Lebanon's Bekaa Valley. The tetrakionion rose here circa the 1st to 4th centuries; Caliph Al-Walid ibn Abdel Malek built Gerrha in the 8th century. The site was later abandoned, leaving many ruins that are well preserved today in the town renamed Anjar, deriving from the Arabic Ayn Gerrha, meaning "source of Gerrha." If Roman influence predating the Umayyads mixes with Islam in Anjar, whispers of the bygone caliphate are felt everywhere in the majestic Alhambra Palace in Spain (right), whence the remnants of the Umayyads set up a new, smaller dynasty after being driven from Damascus. The palace was erected circa 1318–1354, and Islamic rule in Iberia would continue until 1492, when the last Muslim ruler of Granada, Boabdil, surrendered the kingdom to the Catholic queen Isabella I of Castile and her husband, Ferdinand II of Aragon—who, incidentally, were sponsoring Christopher Columbus's first voyage to the so-called New World that very year.

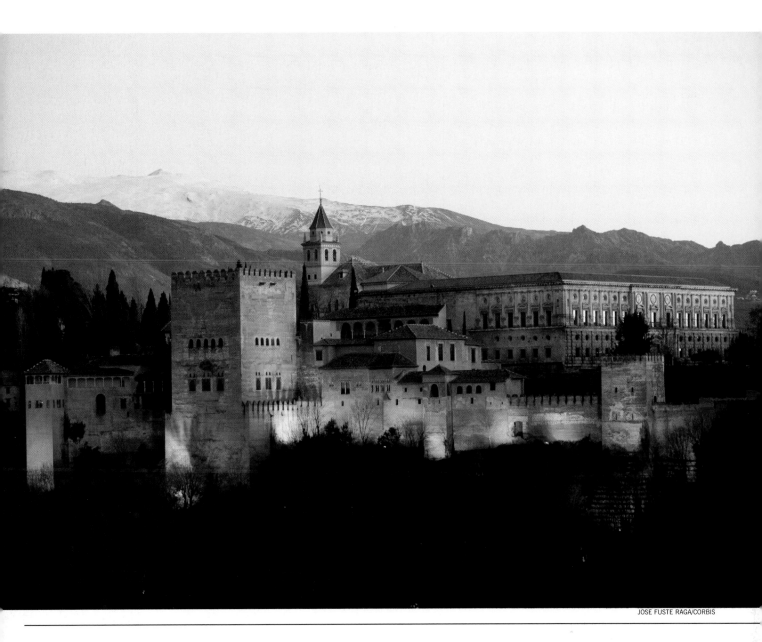

was effective in pushing out to all corners the tongue and tenets of Islam. Their young standing army grew quickly strong. Distinctly Arab Muslim coinage was struck, supplanting Byzantine and Sassanid currencies within the caliphate's sphere. Major architectural works—like the glittering Dome of the Rock in Jerusalem (please see page 7)—trumpeted the arrival of this new societal and religious force. At its largest, the Umayyad Caliphate encompassed more than 5 million square miles: along with the Persian and Roman, one of the biggest empires ever, and still today fifth among the largest contiguous empires in history.

But the caliphate continued to have rivals inside Islam as well as outside, and it was unseated in 750 by the Abbasid family, which descended from Muhammad's uncle. If this marked the end of an era, and it did, it was not the end of the Umayyads. One survivor of the usurpation, Abd ar-Rahman, fled to the Muslim-held Iberian Peninsula and established a new dynasty in Córdoba, in Spain. That city flourished, and in 929, with the dominance of the Abbasids flagging, the Umayyads joined a small chorus of regional powers calling themselves caliphates. Córdoba became a luminous beacon of culture in Europe, but again Islamic civil war splintered the caliphate, and the city was in tatters by 1031. Over the subsequent centuries, conquering Christians arrived to pick up the pieces.

That was Córdoba's and the Umayyads' fate, but it certainly was not Islam's—as we well know. The age of the caliphs would last into the 13th century, to be replaced by a more generalized worship specifically focused on Muhammad and Allah, and the religion would continue to burgeon. Interestingly, some Muslims still maintain today that Islam must always have a caliph as head of the community. They openly profess a goal of—somewhere, sometime—reestablishing the caliphate.

This chapter is not so much a sequel to the one on the Roman Empires but rather a continuation. It is about the later life of the most resilient of those empires, and is characterized by the arrival of new directions, philosophies and flavors. The Byzantine Empire is certainly the Eastern Roman Empire, Part II. And it is equally its own thing.

As we know, when the Roman Empire's first Christian leader, Constantine the Great, sought to shift the nucleus of his expansive operation to what he considered a more central location, his pick was the ancient town of Byzantium (modern-day Istanbul). Rechristened in A.D. 330, Constantinople in short order grew to rival the political, economic and Christian influence of Rome itself, and within decades it became clear that this was a whole new empire, free of many old influences and, despite Constantine's famous conversion to Christianity, eager to blend parts of the local cultural heritage with what the first emperor had brought from Italy. The formal split of the Roman Empire occurred in 395; already the Constantinople-led eastern half was flourishing, and would continue to do so.

When might we say that "Eastern" gave way to "Byzantine"? Well, there is no consensus as to which event or epoch across a several-hundred-year span officially marked the beginning of this new empire. But it is clear that something fresh emerged, something straddling the line between East and West, ancient and medieval—a distinct cultural cocktail of pervasive Christianity mixed with Roman and Greek traditions that were the Byzantine birthright.

This new thing was energetic, and grew large.

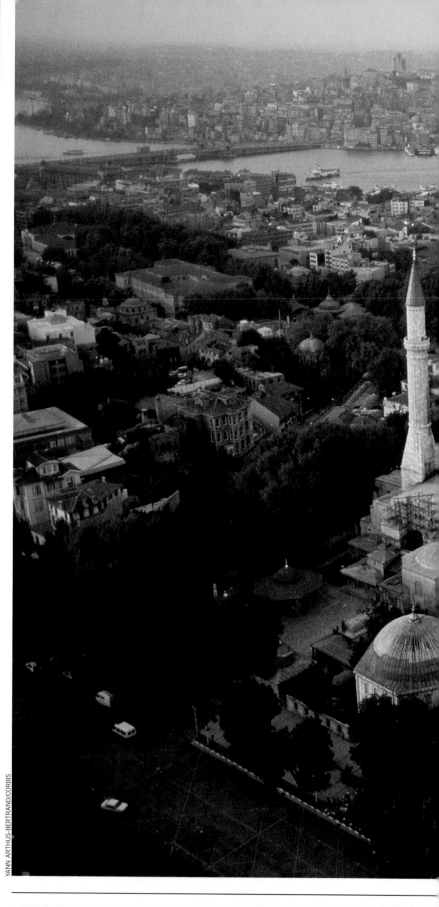

At left is a portrait of a woman made not long after the time of Jesus in the Ancient Egyptian town of Hawara that found its way to the art-loving elite of Byzantium. Above is an aerial view of the altogether astonishing Hagia Sophia.

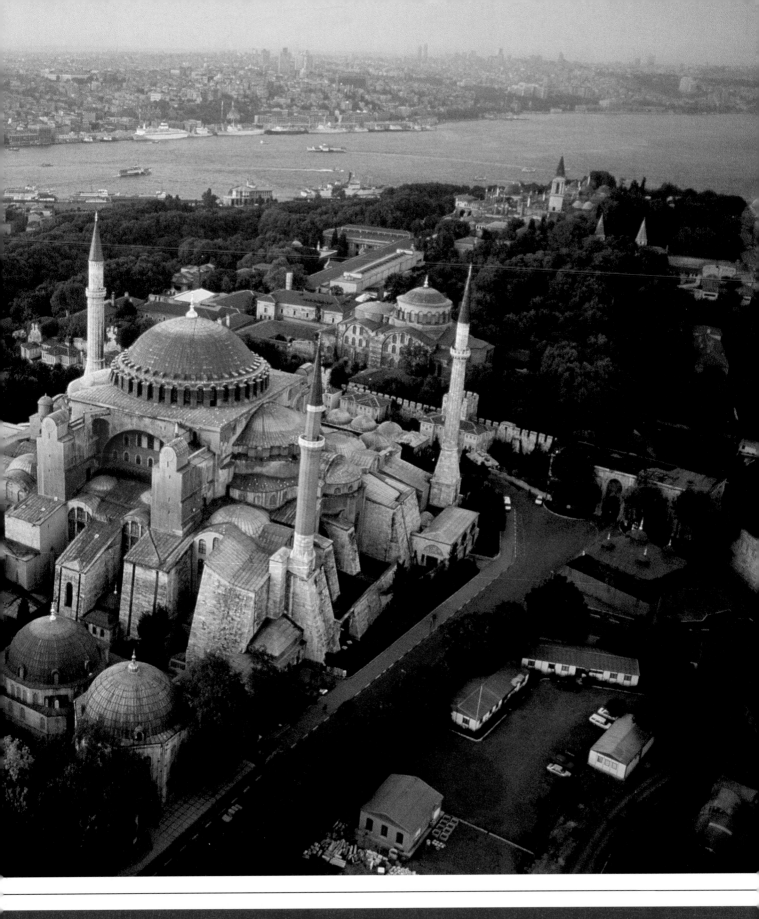

THE BYZANTINE EMPIRE

In the 6th century, at its greatest reach geographically, the Byzantine Empire's footprint encircled the Mediterranean Sea, from Italy and the Balkans to Asia Minor, the Middle East, North Africa and southern Spain. The Eastern Empire had, from the first, exhibited resistance to any imposition of language or culture by the Western Empire, which was looked upon as an effort to "Latinize," and had clung to its Greek roots in language and culture. If you perceive this leading, within the Christian strain, to Greek Orthodoxy, you are correct. Byzantine

emperors were considered to be hand-picked by God, and the affairs of state they oversaw often were concerned with the preservation of Orthodox ("right believing") Christianity. Predictably, that led to dustups with Constantinople's top bishop, a position in Christendom that was second only to the Pope's in Rome.

The earnest and extravagant piety of the Byzantines was made gloriously manifest in sensational churches, the epitome of which was the awe-inspiring 6th century Hagia Sophia in Constantinople. Other high-aesthetic creations included new hymns, liturgical prayers and chants. Christian icons, paintings and elaborate mosaics were regularly brilliant and sometimes transcendent in their artistic quality.

The empire's wealth and notable diplomatic prowess helped keep would-be invaders either wary or disarmed. But ultimately the Byzantine Empire suffered a slow demise under the constant pressure of the cultural gulf with emerging Latin powers in Europe. There were the usual problems, too—encroaching Arab armies, including that of the Umayyads; theological scrapes with Rome (leaders there and in the "New Rome," meaning Constantinople, excommunicated each other more than once)—and all of this amounted to attrition. In 1204, for the first time in its nearly nine-century history, Constantinople fell to invaders. Christian invaders, no less: fighters from the Fourth Crusade, who plundered ruthlessly. The Byzantines later reclaimed their capital but were

unable to rekindle past glories with what little was left of their empire. On May 29, 1453, with the last-ever Byzantine emperor seen personally defending the city walls, Constantinople was overrun and the remnant dynasty extinguished forever by the Islamic Ottoman Turks.

Byzantium's legacy endures. Byzantine art and scholarship—particularly the perpetuation of Greek language, literature and thought—was instrumental in shaping the Italian Renaissance and later the Enlightenment. And even as the empire's territory contracted during its prolonged decline, its Orthodox Church continued to expand, and today remains a major wing of Christianity—one that, admittedly, continues to have some difficulty conversing with Rome.

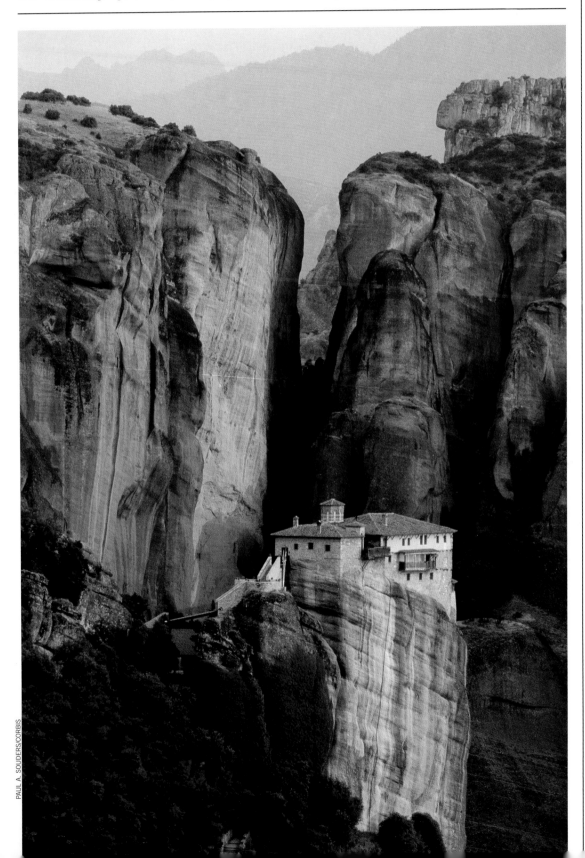

The city Byzantium in present-day Turkey was hardly a surprising place for a Christian-leaning emperor like Constantine to feel at home; its heritage was longstanding and heartfelt. At top on the opposite page are the Christian caves in Cappadocia, Turkey, which were used by Jesus-followers for clandestine services in the early decades of their movement. Bottom: Fresco paintings adorn the vaulted ceiling of one of the several early Christian churches carved into the strange pinnacled rock forms in Cappadocia. The churches today lie within the Open-Air Museum situated close to the town of Göreme. The Orthodox Christian movement had a headquarters in Constantinople and was far-reaching. The Roussanou Monastery in Metéora, Greece, seen at left, is one of six ancient Orthodox monasteries in that signal town.

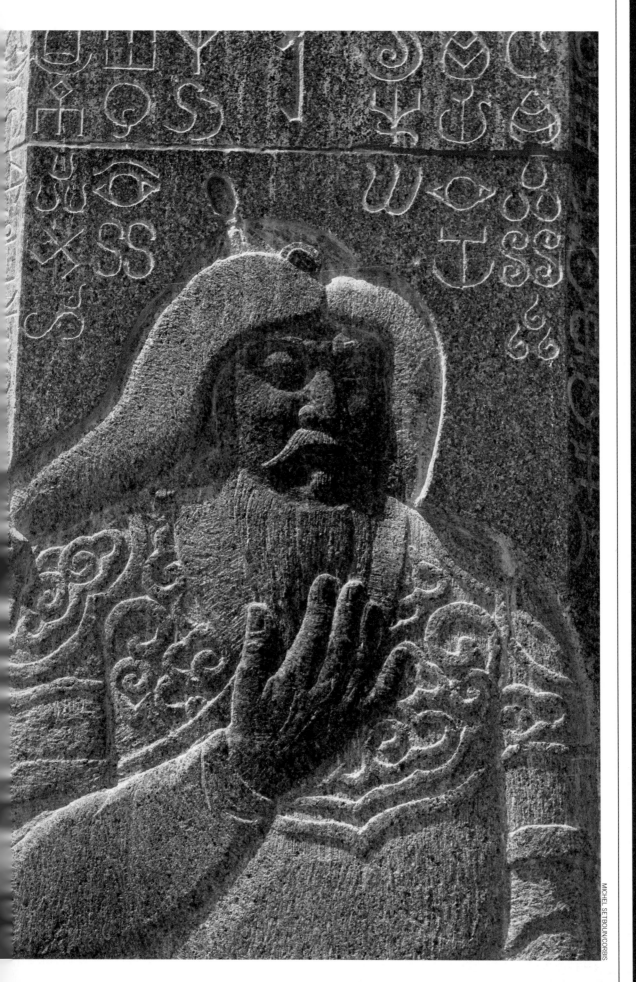

At left is a close-up of the Genghis Khan statue and monument at Khodoo Aral in Mongolia. The monument marks the location of the first capital of his empire. Right: Khara Khoto or "Black City" is the name given to the ancient fortified town once occupied by Genghis. With massive mud walls guarding a nearly 500-yard-wide flank, the town was a southern bastion for the Mongols. The Venetian wayfarer Marco Polo claimed not only to have met Genghis's grandson Kublai Khan during his 13th century travels in China, but to have stayed at Khara Khoto. In 1372, Ming troops, of which we will learn more just a few pages on, conquered the fortress by diverting the flow of the river that supplied its water.

If the Macedonian Empire was largely the trademark of one man, all but thoroughly synonymous with Alexander the Great, then so it is here, in this second case. Think: Mongol Empire, and then conjure Genghis Khan. Here was a person who rose from the bottom to the absolute top, and he proved so successful at Eurasian domination that, in showing it could be done, he inspired future tyrants to give it—and even global conquest—a try.

In the late 12th century in the region known today as Outer Mongolia there were several warring tribes, and from this chaotic situation a fierce fighter named Temüjin, the son of a fallen Mongol chieftain, emerged as particularly skilled not only on the battlefield but as a leader and organizer. He and his men came to rule over the steppe, and in 1206 a conclave of Mongol warlords anointed him Genghis Khan—"Universal Ruler"—and pledged fealty. Scholars today note that the *prénom* is more accurately pronounced "Chinggis," and the name may have meant "oceanic" as much as "universal" ruler, but such details mattered little to those along the Mongol warpath.

The khan went to work expanding his confederacy's reach. In 1211 he began his conquest of north China, and by 1215 he held most of the Jin Empire; he then conquered Turkistan, Transoxania

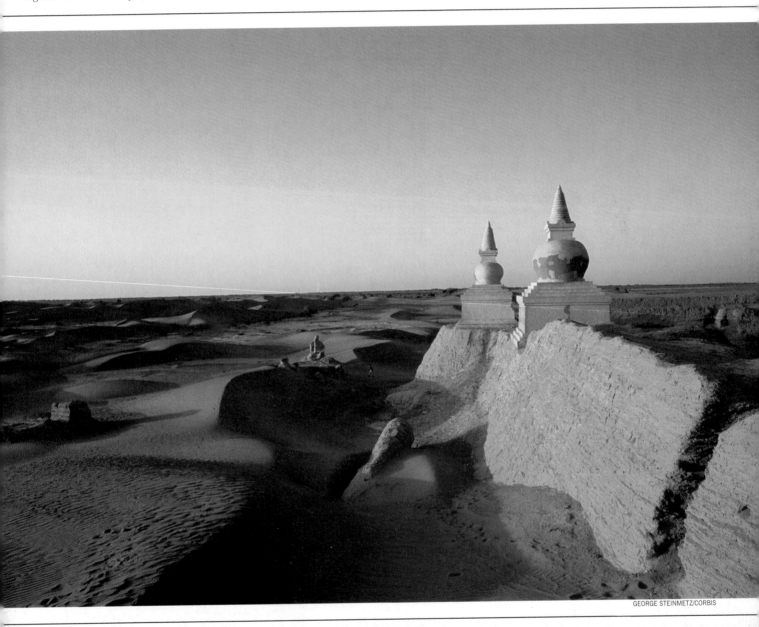

THE MONGOL EMPIRE

and Afghanistan, and penetrated southeastern Europe. To the world around them, Genghis Khan's Mongols seemed dispatched by the devil, horsemen of the apocalypse. But they weren't wild-eyed madmen, they were skilled warriors. Mongol expertise on horseback and marksmanship with a bow were learned early on: Children were in the saddle before they were on their feet. In this military culture, they were professionals by the time they reached adolescence. Often outnumbered in battle, the Mongols nonetheless cast a shadow so dark and deep that the sight of their galloping hordes could prompt surrender.

In the khan's vigorously violent world, loyalty and respect were demanded of everyone, Mongol or not, and loyalty would be obtained, one way or another. Those who forced the Mongols to conquer them more than once could expect the worst of the khan's wrath, and the *ordinary* wrath of khan included the use of war prisoners as front-line defense, literal cannon fodder. The Mongols leveled cities, erased populations—all the while sending a warning to those who were next in their way.

The Mongols were savvy as well as ferocious, known for their ready adoption of technology gleaned from captured engineers. As they progressed, they employed newfangled catapults and explosives in attacking walled cities.

Before Genghis Khan's death in 1227, he had captured modern-day Beijing and forged a massive empire that extended from northern China west to the Caspian Sea. Mongol rule continued to expand. Under the leadership of Genghis's son Ögödei, the Mongols took over Russia and pushed farther into Europe. In 1279, Genghis Khan's grandson Kublai Khan completed the conquest of China. By the late 13th century the Mongols had created the largest contiguous land empire in history, then or since. (Present-day geneticists studying Y-chromosome data in the part of the globe that the Mongols once overran have determined that 8 percent of men living there today—16 million, or almost 0.5 percent of the world's population—share a nearly identical chromosome. Genghis Khan and his men spread their kingdom, and their seed, far and wide.) Simply because the Mongols' collection of nations and cities grew so very great, these people can be said to have played a significant role in introducing far-flung peoples to one another and in fostering the spread of culture, scholarship and trade. But these highfalutin civic achievements weren't their principal game or goal. They were good at fighting. They were the kings of conquest.

As large and mighty as the Mongol Empire was,

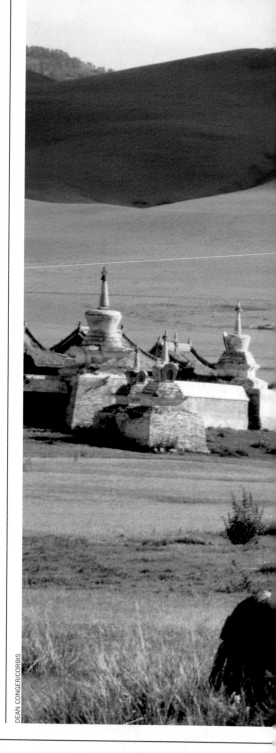

At right, a solitary tortoise marks the site of Karakorum, Genghis Khan's capital; passersby drop stones on the statue as a kind of prayer. When the khan contested the Khwarezm Shah Dynasty in this northwest corner of Mongolia's Ovorhangay province beginning in 1218, Karakorum wasn't much more than a yurt village, and remained such under the great khan. It was left to Genghis's successor, Ögödei, to erect walls and a palace. Möngke Khan, Ögödei's nephew and one of the four sons of Sorghaghtani Beki—a woman credited with being responsible for much of the Mongol trade openings and growth in learning— further improved Karakorum and completed the great stupa (spired temple). After Möngke's brother Kublai took over in 1260, he moved the Mongol capital first to Shangdu and then to Dadu, today's Beijing. Beyond the tortoise are seen the spires of the Erdeni Dzu monastery, dating from the 16th century: probably the oldest surviving Buddhist monastery in Mongolia.

DEAN CONGER/CORBIS

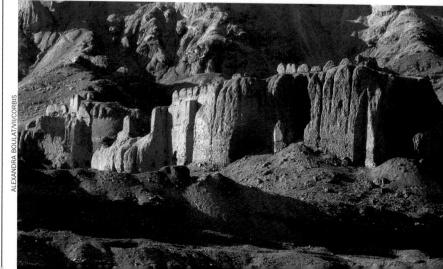

ALEXANDRA BOULAT/VII/CORBIS

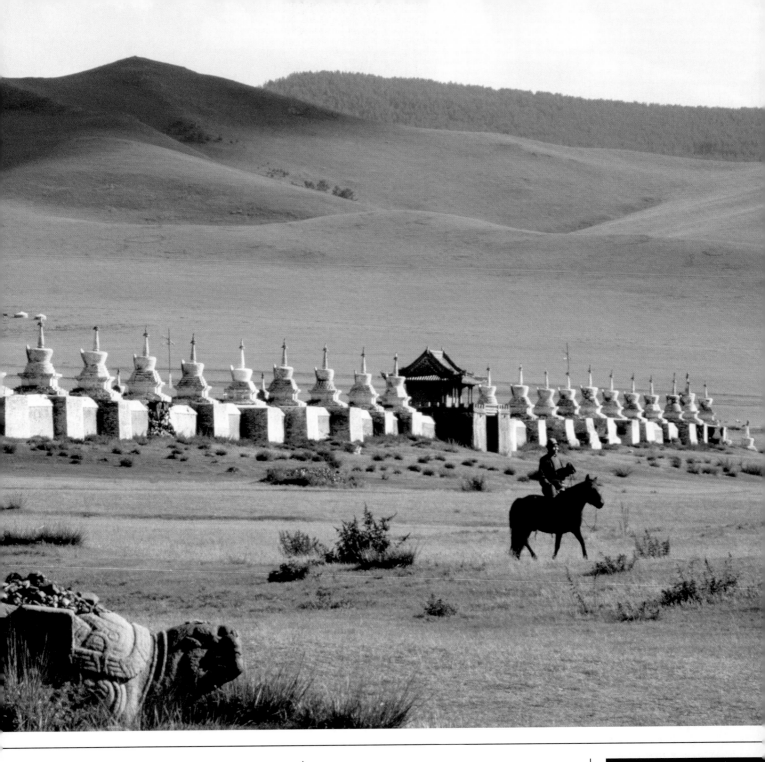

a regime built by battle—and built on a constant thirst for battle—it wasn't built to last. Eventually the whole of it was divided into a quarrelsome quartet of Mongol kingdoms, the Yuan Dynasty in China chief among them. Persia buttressed (and hosted) the Il-Khanid Dynasty; Russia supported the Golden Horde; and then there was the Chaghatai in central Asia. The Mongol people had grown used to having one khan at the helm, and now there was all this chaos, with the swords often trained inward. As we will learn in the following chapter, by the late 1300s, the Mongols were vulnerable, their strength—what was left of it—again confined largely to the steppe, whence Genghis Khan had once led his nation to the wider world. In the 1700s, even this homeland would come under Chinese authority.

The postscript is almost sentimental, which seems an unusual term to use when considering the Mongols. In the 20th century, an independent, democratic Mongolia was cleaved from China and, later, from Soviet influence. In this place, there is today a renewed verve for studying and reclaiming Genghis Khan as a national hero.

Opposite: Among the many scars in Afghanistan today are the silent ruins of Shahr-i-Zuhak in the Bamiyan Valley. An ancient Buddhist town, it was destroyed by Genghis Khan in 1221. Its geographical location and the date of its obliteration are indicative of the great warrior's reach, and just how fast he moved once he got started.

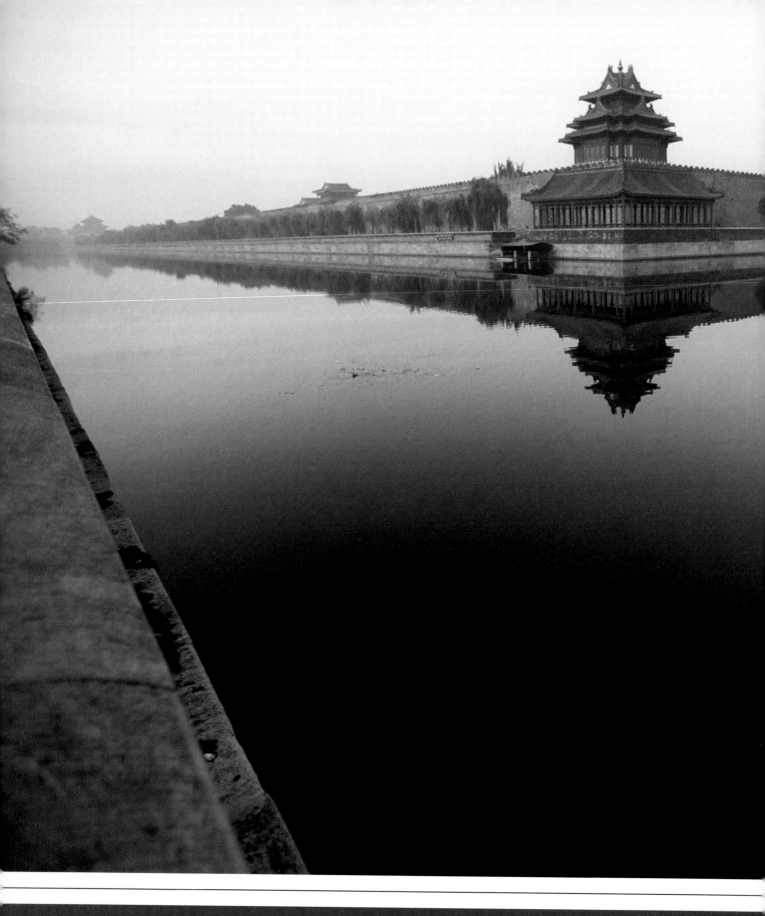

THE MING DYNASTY

It is tempting to say that the Ming and the Mongols represent the yin and yang of China in the Middle Ages. It is just as tempting to see the Ming as latter-day Han, one millennium on: progressive and thoughtful. In truth, they lie somewhere close to the middle on the cultural continuum between the ethereal Han and the earthly Mongols, as we shall see.

How did they come to power? In 1368 a peasant turned rebel military leader, Zhu Yuanzhang, rose among the ranks to successfully overthrow the Mongol dominance and reestablish native rule in the largest part of China. Bestowing on himself the reign title of Hongwu—meaning "Vastly Martial"—Zhu would be known to history as the Hongwu emperor. As such, he was the founder of the Ming Dynasty, a period of great prosperity, architectural achievement and governmental progress widely regarded today as one of the very most significant in Chinese history.

It is true that, under the Hongwu emperor, a

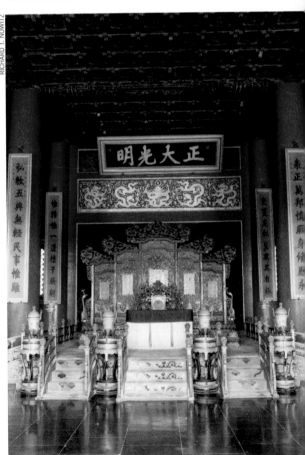

Above, left, is the moat around the Forbidden City in Beijing, and directly above is the front chamber of the Palace of Heavenly Purity inside the city, where the emperor attended to state affairs almost every day.

governmental structure greatly resembling that of the Mongols—autocratic in the extreme—was established. Eliminating the posts of prime minister and chancellor, Hongwu, aided by an entourage of appointed scholarly servants, assumed complete control. This "all powerful" arrangement, perpetuated by succeeding emperors, led to the perfection of a civil service system that would be adopted by the succeeding Qing Dynasty and would endure until China's imperial institution was abolished in 1912.

The Vastly Martial emperor laid the groundwork, but the Ming Dynasty is remembered for where it progressed to after its founding. Expansion, growth and greatness were the hallmarks of its third ruler, Zhu Di. Although he was Hongwu's son, he was not in line for succession and took the throne by force in 1402. He too was an absolute dictator, but chose the far more mellifluous reign title Yongle—meaning "Perpetual Happiness." Though personally temperamental and abusive, the Yongle emperor managed to build an administration so strong and stable it could control the empire while allowing talent to flourish—another yin-yang equation that would characterize the remainder of the dynasty. Yongle transferred the national capital and central government from Nanjing to Beijing and built what remains the largest palace in the world: the Forbidden City. It is an apt symbol for the Ming era, awesome yet sublime. Commissioned in 1406, completed in 1420, the Forbidden City is the utmost expression of the ancient Chinese art and science called Feng Shui: a design system meant to align spiritual forces and ensure health and happiness. Composed with an eye always trained on the number nine or a multiple of it—a number symbolizing the emperor's divinity—the Forbidden City contains 9,999 rooms and spans roughly 180 acres. It is beautiful, and yet it has that frightful name. Figure it out, and you have figured out the Ming.

For more than two hundred years of Ming rule, the Forbidden City would be home to 14 emperors, their imperial families, concubines, servants, civic officials and a eunuch court thousands strong. Another impressive building project was completed 30 miles north of Beijing when the Yongle emperor chose a site for his burial. Known today as the Thirteen Tombs, it houses the remains of 13 Ming emperors, their empresses and second wives, and stands with the Great Pyramid and the Taj Mahal as one of history's most impressive extant gravesites. The Yongle emperor also built a formidable naval fleet, which he entrusted to his favorite eunuch, Zheng He. The armada featured more than 300 ships and some 27,000 men. It would make seven grand naval expeditions from

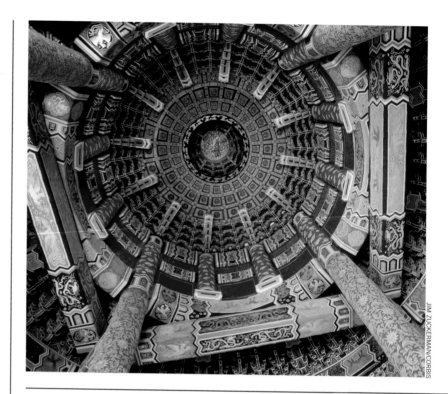

1405 to 1433, intent not so much on conquest as on displaying the wealth and power of China. The Ming Dynasty had learned, quickly, how to build big and impressive things, and the Yongle emperor wanted the world to know it. His successors cared not so much. These grand voyages in the Indian Ocean were costly, and after Yongle died in 1424 and Zheng He followed in 1433, the fleet was disbanded. It is interesting to speculate, since history tells us the world was just then entering the Age of Discovery, what might have been if Ming emperors after the Yongle had tried to export their empire through transoceanic colonization. Surely the Portuguese, Spanish, French, Dutch and British would have had another potent rival to deal with.

But the Ming turned out to be isolationists intent on retaining power at home. This attitude was made manifest in 1474 when the empire began reinforcing the Great Wall of China, raising it to the glory we know today. For a while, the wall worked, but in 1644 it was breached by the Manchus. The Ming authority had already been undermined by inner turmoil between civic officials, interfering eunuchs and a line of inattentive emperors; the dynasty fell to the Manchus, who readily established the Qing Dynasty, a civilization that would, as we shall see a few pages on, reign until 1912.

Today, the Forbidden City, the Thirteen Tombs and the Great Wall remind any who behold them that imperial China was capable of not only astonishing achievements but otherworldly will.

Above is the ceiling of the Temple of Heaven and at right is the Mutianyu section of the Great Wall of China, 50 miles northeast of Beijing in Hebei Province. The temple, in the southeastern part of central Beijing, was an important place of worship during the Ming and Qing dynasties. Even the emperors would go there to appeal to Heaven for a bountiful harvest. The foundations of the Mutianyu section of the wall were erected as early as the mid–6th century, but were thoroughly rebuilt during the Ming Dynasty by General Xu Da and his men. Always among the most impressive and effective parts of the wall, the Mutianyu section remains among the best preserved today.

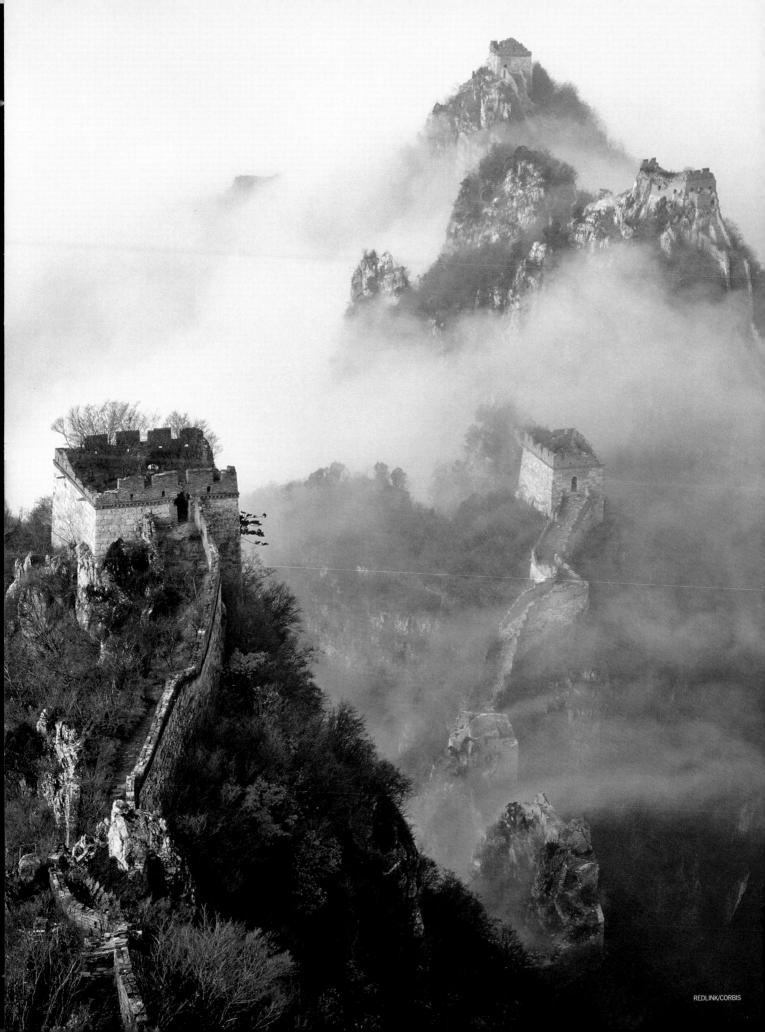

By now we understand that the ancient world was a much bigger place than just southeastern Asia, northern Africa and southern Europe. We have traveled west to visit the Maya of Mesoamerica, and have just ventured far to the northeast, to Mongolia, to meet Genghis Khan, then to Beijing to meet the Ming. Now we go back west across the Atlantic from the Fertile Crescent—west, and south, where existed the largest empire in pre-Columbian America, that of the Inca.

Today when a researcher or tourist goes to Peru to experience the globally famous mountaintop ruins at Machu Picchu, his or her jumping off point is Cuzco in the valley below. This village/town/capital has always been significant in Inca lore and life—more significant than Machu Picchu itself—figuring prominently in Incan oral as well as political history. Those stories are fantastic indeed: Eight siblings emerge from a cave and set off to find a place to settle their race; they are followed by countrymen who emerge from neighboring caves. One of the four brothers carries a staff made of gold, and where this staff is thrust into the ground will become home base for the Inca.

The brothers, ambitious, become rivals, and as they journey, three of them drop away: trapped by the others, turned to stone, the very stuff of origin stories. Only Ayar Manco and his sisters go on to Cuzco, where the staff is sunk into the ground. The people of the valley, who were engaged in an industrious agrarian lifestyle, challenge these newcomers, but one of the sisters, Mama Ocllo, turns out to be a warrior queen: She fells an opposition fighter with stones, then tears out his lungs and blows into them, scaring off all other comers. The brother who had reached Cuzco becomes Manco Capac, founder of the Inca people, and he, his family and his followers build the first Inca settlement. Then Capac too is turned to stone and is succeeded as ruler by his son, Sinchi Roca.

If some of this happened, it would have been in the 13th century, according to what we now know about Incan origins. In the time of Manco Capac and Sinchi Roca, the Inca were pretty much a tribe of pastoral people who organized a small city-state called the Kingdom of Cuzco, which became the administrative and, subsequently, military hub of their nascent civilization. It would be left to other generations of leaders in the next century to make

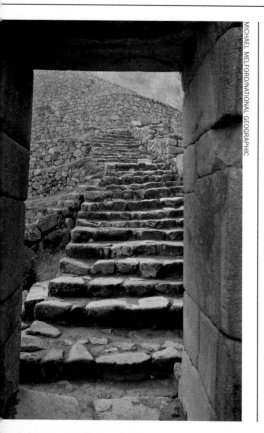

MICHAEL MELFORD/NATIONAL GEOGRAPHIC

BRIAN A. VIKANDER/CORBIS

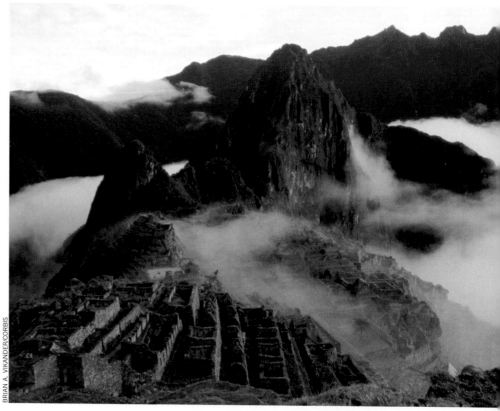

THE INCA EMPIRE

the Inca truly great: to build an empire. Pachacuti Inca Yupanqui (meaning "earth shaker") was the ninth Sapa Inca, or "Only Inca," when he, aided by his three sons, started challenging, defeating and agglomerating other tribes. The Yupanquis eventually controlled a huge portion of the Andes, a north-to-south swath approximately equivalent to today's Peru and Ecuador put together. To govern such an enterprise, Pachacuti, showing bureaucratic sophistication to back up his military acumen, established four provincial governments reporting to the Inca (which meant, reporting to him). It all worked relatively well as long as the Inca were left to their own devices.

Pachacuti's segmented society was called Tawantinsuyu ("four parts united") and at its apex was home to as few as 4 million people and as many as 12 million (the estimates are so varied because Inca census records were destroyed during the later invasions by the Spanish). Once his empire was mighty, Pachacuti could often entice more remote kingdoms to join the glittering Inca enterprise through conversation rather than conquest. He was succeeded as leader by his second son, Tupac, and the amalgam of a nation—more than a score of local languages in addition to the "official" tongue Quechua; some member-states intensely loyal and others decidedly not—continued to grow. As was happening time and again in the Fertile Crescent, assimilation and cross-pollination led to cultural advancement in the arts and crafts and in agricultural development.

It is probable that it was Pachacuti's family who built Machu Picchu high above Cuzco, but still today, more than a century after the extraordinary five-square-mile place was discovered by Western man and after many excavations and examinations, there are only theories as to what Machu Picchu actually was. Initially, it was regarded as a shrine or open-air cathedral. The Inca adhered to a belief in reincarnation, and perhaps at this high point the dead transitioned to the next world. But maybe it was at least in part a prison, isolated from society à la Alcatraz or Saint Helena? Or a pastoral outpost for high-country shepherds? Or part of the Inca agricultural system called the vertical archipelago? Or Pachacuti's getaway: a summer house for him and his aristocratic friends. This fantastic realm, a true wonder of the world, might once have been as mundane as that. Perhaps one day we will know for sure.

Francisco Pizarro, the great Spanish conquistador, first ventured into the Inca civilization in 1527, and immediately he and his men were astonished not only by the fertility of the land and the society, but by tales they were told of the empire's gold and other riches and the potential for plunder. In 1529 he received royal dispensation to conquer the

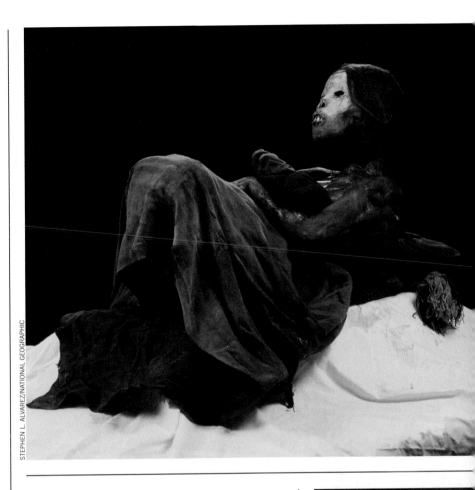

STEPHEN L. ALVAREZ/NATIONAL GEOGRAPHIC

Inca and set himself up as regional viceroy. This was his goal when he returned to South America with 180 men, 37 horses, one cannon—and, more important, great military experience and tactical expertise. Still, even with his leadership skills and his men's discipline, and the help of Indians hostile to the Inca who were recruited along the way, such a relatively small force might have had a hard time with the Inca military. But the empire had recently been weakened by civil war and decimated by the spread of smallpox from Central America (a spread perhaps exacerbated by the Inca's modern road system). Nearly as much as Spanish force, European disease would contribute to the disappearance of the Inca in the decades ahead, as the first smallpox plague was followed by the arrival of typhus, flu, smallpox again, smallpox a third time, diphtheria and measles.

Cunning, deceit, false promises, kidnapping and assassination were all part of Pizarro's assault on the Inca, and once the Spanish had succeeded with the capture of the last Inca stronghold in 1572, they subjugated the native population thoroughly. The Inca were forced to work in the dangerous, regularly lethal silver and gold mines, their toil and recovered treasure all in service to the Spanish crown. The greatness of their empire was only a memory, quickly lost in the mists of the Andes Mountains.

On the opposite page are two photographs from Machu Picchu. At nearly 8,000 feet above sea level, in the midst of a tropical mountain forest, it was built in an incomparably beautiful setting. It was the man-made equivalent of its surroundings: giant walls, terraces, ramps and stairways seeming to bloom naturally from the rock escarpments. More still: The eastern slopes of the Andes, where sits Machu Picchu, are part of the upper Amazon River basin and boast an amazing diversity of flora and fauna to complement the sanctuary. Above: A 500-year-old mummy of a young Inca girl, who was killed by a blow to the head. She was discovered in September 1995 near the summit of 20,630-foot Mount Ampato in southern Peru after a glacier retreated from the upper reaches of the dormant volcano.

THE PORTUGUESE EMPIRE

Heretofore we have examined empires that were born at home and then extended their reach within their region—supersized themselves. Even if we look at the vast holdings of the Persians, Macedonians, Maya or Mongols, we see empires that were largely contiguous, burgeoning outward from the most recent conquest. The kingdoms were, for the most part, terrestrial organisms: They traveled over the land, gobbling more land as they went.

But in the so-called Age of Discovery, a new game was afoot, a game we have just seen played aggressively with the Inca by the Spanish. Lofty title, "Age of Discovery," but not a happy time for those being discovered. It was usually, and summarily: check, checkmate, match to Europe.

As any schoolkid can tell you, in 1492 Christopher Columbus, an Italian in the employ of Spain, sailed the ocean blue and discovered "the New World" by reaching the Caribbean, which he mistakenly thought to be the Far East (and so it would be called the West Indies). As that same smart schoolchild could also tell you, Columbus probably didn't discover North America at all. The Vikings may well have been there earlier, and even such odd historical figures as Ireland's Brendan the Navigator, a monk with a yen for sailing, have their backers. Be that as it may, Columbus remains a towering figure in Age of Discovery annals, but it needs to be noted: Neither Spain nor England nor France nor the Netherlands established the world's first transoceanic global empire.

Portugal did.

One impetus in the early 1400s for the Portuguese to look overseas for a better future was an economic slump at home—home being, essentially, Europe's Iberian Peninsula. An assault on the Muslims in the African area that is today Morocco looked promising. Victory might mean not only the possibility of plunder but the chance to establish foreign trade. That salvo went well, and in the next few years, beginning in 1418, Portuguese ships explored the western coast of the dark continent, much of which they would come to colonize. By mid-century, Portugal had better vessels, better maps and bigger ambitions than most European rivals, and was fixated on finding trade routes to Asia. Continuing to press southward, the explorers discovered new lands in Africa, established trading outposts and built agricultural operations on acquired islands: farms that could send wheat

This is the Tower of Belém in Lisbon, built by King Manuel I in the 15th century as a fortification where the Tagus River enters the Atlantic Ocean. It was also a grandiose entrance to the city, and played several roles during the Age of Discovery when formerly isolationist Portugal sent forth ships—and made new enemies.

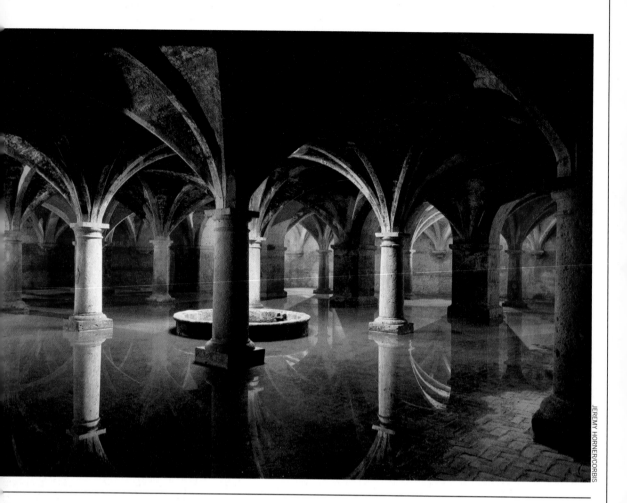

home to Portugal. Meantime, sugar exportation grew lucrative.

A milestone in exploration history came in 1488 when Bartolomeu Dias rounded the Cape of Good Hope at the southern tip of Africa. There were myths on the table at the time—the world was tiny; the Indian Ocean was landlocked—and this exploded the latter. A decade later, Vasco da Gama followed his countryman's pioneering route south, came back north and stepped foot in India. Not long thereafter Pedro Álvares Cabral landed in Brazil, and Portugal was spreading both east and west.

Meantime, of course, that nettlesome Columbus business in the West Indies had caught Portugal's attention. Argument between Spain and Portugal as to *which* was entitled to *what* led to negotiations and to the Treaty of Tordesillas in 1494. This was a pact dripping in hubris: The Portuguese and Spanish essentially split ownership of the world beyond Europe, with a north-south division existing just about a thousand miles west of the Cape Verde Islands. (As the measurement of longitude was inexact in the 15th century, the two nations would argue over holdings for many years as technology grew in sophistication.)

There was reason, back when, for Portugal to be diplomatic and avoid the unwanted distraction of a fight with Spain. It had mastered this Age of

Discovery game and was making piles of money in the seaborne spice, gold, sugar and slave trades. There was nothing humanitarian about any of this: Native Africans, subjugated, were forced to work the Portuguese mines or on farms in Brazil, or on sugar cane farms on African islands, or were hustled onto ships; some 800 slaves arrived in Lisbon each year at the height of their importation.

By the late 1500s, Portugal's eastward-looking network of colonies and trading posts reached along both coasts of Africa, then snaked through the Middle East and around India and Southeast Asia all the way to Nagasaki, Japan. To the west, Brazil and other colonies were booming. Portugal, not a big country, saw its coffers filled. There were battles waged to protect this dispersed empire, certainly, including not-always-successful conflicts with the Chinese. But by and large, Portugal was, for the longest time, able to concentrate on its expansionist, capitalistic ways without the distraction of full-blown war.

In 1580 it began a 60-year partnership with its sometimes testy neighbor, Spain. This might have looked good on paper—one plus one equaling five in terms of strength—but it caused problems for Portugal where few had existed. Neither the Dutch nor the British nor the French got along with Spain, and suddenly much-smaller Portugal, too,

was subject to attacks because of its new alliance. Outposts half a world from Lisbon were hit, and no defense could be mounted in any kind of due course. The empire began its protracted decline.

And it certainly was protracted. Losses in Asia to the Dutch in the 1600s broke Portugal's monopoly there; some colonies in the Americas rose up against their overlords, and in 1822, Brazil freed itself. Portugal retrenched in Africa, but of course the 20th century was unkind to all kinds of empire, from the British on down, as state after state fought for independence. Still Portugal tried to hang on, and most historians date the last gasp of Portugal's transoceanic dynasty as recently as the 1990s. Thus, finally, did the first—and at the time the longest lasting—global empire expire.

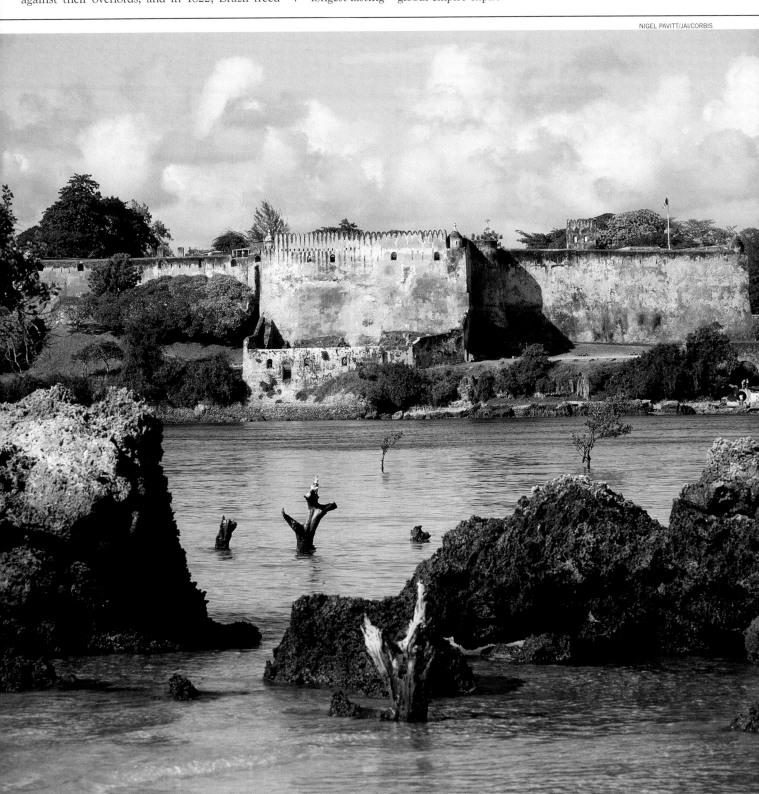

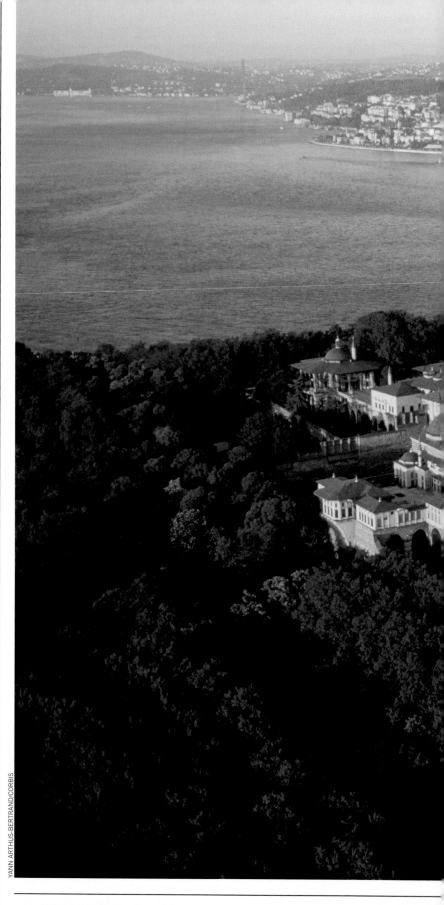

Here, as with Portugal, is another long-standing empire of the second millennium, that of the Eurasian Ottomans. What began in the Middle Ages as a fearsome group of Islamic holy warriors—the Muslim counterpart of Christian Crusaders—grew to be a world power and endured long enough to see action in World War I. There are two ways to look at the ultimate outcome: For the Ottoman Empire, a reluctance to adjust to the progressing world over the course of six centuries ultimately was its undoing. Then again, this obstinate, focused dynasty lasted six centuries: quite a good run.

The roots of the empire were laid around 1300 by Osman I, who was among the Turkish chiefs rising to prominence after the fall of the Seljuq Turks and then of their conquerors, the Asian Mongols. A lot of acreage was changing hands, and from a patch of northwestern Asia Minor—crucially, a continental crossroad where Asia and Europe all-but kiss—the Ottomans carried their Islamic challenge to the withering Byzantine Empire, which was, as we know, a center of devout Christianity

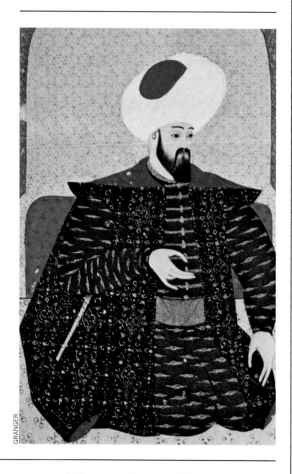

Above is Osman I (1258–1324), founder of the Ottoman Empire, in a 17th century Turkish miniature.
At right is Topkapi Palace in Istanbul. It was the primary residence of the Ottoman sultans for four centuries during their 623-year reign.

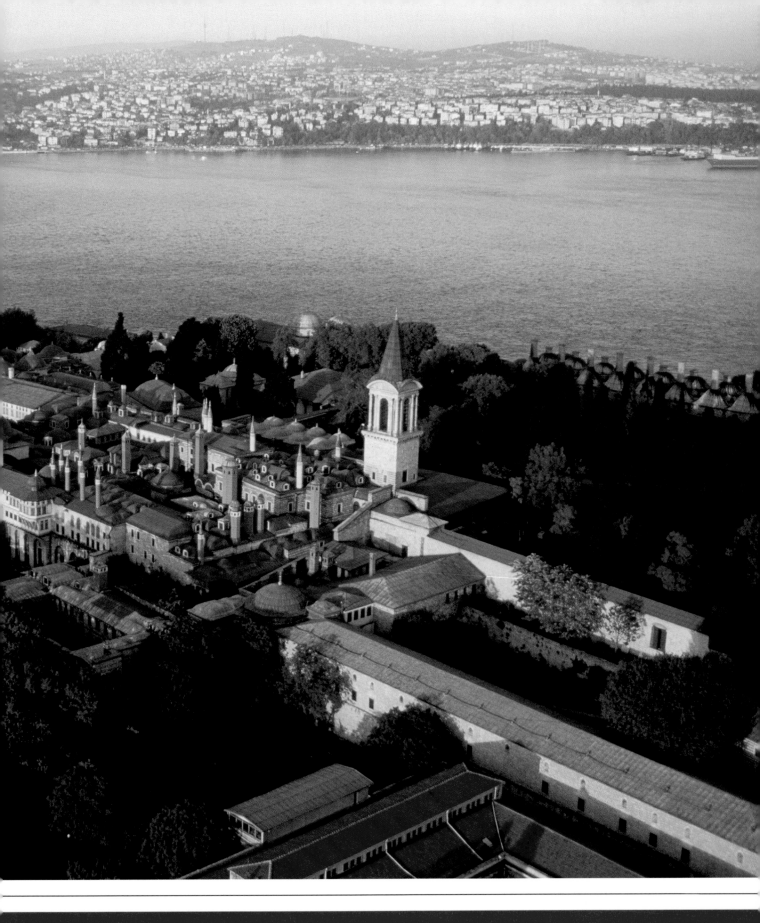

THE OTTOMAN EMPIRE

and historically an heir to Rome. Triumphing over the best defensive efforts of the Crusaders, the Ottomans spread into Europe and then, in the spring of 1453, converged on the trophy city: the Byzantine capital, Constantinople. Ottoman cannons blew open city walls that had stood for a thousand years. When the smoke cleared, an old world capital had become a new one: Istanbul.

In the next century, the fervent Ottomans conquered land in all directions. They consumed Asia Minor, expanded farther into Europe—nearly to Vienna—and east to the Black Sea, dominated large parts of the Mideast and North Africa. As said, their home base was in a plum position along trade routes. The jewels they added to their crown outside that hub included not just Constantinople/Istanbul but Jerusalem, Baghdad, deeply Islamic Mecca and Egypt's Alexandria. This Sunni Muslim empire—for a time, the most potent and important on the planet—obviously came to be an amalgam of peoples and languages: It's the way of the world in empire-building, as we have seen time and again. In one concession to necessity, Ottoman rulers tolerated differing (if unequal) religions, and allowed regional leaders to regulate their own people while of course pledging fealty at every turn.

As with the Portuguese, the Ottomans' decline was slow-burning, and caused by many of the same things that had caught up with previous empires. The political elite took to siphoning power from the ruling sultans under them, and this led to rampant corruption at the highest levels. Wars took their toll. The glue grew hard and cracked. By the mid-to-late 1500s the long Ottoman sunset had begun.

This was not missed by the nations of Europe, several of which were coming of age and would continue to advance during the Renaissance. They stopped worrying so much about checking the Ottoman advance, and more about where there were vulnerabilities, and how best to challenge outright or jockey for influence. For decades—centuries—there was a stubborn resistance at the highest levels of the empire to adopt Western improvements, and by the time reformers held any kind of sway, it was too late. By the early 1900s, the once great dynasty had become known as "the sick man of Europe" and in fact had been pushed almost entirely off the Continent, out of Africa, and into debt.

ATLANTIDE PHOTOTRAVEL/CORBIS

This is the Mosque of Süleyman in Istanbul. It was ordered built by Sultan Süleyman the Magnificent in the mid–16th century, and is fascinating for its combination of Islamic and Byzantine influences. It owes decorative touches to the crosstown Hagia Sophia, which of course was originally a place of Jesus-worship. That building, too, eventually took on a dual personality after the Ottomans reconsecrated it as the mosque of Ayasofya.

Above: Imperial lancers sit on horseback in front of the Sultan's palace in 1912. Opposite, top: During World War I, Istanbul was a target for the air forces of the Allied Powers because it was the headquarters of the Ottoman high command and also was hub of other important military and industrial operations. Bottom: Ottoman-period influence was felt everywhere in Europe, west Asia and North Africa—as here, with these Cairo mosques.

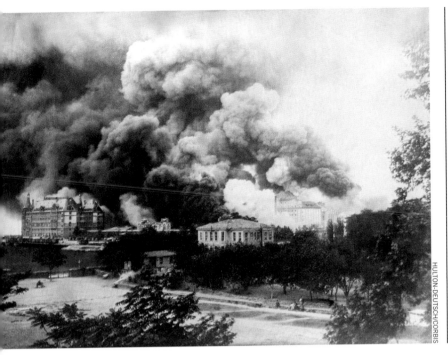

A surprisingly fierce Ottoman army joined Germany and Austria-Hungary in World War I, in 1914, but that alliance lost all the same. Furthermore, the Ottomans' brutal wartime deportation policies and its treatment of Armenians, which resulted in hundreds of thousands of deaths (the exact number and circumstances are still debated), led many to think that the world would be a better place without this remnant nation. Reformer and war hero Mustafa Kemal addressed this sentiment, harnessing a budding nationalist fervor at home in an effort to shed the yoke of the recent (and even long-term) past. He knew that nothing short of a fresh and completely different start was needed. Left with Istanbul and Asia Minor, the Turks, many veteran Ottomans among them, proclaimed the Republic of Turkey in 1923. This secular state was headquartered in Ankara under President Kemal, who later became known as Atatürk, "Father of the Turks." The nation Turkey, thus, can be seen as the Ottoman phoenix, rising from the ashes of empire.

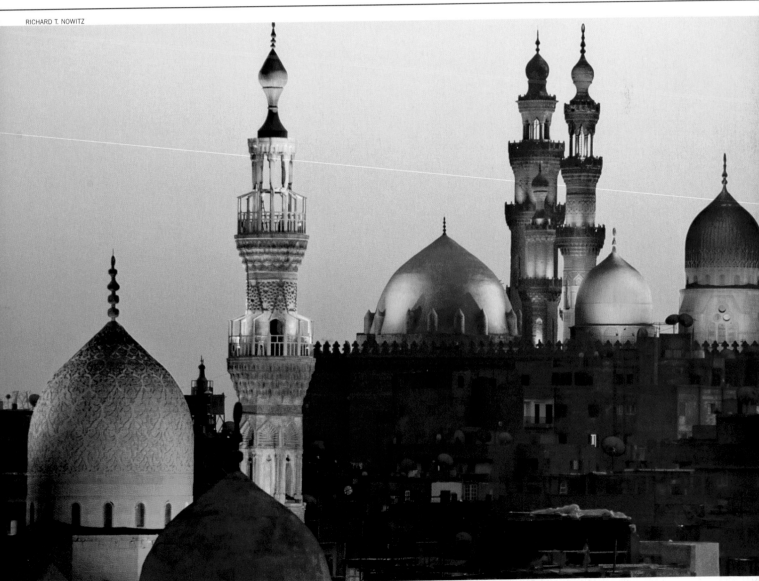

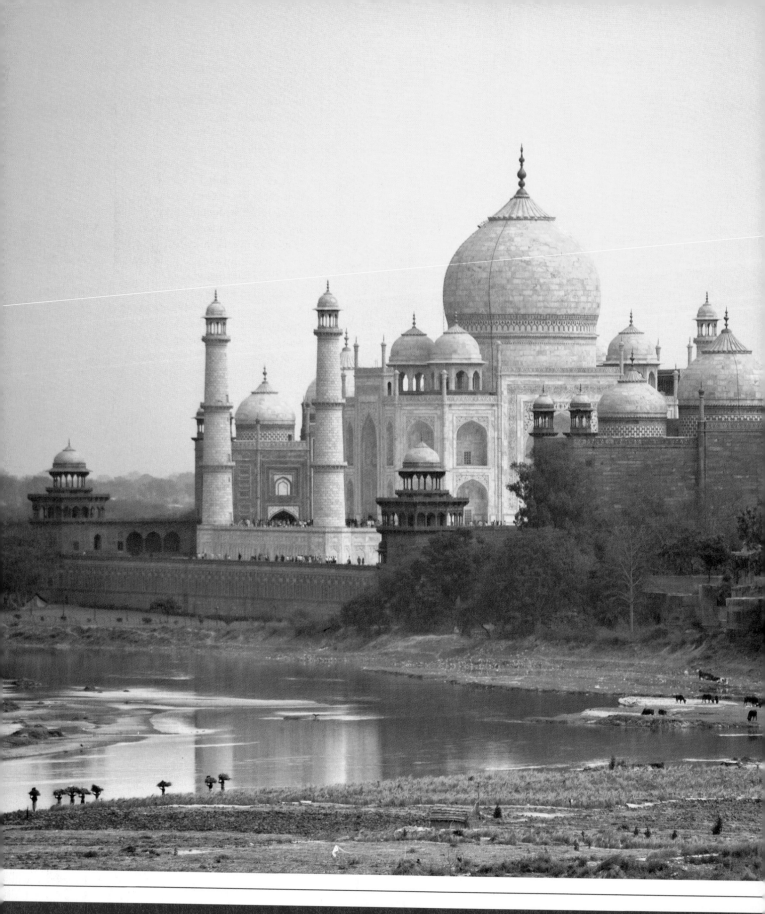

THE MUGHAL DYNASTY

So great was the impression left by our next civilization—the English word *mogul*, meaning a powerful person, was derived from its root—it is perhaps surprising and even unfair that the Mughal Dynasty is remembered best by many Westerners for one big building. Notable for more than two centuries of progressive rule over much of India, the Mughal epoch was distinguished by a succession of effective rulers who not only established a centralized administration which, until the end, practiced religious tolerance but also erected extraordinary, many and varied monuments, most famously, yes, the Taj Mahal.

This perhaps should not be India's first entry in our book. As we have said in these pages: We now know there was an earlier great Indian civilization; it arose in the Indus River valley in the Bronze Age between 3300 and 1900 B.C., with an apex sometime between 2600 and 1900 B.C. Twentieth century excavations proved much about these ancient people, whose culture is now known also as the Harappan Civilization, after the first of its hundreds of cities (Harappa, now a part of Pakistan) to be recovered. Certainly, these archaeological discoveries have undermined the idea that most or all of the advanced early civilizations were spawned within the Fertile Crescent. Much about the Harappan Civilization remains a mystery, as its signs and symbols have never been translated as effectively as those of the Greeks and Romans, or of the Maya and Inca. The Harappan Civilization may have numbered as many as 5 million citizens, and surely it was great. The sophistication of the Indian people is ages old. We know already of the vital part colonies in the "state of India" had to play in Portugal's global empire of the 16th and 17th centuries.

And now we return to the Mughal.

This dynasty was founded in 1526 by Zahir-al-Din Muhammad—a Chagatai Turkic prince commonly known as Babur. A direct descendent of Genghis Kahn, the Mongol conqueror, and Tamerlane (or Timur), the Turkic invader, Babur was a natural military leader who, by the time of his death in 1530, held dominion over most of northern India. Though Babur's son lost control of the empire, his grandson Akbar, assuming the throne at age 14, reestablished the kingdom and became known as the greatest Mughal ruler of all time. Beginning his reign in 1556, he set off to expand his territory

At left is the Taj Mahal on the Jumna River at sunset, and below, seen in a 17th century Indian painting done on ivory, is the woman for whom it was built. Mumtaz Mahal, born Arjumand Banu Begum in 1593, was the favorite wife of Mughal emperor Shah Jahan. She died in 1631, and is entombed today in the Taj, as is he—eternally by her side.

while reforming and strengthening the administration and financial system. In order to successfully do so, Akbar adopted a policy of conciliation with the Hindu Rajputs—the ruling warrior class. To obtain alliances, he married the daughters of Rajput chiefs, who returned the favor by acknowledging him as emperor. He expanded his territories as a result of these bonds, and showed no mercy to those who denied his supremacy, dominating by force. Still, he believed that all religions must be tolerated, if possible. Akbar encouraged unity within his diverse empire by abolishing the taxation of non-Muslims, integrating Hindus into his government and army, and initiating religious discourse—which he would monitor—between Hindus, Parsis, Christians and Muslims. Successful on many levels, Akbar's progressive rule is often portrayed as a model for future governments, for as opportunities and tolerance for non-Muslims expanded, so did the Mughal Empire, to the extent that by the end of Akbar's reign in 1605, he held power in most of north, central and western India. (Portuguese influence at the time was largely in coastal regions on both coasts of the Indian peninsula).

Akbar's powerful government was perpetuated through the successful reign of his son, but the Mughal Dynasty reached its cultural zenith with his grandson Shah Jahan. Acceding to the throne in 1628, Shah Jahan's passion for building marked his rule. First commissioning the construction of two mosques in the empire's capital, Agra—the Moti Masjid (Pearl Mosque) and the Jami' Masjid (Great Mosque)—he went on to construct in Delhi a massive fortress-palace called the Red Fort and another Jami' Masjid, considered one of the finest mosques in India. But Shah Jahan's most famous enterprise will forever be a 42-acre mausoleum complex built for his favorite wife, Mumtaz Mahal, who died in childbirth in 1631. This tomb, the renowned Taj Mahal, took more than 20,000 workers and 22 years to complete. Both the Shah and Mumtaz rest today within its walls.

And his former empire rests in the pages of history. When Shah Jahan fell ill in 1657, his sons fought for succession. The winner, Aurangzeb, through religious and political intolerances, sent the Mughal Dynasty into steady decline. His extremism caused Mughal rule and artistry to evaporate, and all proceeding emperors essentially became puppets of the new British and French influence until the last Mughal emperor was disposed of completely by the British in 1858. Indian independence would not come for another 89 years, by which time the idea of "empire" and "dynasty" of any kind was anathema to many among the citizenry.

Below we see the dismal interior of the Agra Fort, crosstown from the fabulous Taj Mahal. The romantic Shah Jahan, builder of the Taj for his wife, was imprisoned here by his own son, Emperor Aurangzeb, in a power grab after Shah Jahan fell ill in 1657. He was confined in this place until his death in 1666. At right is the domed loggia of the Pearl Mosque at the Red Fort in Delhi, yet another example of the golden age of Mughal architecture overseen by Shah Jahan: the Taj, the Red Fort, several mosques in Lahore, another fine mosque in Thatta, the Jami' Masjid in Delhi, many other buildings in Agra. Shah Jahan is remembered warmly today. His son is not.

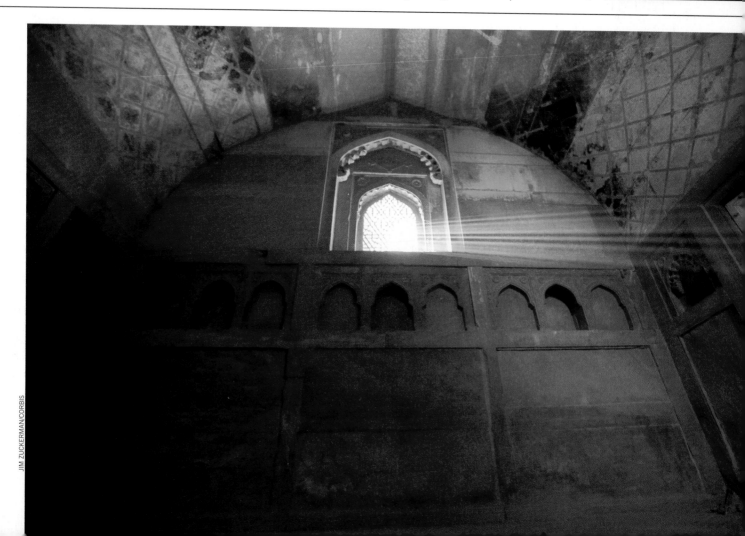

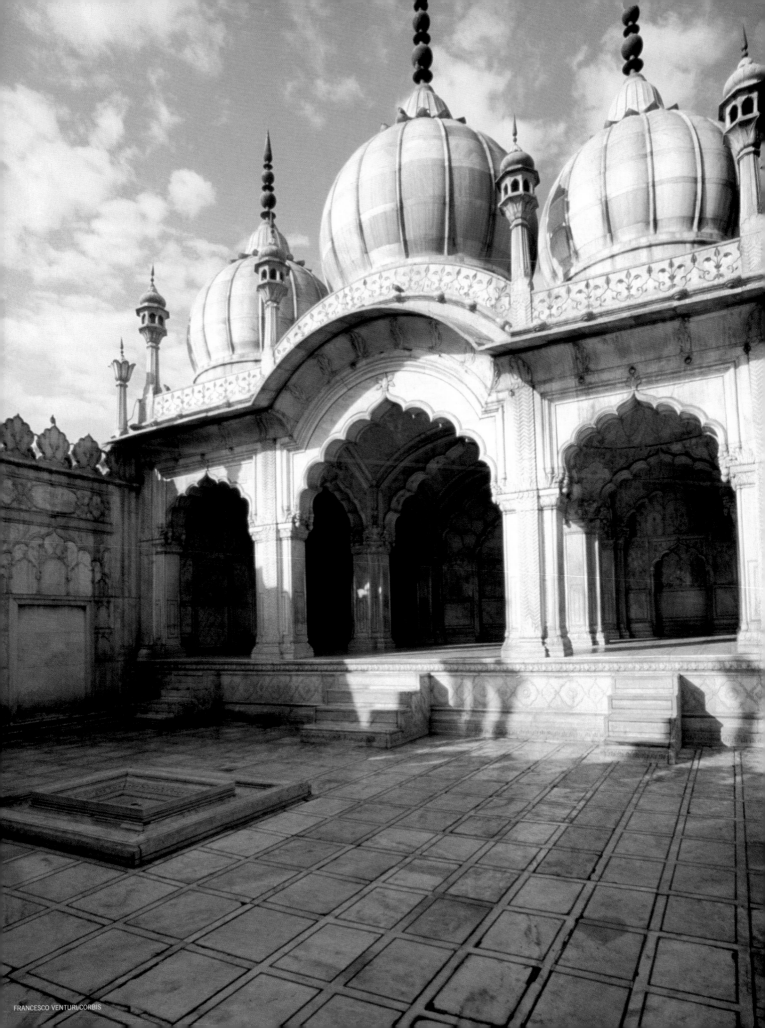

BRIDGEMAN-GIRAUDON / ART RESOURCE, NY

A little earlier in our pages, when dealing with the first global transoceanic empire—that of the Portuguese—we may have appeared to downplay the role of Spain in the early decades of the Age of Discovery, and specifically Spain's intrepid hired hand, the Italian Christopher Columbus. We certainly did not intend to do so; there really is no downplaying Spain's importance as a transoceanic conqueror, even if rival Portugal was first and foremost, particularly with its eastward colonization to complement its forays westward and southward. And as for Columbus: After that first, 1492 journey to the "New World," when he landed in what is today the Bahamas, Cuba and Hispaniola before returning to Barcelona with gold, parrots, spices and human captives, he made three more Atlantic salvos, and opened the seaways to other European explorers. He sparked the European land and resources grab in the Americas. Dominating that action, thanks to him, was Spain. Under the joint leadership of sovereigns Isabella and Ferdinand, Spain had an upper hand in the West, and when the nation entered into that brazen Treaty of Tordesillas with Portugal, basically divvying up the world as if drawing lots, Spain wound up with "rights" to lands from Alaska to Cape Horn, plus far-western parts of Asia. On paper (and in many places, on the ground), Spain was already mighty, and in the 16th and 17th centuries it became *the* global powerhouse under the rule of the German House of Habsburg, reaching its zenith under the rule of King Philip II, who reigned from 1556 to 1598. How immense was Spain? At various times during his tenure Philip was king of Portugal and, through his marriage to Mary I, Sicily, Naples, Great Britain and Ireland. That said, the Spanish Empire was by necessity more of a confederation than a country, with many provinces wary of Habsburg. And so, within his realm, Philip was a diplomat and a juggler as much as he was an autocratic monarch.

In order to govern its lately acquired overseas lands, Spain divided its dominion into four viceroyalties: geographic regions governed locally. The first of these, established in 1535, was the Viceroyalty of New Spain. It was the product of Spanish conquistador Hernán Cortés's defeat of the most powerful Aztec city, Tenochtitlán, in the Valley of Mexico. Initially, New Spain's territory included all Spanish lands north of the Isthmus of Panama, with the renamed Tenochtitlán as capital: Mexico City. New Spain expanded rapidly to cover ground in what would one day become the central and southwestern United States, and eastward lands from the Gulf of Mexico to Florida. In 1565, when Spain conquered the Philippines, those islands too came under New Spain's jurisdiction.

Before 1543, New Spain was run by Viceroy Antonio de Mendoza, a relatively just and compassionate leader who stabilized the conquered Indian societies while increasing royal revenue. Mendoza worked earnestly to limit exploitation of the Indians, but he always kept his eyes on the monetary prize. A reflection of his success: During the 16th century, Spain held in gold and silver the equivalent of $1.5 trillion in today's U.S. dollars, all acquired from mines in New Spain. This very profitable first phase of Spanish conquest in the Americas was spadework for further expansion, and in 1550, Mendoza became governor of the newly established Viceroyalty of Peru, which included territories from modern-day Argentina, Bolivia, Chile, Colombia, Ecuador, Panama, Peru and Venezuela.

Though the reign of the Habsburgs would endure nearly two centuries, the death in 1700 of the heirless Charles II, who would in fact be the last Habsburg king, led to the War of Spanish Succession and the empire's loss of its European assets. Philip V prevailed as the first king of Spain under the House of Bourbon, and he and his immediate successors would add to Spain's overseas empire the Viceroyalty of New Granada in 1717 and the Viceroyalty of the Río del la Plata in 1776. However, as we have seen time and again in these pages, when wars start they do not readily end, as rivals smell blood in the water. The 1700s saw an economic recovery in Spain, but the fighting at home and in the New World territories could not be quelled. Over the course of the 1800s, Spain would lose its global empire almost entirely, maintaining today its Iberian Peninsula stronghold, the Balearic Islands, the Canary Islands and two small enclaves in North Africa.

It had been a long, strange trip since Columbus sailed the ocean blue.

CAMERON DAVIDSON/CORBIS

Left: Christopher Columbus being received by Isabella and Ferdinand, his sponsors for his first of several successful—if misunderstood— missions to the so-called New World.

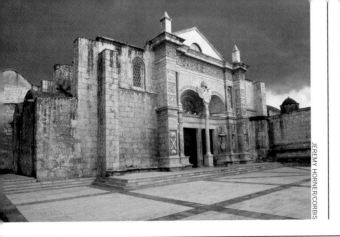

JEREMY HORNER/CORBIS

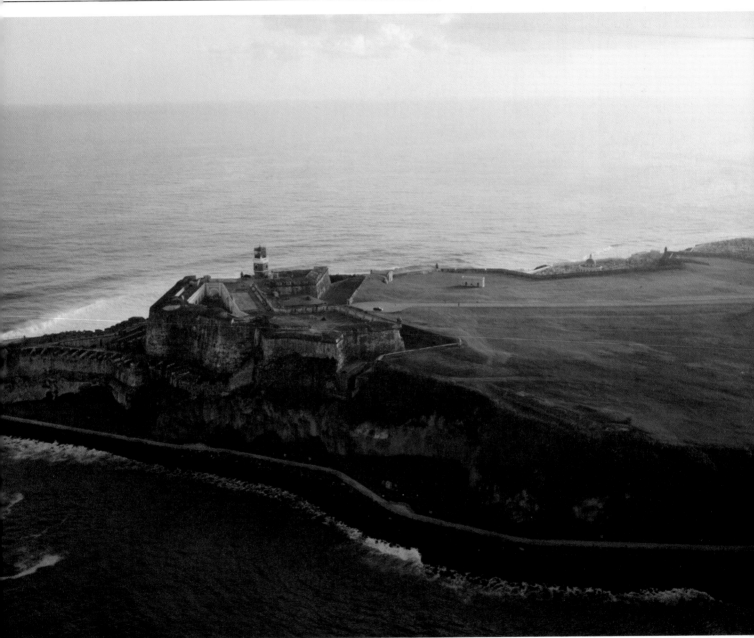

THE SPANISH EMPIRE

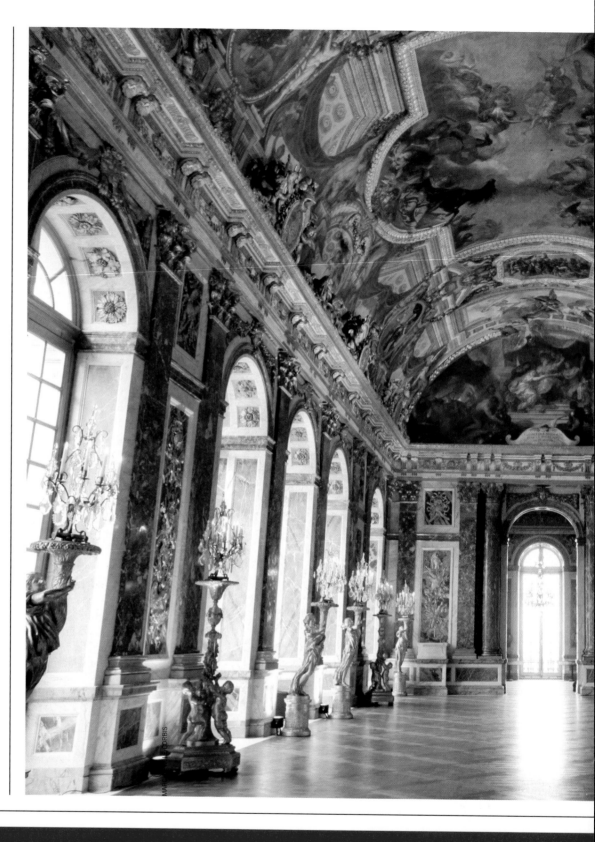

Opposite is a 19th century rendering by Gyula Benczúr of an 18th century drama: King Louis XVI and Marie-Antoinette with their children at Versailles on October 6, 1789, before their final fate, as dictated by the chiefs of the French Revolution, befell them. At right is the Hall of Mirrors at the Palace of Versailles after a modern restoration. The revolution is in some ways a historical sidelight to French conquest, but it is at the heart of France as a great civilization. There were utopians, idealists and the vengeful disenfranchised at the barricades, and it all certainly went less well than did its contemporary counterpart in North America.

THE FRENCH EMPIRES
(AND NAPOLEON)

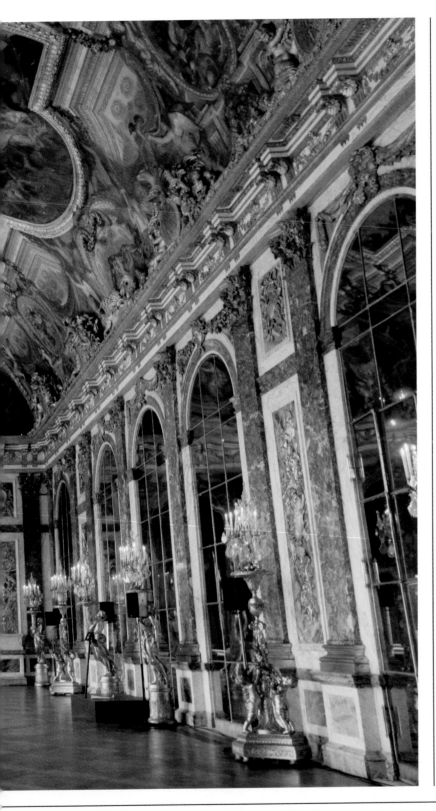

Global empire: All of the major players in Europe took their shot at one point or another—the Italians (the Romans), the Portuguese, the Spanish, the British, certainly the Germans—and at one point or another, each of them achieved a politically (if not culturally, philosophically or spiritually) organized civilization to which world history still pays attention. On the heels of the Spanish and Portuguese annexations during the Age of Discovery came, beginning in the 1600s, the French colonial effort, which would grow into a vast empire in the 19th and 20th centuries, peaking with holdings of nearly 5 million square miles in the 1920s and '30s. Only France's great and eternal rival, England, had a larger empire (which of course went down like corked wine in Paris).

France did not enjoy quick success in North America, as the Spanish were inclined to exercise the rights they and the Portuguese had decided upon. But eventually the French made inroads in Canada, in the colony of Acadia (today, Nova Scotia, New Brunswick and Prince Edward Island). The limited number of settlers in this territory known as New France forged alliances with the First Nations people (Indians) and established a boisterous fur trade. Then they migrated, and the long-ago French colonial expansion can still be sensed today in language, accents and cuisines extant in eastern and central Canada, up to Hudson Bay and then down the midsection of the United States (back when: Louisiana) all the way to New Orleans. France was, meanwhile, engaged in acquiring territories in the Caribbean (the French West Indies, including Saint-Domingue—today, Haiti—Guadeloupe, Martinique and Saint Lucia) and in India as well. Certainly French empire-building was going well.

Regardless of the early interactions with the Spanish in North America, France always had Britain in sight—more so than Portugal or Spain. Unfortunately for the French, the British had their eyes on the French as well, and coveted many of the same territories and their riches. In North America, the British colonies along the eastern seaboard of what would become the United States developed at a far greater economic pace than did the French outposts, and eventually London came

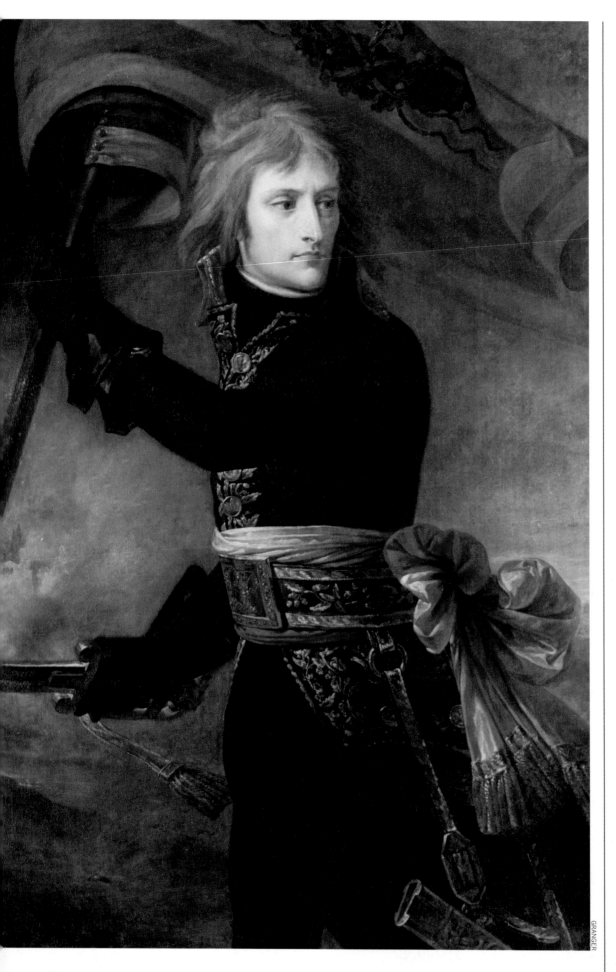

to dominate that playing field. The shared enmity of London and Paris was of course deep-rooted, and one monarchy was eager to undermine the other at any turn; witness how France was willing to help the colonists during the U.S. War of Independence. Britain was game for the fight, and better at it, and generally succeeded in beating France in the 18th and 19th centuries. Thus ended what is called the Grand Empire. But France was not done.

Before we get to France's Second Empire, we pause to deal with Napoleon Bonaparte, and to emphasize that a great civilization should not be judged only by its growth, its spreading "empire." Ancient Greece was defensive and inward-looking in ways that Rome was not; and under Napoleon I, emperor of the French from 1804 to 1814 (with a brief return to power in 1815), France regained momentum—and its sense of nationhood—after the chaotic French Revolution, while, initially, tending to its knitting at home as much as seeking foreign spoils. Napoleon, an admittedly imperialistic ruler, was also a latter-day Hammurabi, and his Napoleonic Code influences civil law in free nations throughout the world today. As a military man, he was not so much a disciple of Alexander as an earlier General Eisenhower: brilliant in opposing those who came at his country, ready to take the fight to them when the time was right. His brilliance in the field is studied at West Point today.

In the early 19th century, various coalitions involving just about every major European power (and certainly England) challenged the French Empire, but Napoleon, often against larger armies, prevailed in what would be called, in his honor, the Napoleonic Wars. France was, for a time, the dominant Continental European nation, and Napoleon consolidated power by making—or forcing—alliances everywhere. Only when he greatly overstepped, invading Russia in 1812, did he suffer; weakened, he was defeated by the Sixth Coalition the following year, was forced to abdicate the year after that, and was exiled to the Mediterranean island of Elba, from which he escaped to reclaim power. However, he suffered a climactic defeat in June of 1815 at the Battle of Waterloo. After this three-year flurry of activity, he was confined during the last six years of his life on the island of Saint Helena, guarded by the detested British.

Later in the 19th century, France began its second grand and successful campaign of colonization, this one largely concentrated on Africa and Indochina. As we have already seen in our pages, the 20th century was marked, particularly in the post–World War II years, by the spread of independence movements and a general view that colonization was, at the end of the day, just plain wrong. For an example of how recent the dismantling of these global empires—the French, the British, the Portuguese—was, we can look at Vietnam. Many know that, before the U.S. became involved in that divided Asian nation in a professed effort to halt the march of communism, the French were fighting their own losing war there. But the reason was different. The French were trying to hold on to a longtime possession; they were struggling to keep their empire intact. As we know: to no avail.

In the 21st century, the world still suffers its surfeit of despots, tyrants and dictators, and successful democracies are the exceptional example rather than the rule. But two historical traditions far less in force today than they have been in the past several centuries are absolute (as opposed to constitutional) monarchies and global landlords.

The last imperial dynasty to rule in China, the Qing Dynasty—*qing* meaning "pure"—was established in 1636 by the Manchus, a semi-nomadic people living northeast of the Great Wall in Manchuria. (When you look at the Mongols and Manchus, China seems to have had a mini-tradition of northern hordes organizing themselves up there, then sweeping south.) Securing its rule over the Ming Dynasty in 1644 upon capture of the capital city of Beijing, the Qing established an empire that would grow to encompass territories in Central Asia, Tibet and Siberia. With these new lands came many new people, and the population grew from 150 million to 450 million, with many of the non-Chinese minorities integrated into a newly constituted national economy, and sinicized in other ways as well.

The supremacy of the Qing Dynasty created a political, economic and cultural dominion that would last 268 years. The success of the Qing was exemplified in the brilliant reigns, during the 17th and 18th centuries, of two monarchs: the Kangxi emperor and his grandson, the Qianlong emperor. Under these rulers, each of whom reigned for about 60 years, China saw an extended period of economic prosperity and political stability, as well as artistic advancement, as the Manchus embraced Chinese cultural traditions and filtered them through a new lens.

A conquering dynasty, the Qing were foreigners in Beijing, and they knew it. The course they sagely chose was to seek the acceptance of their Chinese citizenry. Adopting Ming governmental structures and continuing to employ Ming officials, the Manchus sought approval from the scholarly class. The Kangxi emperor was particularly active

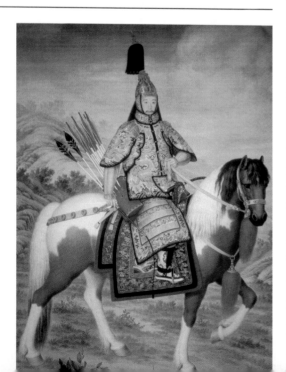

In a literal example of the pen—or brush—being mightier than the sword, the Kangxi emperor found great success in getting his new subjects to go along with, and even feel good about, Beijing through the creation of celebratory, colorful scrolls. At right is a detail from Scroll Three of the emperor's Southern Inspection Tour series, this one concerned with Kangxi's trip from Jinan to Mount Tai in 1698. Depicted are dignitaries of the city of Tai'an gathered around an altar, awaiting the arrival of the emperor. Mount Tai, one of China's so-called Five Great Mountains, has been a point of pilgrimage for more than 3,000 years. Emperors and peasants have come to worship at this place associated with birth and renewal—surely a point not missed by the Kangxi emperor as he was selling the Qing Dynasty. Since the scrolls worked so well for him, they were adopted by his grandson, the Qianlong emperor (left), whose reign was equal to Grandfather's in terms of extraordinary length and accomplishment.

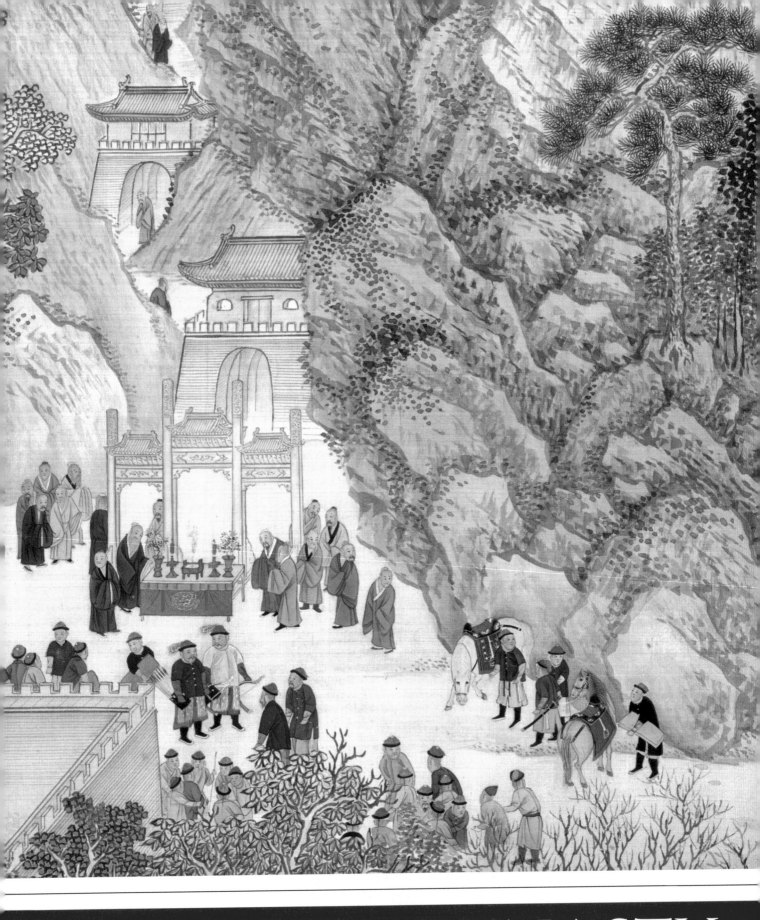

THE QING DYNASTY

in this effort. Inviting southern scholars to his court, he included them in the transformation of his leadership from a Manchu style of governance to a Confucian way of seeing things. Ming standards were retained, and at the end of the day the emperor won over not only the elite, but the man and woman in the street as well.

In the second half of his reign, Kangxi focused on economic prosperity and advancement of the arts. He commissioned a record of the second in his series of southern inspection tours: a set of a dozen scrolls depicting his official visits to the economic and cultural centers of the south. Measuring 27 inches high and 85 feet in length, each of the 12 scrolls documented one segment of his journey, and proved to be very effective—not to mention aesthetically amazing—early versions of the press release. Kangxi's inspection tours not only inspired the people but served to solidify Manchu rule in China. By the end of his reign in 1722, the Qing Dynasty had broadened its control to Outer Mongolia and Tibet.

The dynasty reached its height under the Qianlong emperor. Qianlong, like his grandfather Kangxi, made six inspection tours, documenting one in a set of 12 scrolls. What had worked well in the past worked well again, and the empire grew to a size unprecedented in Chinese history. Under

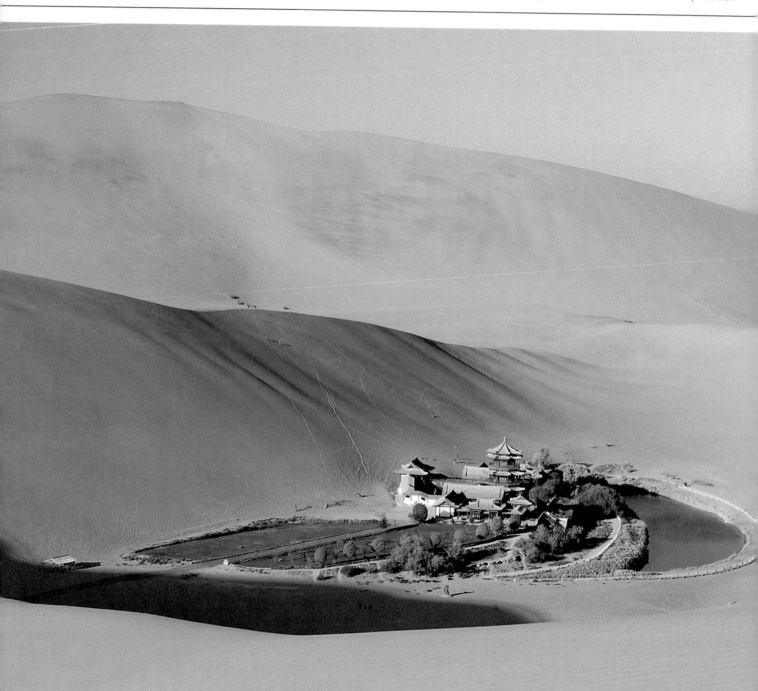

Qianlong's watch, this enormous and multiethnic enterprise, comprising Han Chinese, Mongols, Tibetans, Manchus and others, seemed to defy the notion that a diverse, stitched-together society could not live in peace. Qianlong dubbed himself the "universal ruler," and this didn't seem a specious claim. During his tenure commerce, including printmaking and porcelain manufacturing, continued to thrive; a patron of the arts, Qianlong commissioned not only those scrolls but paintings and great literary works.

Qianlong's reign was an unqualified success, but he could not live forever, and subsequent, less-talented emperors faced increasing disapproval and then unrest. In the 1850s and '60s, civil uprisings such as the Taiping and Nian rebellions were gaining steam. By 1900 revolutionary groups had developed across the land. Then, in October of 1911, the Republican Revolution led to the abdication of the last imperial emperor, Puyi. With that, the Qing Dynasty was no more. The Republic of China took its place in 1912, and this new formation would last until 1949, when it yielded to Mao Zedong's People's Republic of China. Mao would go on to prove that enormous, disparate China could be kept together—and in line—through subjugation and coercion quite as effectively as with Qing-style persuasion.

JOSE FUSTE RAGA/CORBIS

DIEGO AZUBEL/EPA/CORBIS

BETTMANN/CORBIS

Far left: Asia's largest desert (and the world's fifth largest), the Gobi, half a million square miles in northern and northwestern China and southern Mongolia, is home to the seemingly miraculous Crescent Moon Lake, which has existed at the base of Echoing-Sand Mountain for millennia. During the Qing Dynasty, it was given the name Yueyaquan. As with many spectacular natural sites in China, it has long attracted spiritual seekers (that is a temple hugging its shore). Left, top: In the summer of 2011, visitors enjoy a boat ride on a lotus pond at the old Summer Palace, also known as Yuanmingyuan, located on the outskirts of Beijing. The serene setting has been a pastoral paradise since time immemorial. In 1750 the Qianlong emperor began work on the formally named Garden of Clear Ripples, which would become the Summer Palace. In 1752, Qianlong gave nearby Longevity Hill its name in honor of his mother's 60th birthday. Left, bottom: Puyi, who abdicated while still a boy in 1912, stands in a courtyard in 1924. He was not only the last Qing emperor, but his reign marked an end to imperial China and the beginning of its history as a—titular—republic. Puyi's life remained complicated after he stepped down. In 1934 he was declared by the Japanese to be emperor of the puppet state of Manchukuo; this reign lasted until the end of World War II. From 1964 until his death in 1967, Puyi, now back in the fold, served on the Chinese People's Political Consultative Conference.

For nearly two centuries, from 1721 until 1917, the Russian Empire was a grand and sometimes glorious thing, blanketing Eastern Europe and Asia, entrancing or horrifying the world with its flamboyant, larger-than-life leaders and glittering St. Petersburg palaces. At its zenith in the 1800s it was the third largest empire by landmass in world history, trailing only the British and Mongol empires, and by century's end it had the third largest population on the planet—more than 125 million registered subjects—after the Qing Dynasty and the British Empire.

The fact is, the Russian Empire was plenty big and probably already an empire before it was formally called such. When Ivan IV, Ivan the Terrible, was crowned the first-ever czar of all Russia in 1547, the term *czardom* began to be used, and the difference between this and an empire can be seen as a question of semantics. Ivan initiated the successful conquests of Astrakhan and Siberia, among other places, and built a state of more than 1.5 million square miles, which certainly looks like an empire on paper. But it was left to Peter I, also known as Peter the Great, to officially rename the czardom Empire of All Russias in 1721, and he changed its character as well. An instinctive

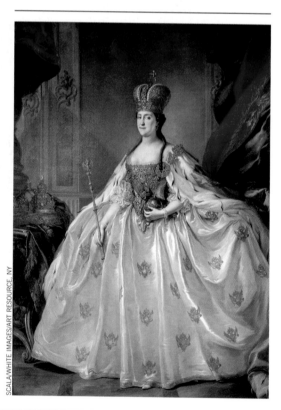

Having angled her way to the palace by way of marriage, Catherine was only a coup away from the top job. And quite a coup it was, with an assassination following. Above, in her coronation robe. The gleaming lobby is at the Hermitage in St. Petersburg, once Catherine's hobby, today one of the world's great museums.

THE RUSSIAN EMPIRE

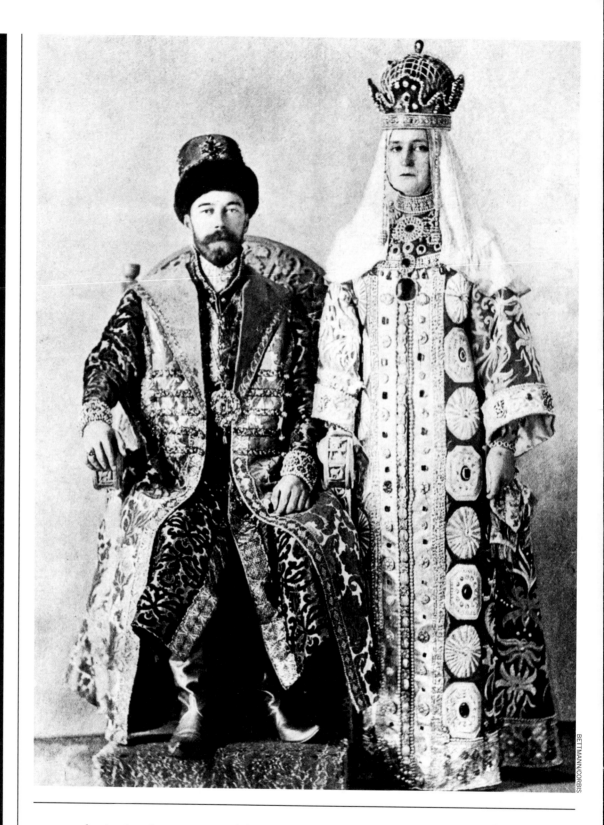

The folks on these two pages seem to have purposely dressed for contrast. On the opposite page, the year is 1895, and the serious-minded fellows include members of the leadership of the St. Petersburg League of Struggle for the Emancipation of the Working Class (from left): V.V. Starkov, G.M. Krzhizhanovsky, A.L. Malchenko, V.I. Ulyanov, P.K. Zaporozhets, L. Martov and A.A. Vaneyev. The man in the middle, Ulyanov, is not front-and-center by accident; he will become better known to history as Vladimir Lenin once his Bolsheviks take over. When they do so, it will be at the dire expense of Czar Nicholas II and his wife, Czarina Alexandra (right), and their children. Only yesterday, this royal family waltzed through one venue of opulence after another at the seasonal palaces in St. Petersburg and at the Kremlin in Moscow (the Reception Hall, seen opposite circa 1890). But only tomorrow, St. Petersburg will no longer be the capital and the seat of power will be in Moscow at the Kremlin—in perception and in fact, a suddenly more austere and forbidding building.

autocrat, he instituted autocracy, and he, too, expanded Russia's reach. When he gained strategic access to the Baltic Sea in the north, he moved the capital city from Moscow to St. Petersburg. He modernized the centralized government, and did away with local rule. He aimed to make Russia, like himself, great, and he had achieved much of his goal by the time of his death in 1725.

Three able women—his wife, Catherine I; Empress Anna; and Peter and Catherine's daughter Elizabeth—followed him successively to the throne, and then came another of these occasional Russian superheroes, Catherine II, also known as Catherine the Great. This was a woman who knew what she wanted and made sure that she got it, often beating long odds. Once she had power, she held it until her death, also against the odds. Meantime she made Russia larger and mightier

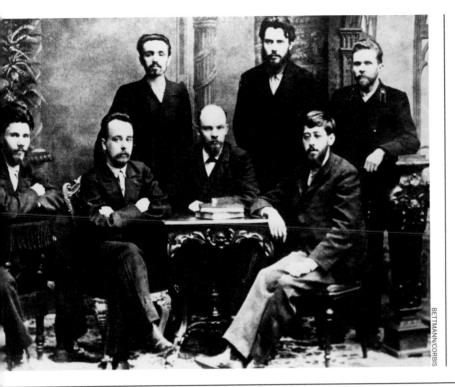

than ever, unbalancing the scales in Europe.

An instant irony is that she was hardly Russian, maybe a twig or two of Russian on the bottommost branches of her family tree. The facts: Catherine II, famous empress of Russia, was born Sophie Friederike Auguste in what is now Poland to a Prussian general and his ambitious wife, who had designs for her daughter's Greatness. Young Sophie hardly needed coaxing. She would write years later in her memoirs that as soon as she arrived in Russia as a teenage girl she had it in mind to one day wear the crown of the empress, which meant setting her sights on young Karl Peter Ulrich, Duke of Holstein-Gottorp, a czar apparent. She was feverish to learn the Russian language and announced she would convert to Eastern Orthodoxy, a decision that infuriated her father. The day after she joined the Russian Orthodox Church in 1744, receiving the name Catherine, she became engaged to Peter, and they wed one year later, after the bride had turned 16.

Her husband became Czar Peter III in 1761, then

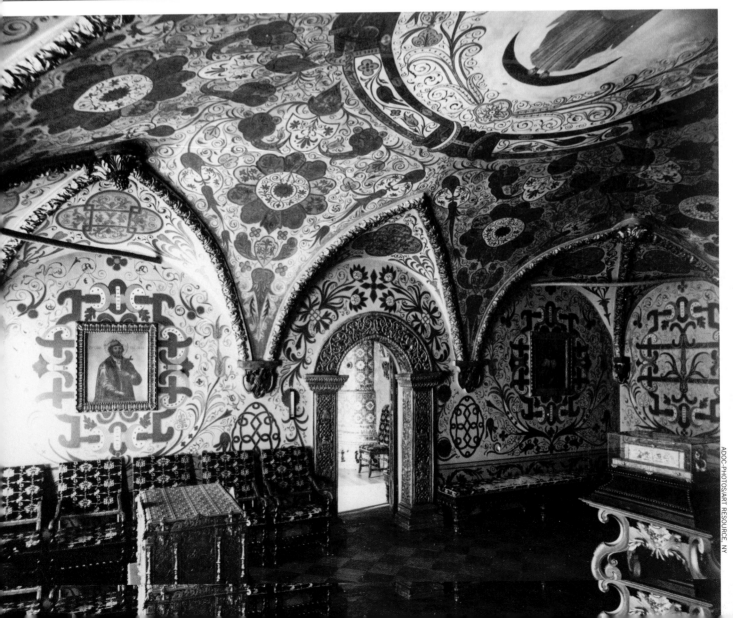

was deposed in a coup d'état barely six months later while he was away and she was in residence at the fabulous Winter Palace in St. Petersburg. Catherine was a woman of many parts: She was strategic in her actions, intelligent, sociable, promiscuous, ruthless. She had known Peter's political opponents before the overthrow and did not demur when it was proposed she rule Russia. There is no evidence that she was a party to the assassination plot that took her husband's life shortly after the coup. But with Catherine—and with the constantly melodramatic Russian Empire—who knows?

During her long, 34-year reign, Catherine expanded Russian territory by war (often at the expense of the Ottoman Empire) and diplomacy; was the nation's greatest-ever patron of the arts, starting the Hermitage Museum in St. Petersburg with her personal collection; raised the country's profile as a sophisticated society with her cultured friends, such as Voltaire and Diderot, elsewhere on the Continent; sponsored programs to greatly improve education—and meantime put down domestic rebellion, which did occasionally raise its head, with a ruthless vengeance. Catherine, queen of the Russian Enlightenment, handed over

an empire that was strong and, now, worldly.

In the first part of the 19th century, Napoleon Bonaparte made the bad mistake mentioned earlier of invading Russia, where he was defeated by the forces of Czar Alexander I. In the second half of the century, Russia fell badly behind the west as the Industrial Revolution took hold abroad, while serfdom continued to be stubbornly perpetuated at home. Dissent arose, and rather than emulate such as Peter the Great and Catherine the Great—fundamentally reformers, modernists and liberal thinkers—the czars chose censorship and repression, which would be part of the Russian mind-set from that time forward. The emancipation of the serfs in 1861 showed chinks in the czarist armor. The assassination of Czar Alexander II in 1881 by terrorists showed more. And meanwhile, Russia's armies were engaged in wars. In quelling uprisings in acquired lands (such as Poland), in trying to push the edges of boundary yet farther, and in finally and fatally entering global conflicts, they became overtaxed and overassigned, and increasingly ineffective.

That the Russian Revolution of 1917 and the rise of Lenin's Bolsheviks represented the death knell

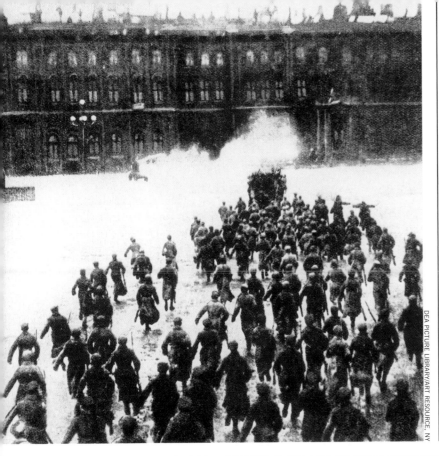

for the long reign of the czars is assumed wisdom. But it can also be said: The wages of World War I, on top of those of the Crimean War and the Russo-Japanese War, did them in. After rebuffing Napoleon, the Russian military was seen as the to-be-feared world-beater. But now it was not only weary, it was exposed, and Czar Nicholas II was the unfortunate leader to be in the wrong place at the weakened time.

Many dissident groups were in play immediately after the Great War, several of them trying to interpret the Industrial Revolution and what it might mean for the working man and the ruling class. Lenin's Bolsheviks advocated a small leadership working on behalf of a large proletariat, and they gained adherents. Strikes led to violence, which led to civil war, which led to Nicholas's abdication (on March 15, 1917), which was followed by the dramatic assassination of Nicholas and the mass murder of his family (no, sorry: Daughter Anastasia did not survive). An appointed Provisional Government in St. Petersburg yielded quickly to the newly formed Soviet Union, which eventually moved the capital back to Moscow: an extraordinary circle closed.

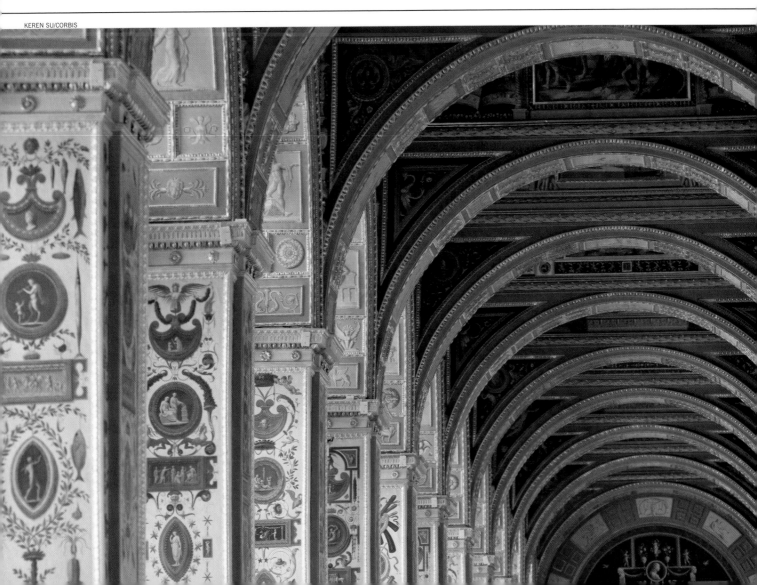

Queen Elizabeth I (right) fixed the problems at home, then was willing to venture beyond British shores. Her principal agent in looking at the New World across the Atlantic was Sir Walter Raleigh (below, left), who after two voyages did not successfully colonize in North America, but showed the way. His efforts did lead to a settlement on Roanoke Island (in what was then called Virginia, now a part of North Carolina), where today there is a statue of Virginia Dare in the properly named Elizabethan Gardens (far right). Who was she? The first European child born in what would eventually become the United States. Despite the distinction, her fate was ill. The Roanoke Colony did not stick; it had vanished altogether by the time later British ships landed in Virginia. What happened to the Lost Colony is still debated today. England's eventual 17th century successes in Virginia, New England and elsewhere along the coast led to a strong set of 18th century colonies, which stressed their wish to be free. George III (below, right) was the victim of that wish.

To reiterate a point made earlier in these pages: "civilization" does not equate with "empire"—you don't need to be one to qualify for the other. England was poised to be a great civilization before it was a world-beating empire. In the Elizabethan Era of the late 16th and early 17th centuries, it was only beginning to get serious about colonization, but it already had in its midst William Shakespeare, among so many other artistic geniuses—painters, poets, a richness of playwrights. It had developed a sophisticated economy, an intellectual elite (for instance, the philosopher and scientist Francis Bacon) and an increasingly disciplined military. It was small, to be sure—consider that on that scepter'd isle off the European mainland, England and Scotland were still separate kingdoms when London started looking abroad—but, history now tells us: The British were ready. That England was, under Elizabeth, about to embark on a long campaign that would result in an exercise of dominion over nearly one fourth of the earth's land (13,000,059 square miles) and a fifth of the world's

THE BRITISH EMPIRE

people (458 million)—and that it would remain the world's most potent global power for more than a century—well, that could never have been guessed. Never.

Shakespeare's green-eyed monster—envy, jealousy, call it what you will—spurred England (and France and the Netherlands) to enter the Age of Discovery sweepstakes well after Portugal and Spain had set the ground rules. The Iberian pioneers had proved that there was gold in far away hills, and all strong European states soon coveted a share. England made a salvo directed at North America, then retreated. In 1497, Henry VII sent John Cabot west to find a route to Asia by way of a presumed North Atlantic passage. Cabot reached Newfoundland, returned home with the erroneous news that he had made it to Asia, traveled out into the Atlantic once more and was never heard from again.

Chastened by this early experience, England made no further attempts at transoceanic discovery and colonization until the essential, legendary reign of Elizabeth I. The daughter of the notorious Henry VIII and Anne Boleyn, born in 1533, she had a tortuous route to the throne: her mother executed; herself declared illegitimate; her designation overturned by Parliament in 1544; imprisoned by her half sister, Mary; released; then ultimately given the crown. When she was made queen, England was, frankly, downtrodden—beset by internal problems and distressed by failures in its wars against the French. Elizabeth turned things around. She presided over an astonishing period of growth in Britain's cultural and political influence. She stabilized labor unrest, instituted currency reforms and laws to aid the poor, and boosted agriculture and industry. Seeking peace in Europe, she defeated Spain and held France at bay. Vain and fickle, brave and bold, she set her nation on its path to greatness.

Among her favorites was Sir Walter Raleigh, who first handled close-at-hand properties that had been confiscated from the Irish, then sailed forth to attempt colonization in the New World, then went in search of the mythical El Dorado in South America—before being put to death by the British Crown (Elizabeth, his patroness, had passed on) to appease the Spanish for an impertinent Southern Hemisphere incursion.

England now knew its way to North America and was able to parlay that knowledge. John Rolfe (and Pocahontas) in Jamestown Colony; Myles Standish and the religious refugees (the Pilgrims) in Plymouth Colony: They were all part of this saga, as were the Scots-Irish who crossed the Atlantic and pushed into the Appalachians (pushing Native Americans around as they did so). Before too terribly long—about a century and a bit more—the English colonies of the eastern seaboard had grown

Above: Victoria, Queen of Great Britain and Ireland and Empress of India, pictured at her writing desk, circa 1890. Her Indian servant Abdul Karim, otherwise known as the "Munshi," a Hindu word meaning "teacher," stands in the background. Left: Members of the Royal Artillery during the Crimean War, circa 1855. This conflict, which pitted an alliance of England, France and the Ottoman Empire against Russia, has been called the first modern war, and prepared all sides for what was to come.

Left: Circa 1900 in Bloemfontein, South Africa, a nurse and other medical aides tend to sick and wounded British soldiers in a makeshift hospital ward. The Crimean War was unpopular at home, as it was largely about protecting the Ottomans from the Russians. The Boer Wars, by contrast, were about protecting what was seen as a "possession." Below: A worker painting one shell amidst a sea of them at a World War I munitions factory.

considerably and were a well-organized, productive societal unit, invaluable to the Crown.

Perhaps too invaluable for London's good.

Too productive.

Too well-organized.

By the mid–18th century, leaders of British outposts in North America came to feel they were being exploited, and eventually took up arms in a quest for independence. King George III certainly prized his dogged colonies across the sea, but this revolutionary war fairly mystified him, as it did many other British leaders and military men. For the longest time, the Redcoats seemed to win every battle but face only sterner and more perplexing opposition. For the English, the war became a quagmire, not unlike what the United States itself would much later experience in Vietnam. The Thirteen Colonies, led by the indispensable George Washington, eventually won their freedom, and the great British Empire was, if not critically wounded, certainly bruised.

Yes, England made feints in the years immediately ahead to recapture what it had so ignominiously lost— the War of 1812 and so forth—but essentially London

At left are British troops arriving home after advancing German troops forced an emergency evacuation of the Allied forces from Dunkirk in June 1940, and above is the dome of St. Paul's Cathedral in London seen through the smoke caused by a German air raid during the Blitz. The British Empire was thoroughly unused to being beaten, but at the time even questions of empire were less important than survival—and repelling the evil. Eventually, victory was won, and old nationalistic enmities were put aside among new friends. Opposite: General Charles de Gaulle, leader of the Free French, and Winston Churchill embrace.

settled upon two long-term courses that would prove propitious: to avoid making blood enemies of the nascent U.S.A. (essentially: to call the past the past), and to look east, south—to the ends of the earth!—for new people and nations to conquer and/or exploit. In America, the English had essentially been fighting against themselves: a civil war with an ocean as the Mason-Dixon Line. Why settle for such a fair fight? There were lots of places and peoples just waiting to be either claimed or overwhelmed. Hadn't the famous 18th century English explorer, navigator and cartographer James Cook told them so with his extraordinary career at sea? He literally gave them the map.

First item of business, as the map emphasized: Deal with France—Britain finally had to come to grips with its neighboring archrival France. It defeated Napoleon in 1815, and rushed off to a hundred years of world dominance. It has been said that the 20th century was "the American century." Using a similar criteria behind that assumption, the 19th was unquestionably the British

century. From Canada to Australia, India to South Africa, the English brolly covered all. The Roman Empire doubtless controlled a larger percentage of the known world in its time and the Mongols ruled over more acreage, but never has one country realized so great a spread over the globe as did Great Britain during the long reign of Queen Victoria in the 19th century. It was said without exaggeration that "the sun never sets on the British Empire."

Who was Victoria? Born in 1819, her heritage was largely Germanic. But she was a quite rightful heir, and became queen at the age of 18. She married her cousin Prince Albert of Saxe-Coburg and Gotha not long thereafter. England had already started its (today complete) transition from an absolute monarchy to a constitutional monarchy—which is to say, a monarchy with very limited powers alongside a representational government, led in this case by a prime minister—and Victoria is regarded historically as having been, most often, politically neutral in an age when England's vying parties produced extraordinarily forceful leaders (Benjamin Disraeli, William Gladstone).

Also, she is famous for having remained a stern, one-dimensional moralist in a time when her country produced cutting-edge writers and thinkers (Robert Browning; the Brontë sisters; Charles Darwin; Charles Dickens; Rudyard Kipling; Alfred, Lord Tennyson; John Stuart Mill; Robert Louis Stevenson). Nevertheless, there she was on the throne in this remarkable period, helping to steer the whole earth-shattering enterprise. Significantly in Europe, she helped steer in a personal way: She and Albert had nine children before his premature death, and the marriages of those offspring led to British alliances with Russia, Germany, Greece, Denmark and Romania.

Meantime, there were the wars—the Crimean, the Boer Wars in South Africa—and the conquests in the Far East. The Victorian Age, as the period extending until and even a bit beyond the queen's death in 1901 is called, was marked by a nationalistic confidence in the country's might, fueled by the Industrial Revolution and a sense of righteousness, even as the British Empire sometimes behaved in a beastly fashion toward its many colonies. Victoria rubber-stamped decisions concerning the issues she needed to deal with, and if she left the messier aspects of empire-building to her ministers, she nonetheless was the face of her epoch.

In confronting the awful ambitions of other nations in World Wars I and II, England never behaved better or more nobly. A man named Winston Churchill was involved in both conflicts, and he said to the British Parliament in June 1940, when the days were dark indeed: "I have, myself, full confidence that if all do their duty, if nothing is neglected . . . we shall prove ourselves once again able to defend our Island home, to ride out the storm of war, and to outlive the menace of tyranny, if necessary for years, if necessary alone." That brave confidence in Britishness was perhaps overstated, but it was nonetheless inspiring.

England and its allies, who had been rallied to the cause by Churchill most forcefully, did prevail, of course. But the meaning of the wars—and of the 20th century generally—was unmistakable. The British Empire was becoming an anachronism in an age when country after country sought, with justice, their independence. Great Britain itself was no longer a superpower, let alone *the* superpower.

Ah, but the civilization that is England did, with tremendous courage and grit, outlive the menace of tyranny, and has proved since, as has its large friend the United States, that such a civilization doesn't need to be an empire to confirm its greatness.

The past is present: In 1953, on the South Pacific island of Tonga, during Queen Elizabeth II's tour of her Commonwealth of Nations—most of which are loyal to the U.K. but not governed by it—she, Prince Philip and Queen Salote Tupou III of Tonga look upon a tortoise said to have been a gift from England's wayfaring Captain Cook back in the 1700s.

FOX PHOTOS/HULTON/GETTY

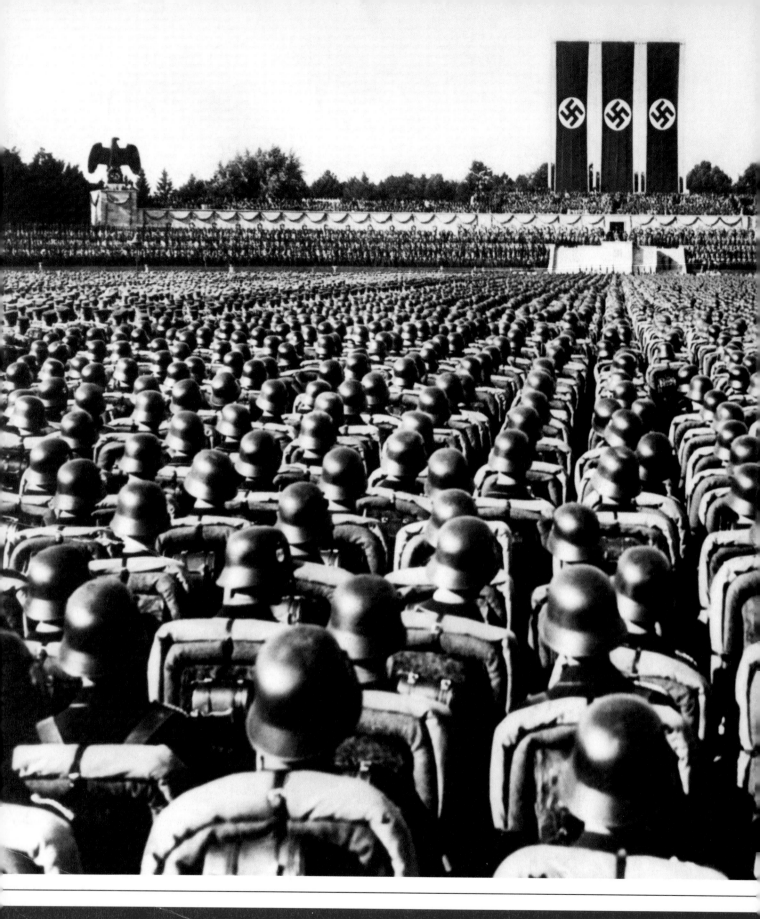

EMPIRES OF THE AXIS

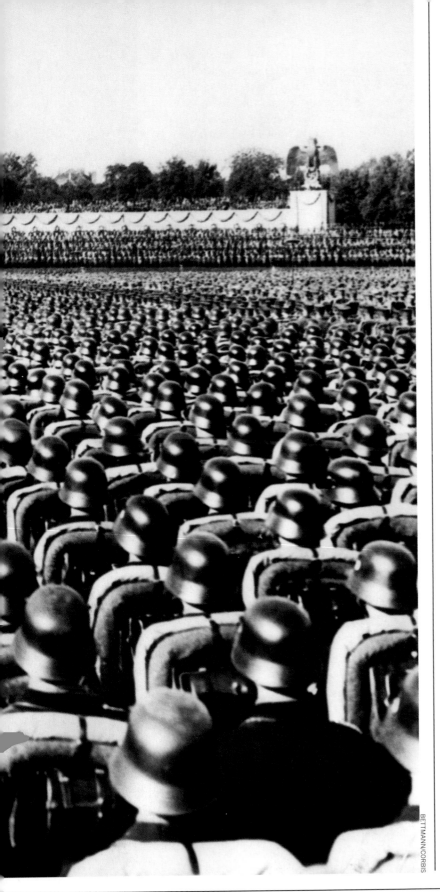

W e include this chapter, set here in our pages between the British Empire and the United States of America, to further examine the question: What is Civilization? When we say "great civilization," is size a primary benchmark consideration? Should it be?

Is *great* perhaps (or should it be?) a loftier, Aristotelian modifier?

What might have been the definition of *Civilization* at 20th century's end had things gone differently?

The passage of so much time somehow inures the Macedonians and even the Mongols from a vigorous prosecution of their motives or methods. We are impressed, all these centuries later, at their military acumen and the sheer extent of their dominion. How they got where they got to is of interest, but after the passage of a half a millennium or more, bloodless. They make their way into a book on great civilizations in part because we didn't really know Alexander or Genghis, not personally. (Probably a good thing.)

But we knew Hitler.

We were present, and watched horrified as he waged his campaign and forged his alliances. Not without reason, we suspected his motives, and during the war we were presented with hard evidence of many of his methods. We saw books burned and ghettoes routed by his regime, his Third Reich. We heard rumors about the worst of German atrocities, and after the war, as we marched toward Berlin, we had the worst rumors confirmed by the death camps.

The Maya practiced human sacrifice, as we have mentioned, but somehow the context of history mitigates. Their Mesoamerican culture was foreign, in many ways, to Western thought and practices. Was this their fault? And if we are to be judgmental, after looking at all of these several civilizations in this book, how do the scales balance after we consider what happened to the Maya—and Inca, and Aztecs and others—at the hands of the Spanish? Who's the bad guy, or the worse guy?

But Hitler and his confederates—a goose-stepping parade across the world, settling old or perceived grievances along the way—are different. A genocide of *6 million innocents,* in the modern day, after humankind had spent such a long time arriving at some base agreements of right and wrong. Such a long time traveling through the rise and fall of the empires described in the chapters of this book, trying to come to some understanding of Civilization.

We address this here, in our penultimate chapter, not to provoke by including the empires of the Axis,

A huge crowd of soldiers in combat gear stands at attention beneath the reviewing stand at Nuremberg, Germany, listening to a speech by Führer Adolf Hitler at a Nazi Party rally in 1936.

but to frame our conversation as it nears its end. In the day itself, arguments were made by supporters of the Third Reich, of Italy or of Japan forwarding the rightfulness of their causes. Arguments were made by many observers from the outside that they should be left alone: If they wanted to impose their views of Civilization on their neighbors, as Alexander or Genghis once had, it was not our business—not until they tried to impose those views on us. This would come to be called, after the fact and once all facts were known, appeasement.

Was there room or opportunity for such arguments back when—back when the pharaohs spread their influence out from Cairo, or when the Persians swept over much of what they knew of the world? Surely there was, and sometimes an attractive counterargument took hold.

In looking at civilizations, we eventually choose—we judge. We prefer the arguments of Ancient Greece, perhaps, or those of the people of the last-gasp British Empire, who stood at the front and faced down evil, rather than those of their ancestors, the British privateers who sailed the world, planting flags everywhere. The properties of Civilization—the very idea of Civilization—prod us to be judgmental. We want to be civilized, and we want others to be too.

The members of the Axis powers did not begin building an immense collection of dominated countries when Adolf Hitler, Italian minister of foreign affairs Galeazzo Ciano and Japanese ambassador to Germany Saburo Kurusu signed the Tripartite Pact on September 27, 1940. Each nation had independently been engaged in empire-building since the 19th century (if you equate Italy with Rome, you could say the Italians had quite a venerable heritage in this regard). But, as an alliance, each made the other stronger and the collective opposition

GRANGER

Left: Benito Mussolini, head of Italy's National Fascist Party, declaims in Rome. Below: Libyan cavalrymen strut their stuff in 1939. Two years earlier, Mussolini had paid a state visit to the often unhappy Italian colony and, in a show of faith, had arranged to be presented with a symbolic sword and a new title, "Protector of Islam." But by 1943 the Allies, principally the British, had driven all Axis forces out of Libya. In 1998, Italy formally apologized to Libya for all the pain it had caused during its nearly 40 years of rule.

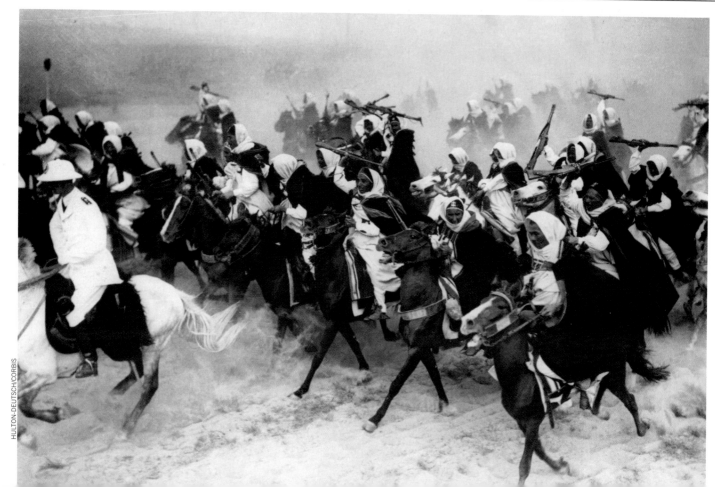

weaker. Theirs was a force formidable and frightful.

And successful. By early 1942, each of the original three Axis powers had realized its greatest-ever spread in the world. Collectively, they were in charge of most of Europe, save the crucial nations England and the Soviet Union; most of the Pacific, save Australia and New Zealand; and most of northwestern and northern Africa, save Egypt. The Axis, taken as a whole (while admitting that it was a political and strategic entity more than a cultural or philosophical one, and might have been predestined to come apart regardless of the war's outcome), had asserted itself as one of history's largest empires.

Just as important: Given the progress that had been made in weaponry, and given Hitler's, Prime Minister Benito Mussolini's and Emperor Hirohito's stated or implied intentions to dominate the planet utterly, it can be regarded as the most frightening empire ever.

How had it come to this?

We can only, in this limited space, speed through an answer to that question.

Modern Italy as a unified state had existed since 1861, and participated with other European nations in the "scramble for Africa" colonization rush. It annexed Eritrea, east and south Somalia, parts of the Ottoman Empire (including Libya) and, after dictator Mussolini took control in 1922, Ethiopia. On May 9, 1936, an official Italian Empire was declared.

The German Empire, the Deutsches Reich ("German Realm"), consisted of 25 constituent territories in Europe, notably the Kingdom of Prussia,

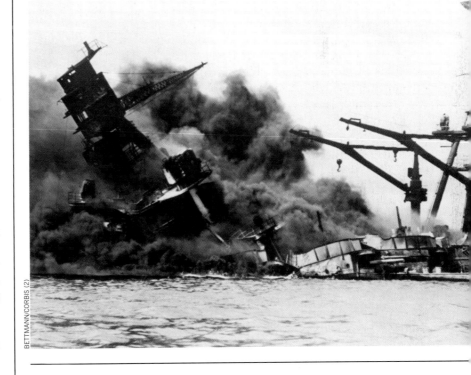

BETTMANN/CORBIS (2)

by the late 1800s. This empire was dismantled after Germany's 1918 defeat in World War I and Emperor Wilhelm II abdicated. Hitler stated that his goal was to reunify Germany, and up until 1939, when his territorial grabs were strictly of areas of German ethnic settlement, Britain and France acquiesced. Then, when the Führer annexed what was left of Czechoslovakia in March of 1939, his duplicity became clear. When he invaded Poland in September, seven nations, including Great

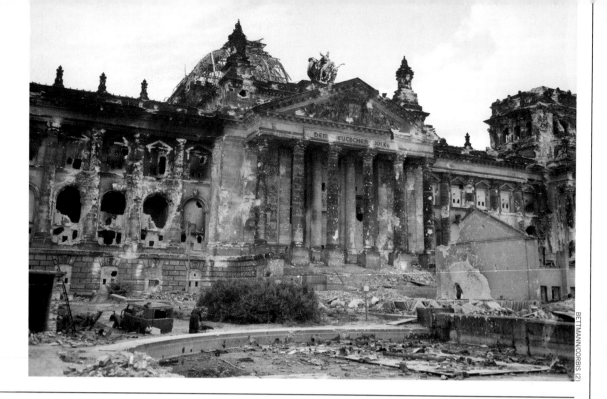

Britain and France, declared war. In the spring and early summer of 1940, the Germans occupied Denmark, Norway, Holland, Belgium and three fifths of France, meanwhile pushing British troops back to the beach at Dunkirk, where the survivors were rescued by boats—all still before the Tripartite Pact was entered into.

The empire of Japan had existed for thousands of years, but in its modern form, dated from the start of the Meiji Restoration in 1868. As Japan rapidly industrialized and militarized in the first half of the 20th century, it became a regional force, taking islands and island groups and warring with—and sometimes occupying parts of—China.

These three predatory countries found they had enough in common to form an alliance, and they showed their collective might early. Germany and Italy won battles in Yugoslavia, Greece, North Africa and Russia in 1941; and Japan, with superior air power, built one of the largest maritime empires ever in the Pacific: nearly 3 million square miles, after Japan took Singapore from the British and accepted the surrender of the Bataan Peninsula in the Philippines in 1942.

That was the year when the Axis was at its apex. But there had been chinks, and now there were mistakes. The German Luftwaffe had lost the Battle of Britain in 1940, and Japan had invited the United States into the war by bombing Pearl Harbor on December 7, 1941. Americans were now engaged in all theaters of the war. The Russian front went miserably for the Nazis. Mussolini was deposed in July of 1943, Allied troops landed on the Italian mainland on September 3, and that country surrendered five days later. The D-day invasion of German-occupied

France was on June 6, 1944, and after continued fierce fighting on the Continent, Berlin fell on May 2, 1945. The United States dropped an atomic bomb on Hiroshima on August 6, 1945, and another on Nagasaki three days later; Japan agreed to surrender five days after that.

There was no more Axis. And there has not since been an empire of Germany . . . or of Italy . . . or of Japan.

At seven o'clock on August 14, 1945, U.S. President Harry S Truman announces Japan's agreement to surrender, and with that World War II is over. Spontaneous celebrations break out across the land, including in New York City's Times Square, where a sailor kissing a nurse is photographed by LIFE's Alfred Eisenstaedt—the magazine's most famous ever picture. Although many men and women have stepped forward through the years claiming to be either the anonymous sailor or the nurse, LIFE, and Eisie, always maintained that we could not be sure, and it's better that way: They are both Americans in this moment of triumph, and all of us are on the precipice of better days. Opposite: A glimpse of what modern civilization in the U.S. would look like over the next several years, with the good life for some being the opportunity to hold down a job, provide an education for the kids, own a place of one's own (top, Levittown, New York, in 1949) and share a backyard cookout with the family (bottom, in 1957).

ALFRED EISENSTAEDT

THE UNITED STATES

The 20th century changed everything in the long history of Civilization's march, and many citizens of the United States would aver: for the better. The way of the world for millennia was monarchies, and suddenly monarchies were in disfavor, and were tumbling everywhere. The world's most powerful nations for centuries were those engaged in colonization and empire-building, and suddenly independence movements were sprouting everywhere and global superstructures were being dismantled. The Axis powers tried the old way—absolute ruler, constant conquest—but they were beaten. The Soviet Union, in the aftermath of World War II, consolidated its power and ruled over a communist empire that was held in check during the Cold War, then came asunder when the USSR came up on the losing end of that long, strange conflict.

By century's turn, no nation had significant holdings much beyond its immediate boundaries, and no army was on the march with an eye toward world or even extra-local dominion. There were still a host of dictatorships, many of them brutal, and there were regional wars that were as awful as the world had ever seen; the many crises in Africa, and the cruelties witnessed during those conflicts, are cases in point.

But in a rarity dating back to the ancients, there was no civilization or ruler trying to impose its will, by force, on the world as the world appeared outside the castle windows. Some critics of the United States would debate that statement, no doubt, but the U.S. wasn't invading foreign shores with the goal of annexation or plunder.

The United States of America—the new face of Civilization?

Perhaps so. With the general fade of monarchies and the inexorable shrinking of empires, there arose in their stead something modern called superpowers. It can be said that this is what Great Britain, France, Spain—or the Mongols, or the Macedonians—once were. But this new breed could stay at home, face off against any perceived foes from a thousand miles away, and deal strategically with the world while never trying to overrun it. The superpower nation could find riches in new ways that had nothing to do with stealing someone else's gold. It had the chance, if it was smart about its affairs, to worry about its own and build a stable and prosperous domesticity, while keeping others

OF AMERICA

Long may she wave: In the postwar years, a flag in the possession of a citizen of the United States of America has a different significance than it may have earlier, and is raised in many places where it means different things. Left: In 1965, a young civil rights activist in Alabama waves the Stars and Stripes during the sometimes violent Selma to Montgomery protest marches. Civil rights in the U.S. was an issue that had hardly been settled by Abraham Lincoln's Emancipation Proclamation or by the Supreme Court–ordered desegregation of schools in 1954. That the citizenry continues to wrestle with it in the courts and the streets— and in the halls of Washington, D.C., where the Civil Rights Act of 1964 and the Voting Rights Act of 1965 are signed into law—is indicative of a free society. Meanwhile, the United States, which has "never lost a war," finds itself in the quagmire of Vietnam, where in 1968 a 1st Cavalry helicopter (top right) delivers ammunition and supplies to U.S. Marines besieged by North Vietnamese troops at the forward base of Khe Sanh. Bottom: Buzz Aldrin stands beside an American flag at Tranquility Base during the July 1969, Apollo 11 mission to the moon. Western civilization, which in Athens had looked skyward and prayed to Apollo, had slipped the bounds of earth and was gazing into a seemingly limitless future.

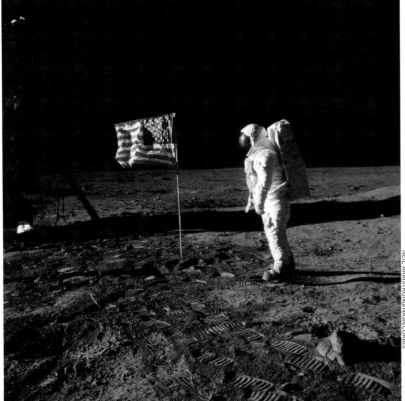

at bay by intimidation or pro-activity. If it accomplished this, it could forward its view of Civilization.

The United States did not set out to do this. In 1775 and '76, when the Colonies decided to engage in combat with the British, of whose empire they were a part—and then when they subsequently enunciated, eloquently, the reasons *why*—it all came down to principles. They hoped and intended to gain independence. This, they finally did, after an eight-year war, and then for the longest time they tried to stay independent as others considered this nascent democracy vulnerable. The probes came from within as well as without: some factions wondering whether they could control this innocent society, which meanwhile was growing by leaps and bounds. Yes, the United States did its form of empire-building with the ruination of Indian nations during its westward push over the Appalachians and the Rockies, and yes, it had left a democratic principle glaringly on the table when declaring itself dedicated to civil rights yet not declaring slavery illegal. But then this nation,

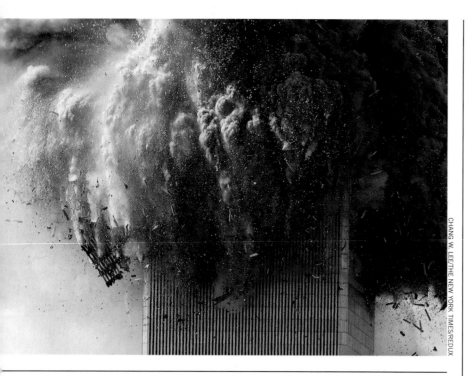

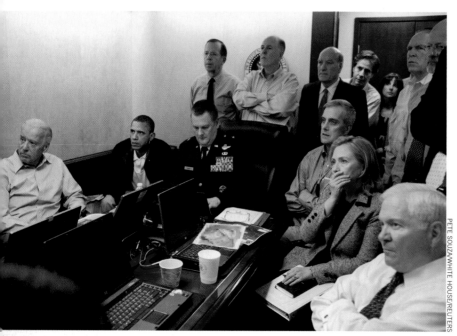

States, during the global expansion of the super-serious British Empire and the hyper-imperialistic Russian Empire, looked like a coltish, imaginative newcomer to the world community's elite. It looked like an alternative and an opportunity.

It proved itself in World War I and won the day in World War II. It was not accidental that Albert Einstein was in America and working for the cause (despite his considerable qualms) before and during this second conflict—it wasn't accidental, it was emblematic. It was what the United States had been pointing toward (even if it never dreamed of playing the starring role on the global stage), from the beginning. Send us your tired, your poor . . . your brilliant, your brave, your idealistic, your optimistic.

When the world emerged from the cauldron and put itself back together in the later 1940s, the Soviet Union knew who the opposition was if it was going to press its case. The "enemy" wasn't the British, it wasn't Europe, it was the U.S.A. This face-off lasted for many tense years, and why the United States prevailed is a complex answer, much more confusing than right-over-wrong. But the United States has always had (or did have, for the longest time) an extra arrow in its quiver: a sense of righteousness. It sold this to the world, and as the world looked at this nation—a success-ful democracy where nothing like it had succeeded to this extent in world history—the United States was strengthened. Workers who might in an earlier time have been communists now were democrats, and the Solidarity movement in Poland rose. The Vatican, which had many quarrels with the secu-lar United States, chose sides, picking Washington over godless Moscow. East Berliners woke up and realized that they might prefer to be West Berliners—better still, just Berliners.

Suddenly, the Cold War too was over, and the world was left with one "superpower": the first-ever true democracy to be the world's most powerful nation.

From 1945 to the present day the United States has drawn a new and very personal picture of a great civilization: law and order, personal free-doms, open elections, constant progress (TV! Wheat production! Cars! Computers! iPhones!), stumbles dealt with through due process and a watchful electorate . . . abject mistakes too, sure, but a social order built so durably that the mistakes could be overcome.

In the 21st century, the rise of China (again!) and the war brought by radical Islam (again!) has everyone wondering what the future holds. Only the future knows. Regardless, when the histories are written, the United States of America will be regarded as a great civilization indeed.

rather astonishingly, confronted this latter chink in its ideological armor during its great crucible, the Civil War, and emerged something close to whole. It continued to wrestle with the question, and how the answer seemed a counterpoint to its loftiest ideals, as the decades marched on.

Plato or Aristotle might have been proud. This society, much like a thinking individual, continu-ally encountered situations and quandaries, and worked its way through them. This looked, to the wider world, like an inviting kind of freedom and liberty. The immigrants flocked. The United

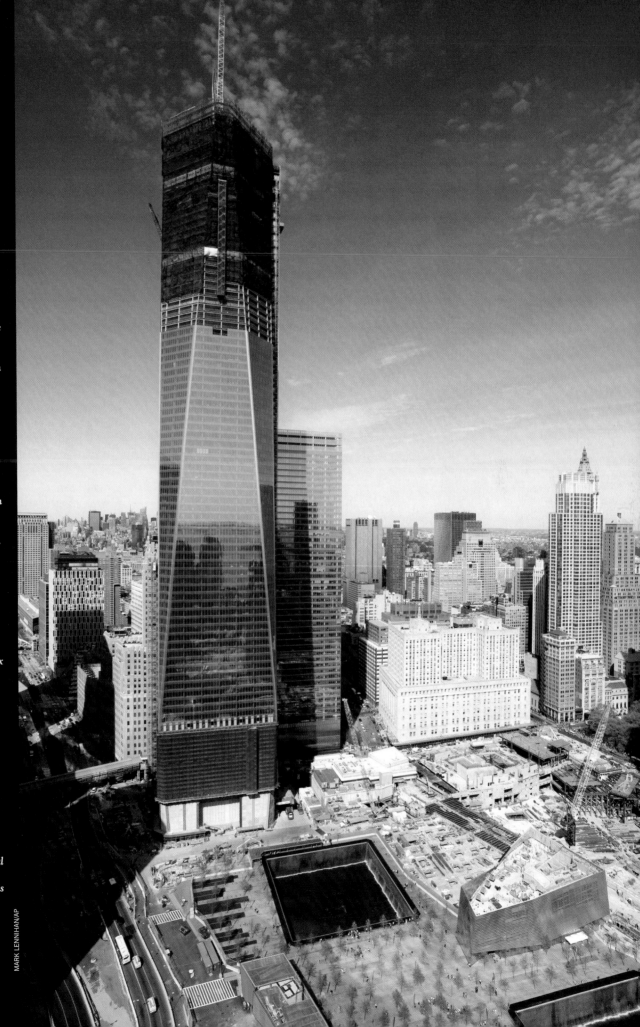

One of the things this review of the world's great civilizations has taught us: If a powerful nation is not always vulnerable, it is still, often, a target of resentment. Opposite, top, the United States is attacked on September 11, 2001, by al-Qaeda, a fanatical Islamist group headquartered in Afghanistan that has sent out, on this crystalline morning, a team of hijackers, some of whom commandeer American Airlines Flight 11 out of Boston and fly it into One World Trade Center in New York City. In the coordinated attacks this day, 2,753 will die. Bottom: Nearly a decade later, President Barack Obama and aides watch in the White House Situation Room as al-Qaeda chief Osama bin Laden is killed by U.S. SEALs at his hideout in Pakistan. Right: In 2012, the new One World Trade Center, previously known as the Freedom Tower, rises into the sky: the principal building in the new WTC complex in lower Manhattan, hard by where the original stood. Quite obviously the message behind the rebuilding was: America stands tall, America remains unbowed. Even the naming represented a considered action. During its planning and the beginnings of its construction, the building most often went by that colloquial name—Freedom Tower—as if emphasis were needed. In 2009 it was announced that the legal name One World Trade Center would be used going forward.

Underlying any civilization is a plan, an idea. Not necessarily intending to form the world's greatest nation, the Thirteen Colonies' Founding Fathers decided, together, how they wanted to shape their own, nascent society, and they set out their principles in the Declaration of Independence. As opposed to the framers of many earlier countries and cultures, they bothered to debate and specify their objectives, and the many reasons and justifications behind them. In the messy version at left, Benjamin Franklin, who along with John Adams was consulting on the draft as written by the eloquent Thomas Jefferson, has inked his suggestions and amendments. In the fine copy, the lofty goals are printed for dissemination beyond Philadelphia to fellow Americans up and down the eastern seaboard. The words will prove inspiring, and their more detailed elucidation in the U.S. Constitution will prove brilliant. More than two centuries later, the nation endures because the principles as first enunciated in 1776 have proved durable. Is democracy the best way to build a civilization? So far, it has done well. The future will, as it always has, continue to judge.

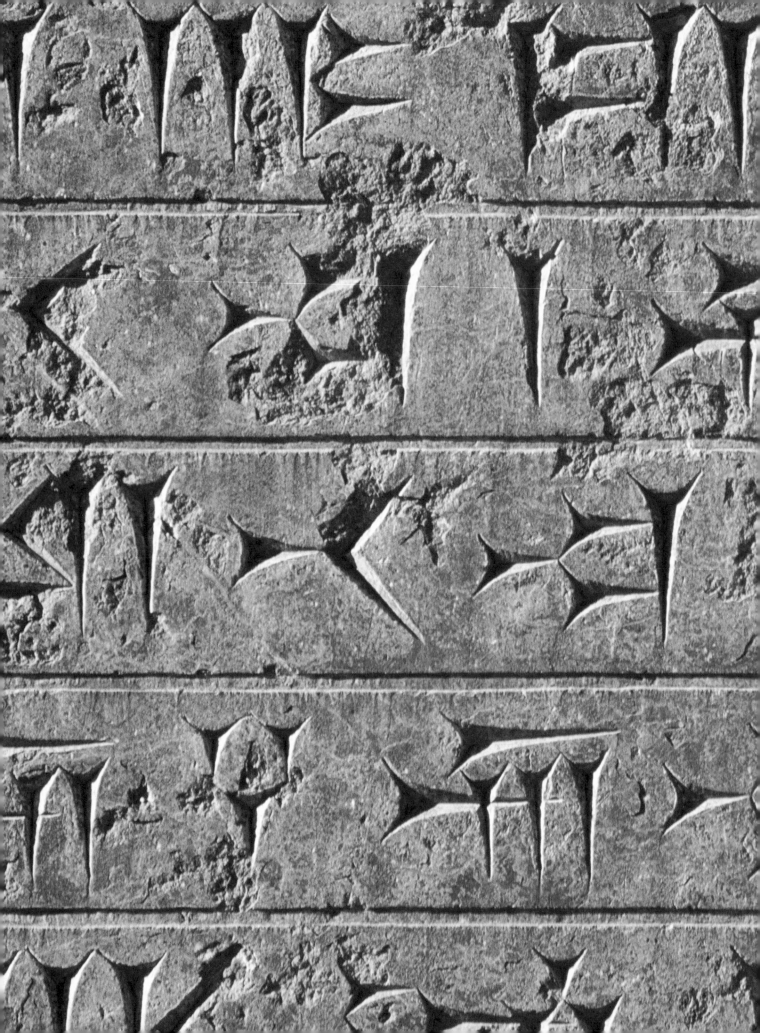